Romanticism and Its Discontents

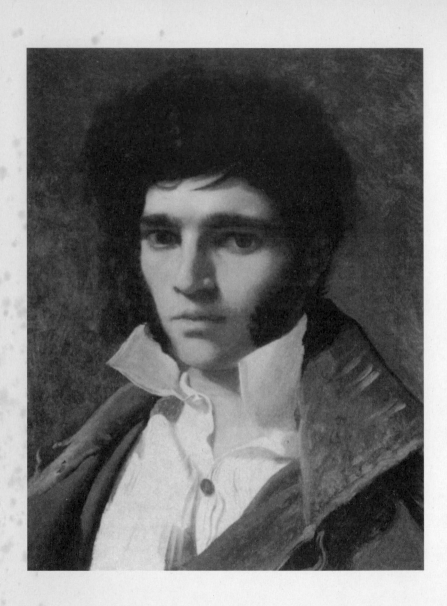

Romanticism and Its Discontents

ANITA BROOKNER

FARRAR, STRAUS AND GIROUX
NEW YORK

Farrar, Straus and Giroux
19 Union Square West, New York 10003

Copyright © 2000 by Anita Brookner
All rights reserved
Printed in the United States of America
Originally published in 2000 by Penguin, Great Britain
Published in 2000 in the United States by Farrar, Straus and Giroux
First paperback edition, 2001

Library of Congress Cataloging-in-Publication Data
Brookner, Anita.
 Romanticism and its discontents / by Anita Brookner.
 p. cm.
 ISBN 0-374-52784-9 (pbk.)
 1. Painting, French. 2. Painting, Modern—19th century—France.
3. Romanticism in art—France. I. Title.

N6847.5.R6 B76 2000
759.4'09'034—dc21

 00-034771

Contents

List of Illustrations

I

Romanticism:
A Change of Outlook

A Romantic has been roughly defined as anyone who believes that it is better to travel hopefully than to arrive. But this will hardly serve as a description of what was a moment in history: the Romantic Movement. No norms can be found for this amorphous entity; its dates vary according to the nationality of the commentator. As against this, it can be perceived, directly, in the images and the writings that it engendered, all tenuously connected by feelings, appearances, and anxieties with which the reader or spectator will be familiar, however distanced in time and preoccupation from those original events he may be.

Romanticism is ultimately about forms of behaviour; it is therefore recognizable. After the eclipse of Napoleon, with his subversive attributes of glamour and authoritarianism, relief was mixed with a feeling of bewilderment. In France the shame of defeat at the hands of a traditional enemy brought to light frustrations which might otherwise have lain undetected: the *enfant du siècle* was born. Thus Romanticism, particularly in France, where the movement is most easily studied, is basically political in origin. It is also religious, or rather spiritual. When Mme du Deffand complained to Voltaire, '*Mais, M. de Voltaire, vous combattez et détruisez toutes les erreurs, mais que mettez-vous à leur place?*'

('M. de Voltaire, you combat and destroy all the errors, but what do you put in their place?'), she was in fact describing the sensation, familiar to anyone who relies on conventional certainties, of having the ground knocked from under her feet and of becoming newly aware of the necessity of improvising alternative belief systems. Brilliant improvisation was after all the hallmark of the Revolution, by which time Mme du Deffand's modest inquiry had been forgotten. Yet it remained valid throughout the period of the Romantic Movement, which may be seen to be roughly equivalent to the years between 1800 and 1880. In France, where behavioural patterns were stronger and more urgent than in either England or Germany, there was a sharper hiatus between the picturesque of the eighteenth century and the huge bewilderment of the period that succeeded the defeat at Waterloo in 1815. Remarks in these pages will therefore be confined to the situation in France, at a time when the concerns of the nation became subservient to individual preoccupations. Napoleon, the charismatic outsider, left his imprint on many lesser men. His memory, for there was no adequate successor, brought in its wake both regret and a desire for emulation. His speed inspired a prodigious output of work, which became translated into deliberate demonstrations of genius; his energy encouraged a certain grandiosity. He is therefore essential to the century, as was Mme du Deffand, a modest and discreet person, whose salon was attended by leading men of letters and the more notable thinkers of her day, to the eighteenth. Her pertinent question to Voltaire was to receive neither affirmation nor clarification in the years to come.

Yet despite the shortage of answers, precisely because

of that shortage, Romanticism, rather than the Romantic Movement, has to be examined with the good faith that Mme du Deffand gave to her question. It has to be examined because it produced an organically connected number of resounding masterpieces in a relatively short space of time. More than that, we know it to be central to the most profound feelings and aspirations of ordinary men and women who will never produce a masterpiece, may never see or read or hear one, but who will, either consciously or unconsciously, recognize the quality that Romanticism seemed to bring to the fore: infinite longing. It is in essence a longing for what is missing, and an attempt to supply it. If the systems that ordained the canons of Augustan or Neo-classical productions were judged to be inadequate, it was not because they were too rigorous, as is sometimes claimed, but precisely because they were not rigorous enough. It was because they did not utilize the full range of personal investigation and self-questioning which the thinking post-Rousseau man had judged to be of interest and importance. Such unexpected and intriguing reactions as had been forced to the fore by the violent and unprecedented events of the Revolution demanded an equivalence in other areas, notably in the arts, as Stendhal so laconically and providentially stated in his brochure of 1823, *Racine et Shakespeare*. This attack on literary chauvinism, which propounds an altogether more flexible alternative to hallowed classical rules, also demanded relevance, a new form and utterance for changed times.

J'ai tâché que le mien convînt aux enfants de la Révolution, aux gens qui cherchent la pensée plus que la beauté des mots, aux gens qui . . .

*ont fait la campagne de Moscou et vu de près les étranges transactions de
1814.* [I want my language to suit the children of the Revolution,
those people who look for thought rather than beauty of style,
those people who took part in the Russian campaign and who
witnessed the curious transactions of 1814.]

Stendhal was not afraid of changed times. He who had
talked with Napoleon outside the gates of Moscow was the
first to condemn Delacroix for reading the newspapers
rather than being present in person at the Greek Wars of
Independence. But Stendhal had had an army career, while
few of his fellow artists could point to a similar experience.
Moreover there were more pressing matters at hand, or
so it seemed. More intimate reactions and discoveries
merited close scrutiny in themselves, for they brought into
play those great behavioural conundrums which have
not yet been resolved: madness, risk, terror, nostalgia,
the unconscious mind or soul, pantheism, primitivism, the
conviction of a secret destiny or calling. These are the
great commonplaces of Romanticism, and they are very
commonplace indeed. But for any serious artist of the early
nineteenth century, trying to reconcile the death of God
with his own longing for infinity, trying to reconcile the
indifference of the natural world with his longing for proof
of love, trying to reconcile his record of historical dis-
appointment with his desire for a sign, Romanticism, or
that modern phenomenon which had yet to receive its title,
was not only the unavoidable totality of his experience, it
was the only condition which had replaced, obliterated,
annihilated all the others. It is in the light of this peculiar
existential mode that one should approach the works of

Chateaubriand, of Hugo, of Baudelaire, of Musset, of Vigny, and of Géricault, of Gros, and of Delacroix, in whose tormented images Baudelaire found some compensation for his troubled mind, a symbiosis rejected by the fastidious Delacroix, whose desire was to be perceived as a pure classicist.

There are, of course, false Romantics. False Romantics can generally be discerned by their ability to strike poses. The group of David's pupils known as the *barbus*, the bearded ones, criticized their master's works and went on to emulate the lilies of the field by producing practically nothing of their own: recognizable student behaviour, but unusual in that place at that time. With these first primitives may be grouped all painters and writers – Blake, Runge, Overbeck, Pforr, Cornelius – who assume a protective colouring of infantilism, believing on good authority that theirs is the Kingdom of Heaven, together with those who have it on the same authority that the meek shall inherit the earth, and whose creeping triumphalism has as its object to overwhelm and encompass orthodoxy, even when that orthodoxy is nominal, by otherworldly means, i.e. by failing – these are the Romantics who give Romanticism a bad name. For again, as Stendhal pointed out, it is not the business of a Romantic to die to the world: on the contrary, he must take risks. '*Il faut du courage pour être romantique, car il faut hasarder*' (*Racine et Shakespeare*). And if this new risk-taking breed, testing every received idea to destruction, should find that doubt or despair or curiosity might interfere with his perception of what had until that time been regarded as appropriate, then it would come about that new forms, new approximations to what was newly perceived as

occasionally or even frequently compulsive, would emerge and would overtake that hitherto sturdy consensus of eighteenth-century truths which no longer served to explain the world.

There is also a danger that Romanticism may be confined to Romantic subject-matter. Here again Stendhal is a resolute and helpful guide. He likens the modern, that is to say the Romantic, artist to a soldier. A soldier not only takes risks with himself; he takes risks with others. It should be remembered that the Romantic painter has designs on the spectator. He is out to remove the spectator from his normal or appropriate perceptual field, and in doing so to infect him with his own personal doubts. Does Caspar David Friedrich have an ambivalent attitude to his stark, not to say threadbare religious imagery? Then this will be communicated not by a distant cross or a ship at sea but by suspending the spectator in a void over an abyss. If Gros wishes to express his misgivings about the orthodoxy of Napoleon's conquests he does so by changing the proportions of his figures, so that the dead in the foreground of his *Battle of Eylau* reach out as if to nudge their way into the living flesh of the spectator (Fig. 11). If Delacroix's disillusionment is to reach a full understanding he will wilfully dissolve the erotic components of his *Death of Sardanapalus* (Fig. 1) until they threaten to slide away out of anyone's grasp, out of the frame, pouring or leaking out of the corners of his canvas. In front of a true Romantic picture the spectator will be forced constantly to adjust his stance, stepping backward or forward or sideways, disconcerted, discomfited, sometimes physically uneasy. These effects will be achieved by the compulsion of the artist working through his chosen subject.

Only Ingres compels the spectator into a state of physical equilibrium, a profound calm based on the exactly centred composition. But through that calm he will impose his iron will, his desire for stasis, and the heroic volume of his fantasies.

When, in December 1765, Mme du Deffand complained to Voltaire about his excessive rationalism, she was in fact making an important general point. '*Mais, M. de Voltaire, vous combattez et détruisez toutes les erreurs, mais que mettez-vous à leur place?*' Out of her own nostalgia for some degree of spiritual comfort, Mme du Deffand formulated a plea that is of cardinal importance for an understanding of the emotional current which gathered momentum throughout the eighteenth century and ran full and unfettered until well past the middle of the nineteenth. This current, which can be described in its first stage as sensibility, in its second as Romanticism, should be accepted as a metaphysical phenomenon if it is to fall into any kind of historical perspective. Having established this first cause, one is nevertheless faced with the task of defining the term. Out of many possible definitions, one early one is worth retaining: at one stage Romantic meant anything capable of being described in a novel, '*dans un roman*'. This neat little definition may not encompass the giants of French Romanticism who depended very much more on contemporary or near-contemporary circumstance, or what Baudelaire famously christened the heroism of modern life. Even within the limits of this definition one is legitimately aware of the fact that the Romantic Movement in France leans towards forms of literature: predominantly pastoral or pantheistic in England, predominantly revivalist and nationalist in Germany,

Romanticism is consistently literary or theatrical in France.

It can be demonstrated quite satisfactorily that although Romanticism does not erupt into painting until the very end of the eighteenth century it is comparatively untrammelled in literature long before this date. One might remember in this connection not necessarily Jean-Jacques Rousseau, often invoked almost automatically as the patron saint of the movement, but a novelist like the Abbé Prévost, who, in the 1730s and 1740s, writes novels with a full repertory of Gothic effects, such as crêpe-hung mortuary chambers and doomed travellers who insist on telling their life stories to their hapless neighbours in stage-coaches. Even more relevant than the novelists are a number of dramatists who accomplish a revolution in theatrical behaviour which is of singular importance for the morphology of Romanticism. Nivelle de la Chaussée, Diderot, and their numerous and more obscure followers create a type of dramatic genre which calls for the actors to go out of their way to give gratuitous demonstrations of the intensity with which they feel. For a long time these demonstrations were confined to tragi-comedies, or *comédies larmoyantes*, in which the gesticulating characters, often morbid, always extravagant, were united at curtain fall, but when they were transposed to a form of tragedy, dealing with contemporary problems, as they were in the works of the pre-Revolutionary dramatist Louis-Sébastien Mercier, one is already very close to the more rhetorical aspect of Romantic paintings. And if one remembers that there was a close alliance between painting and the theatre – Diderot in fact said that the arts of pantomime and pictorial composition were allied if not identical – and if one remembers that both David and Delacroix were

keenly susceptible to the actual example of actors like Talma it is easy enough to establish a second line of continuity between Romantic self-exposure and eighteenth-century literary practice.

Thus the novel and the play can be shown to influence certain Romantic attitudes, and one is justified in emphasizing the fact that Romanticism or sensibility in French literature precedes and to a certain extent controls the movement in painting. But the metaphysical dilemma of Romanticism must be referred back to the matchlessly intelligent Mme du Deffand rather than to her more emotional contemporaries. '*Mais, M. de Voltaire, vous combattez et détruisez toutes les erreurs, mais que mettez-vous à leur place?*' The genesis of the Romantic Movement lies in this plea, for '*les erreurs*', in 1765, would have been understood as the errors of religion as they had obtained until being dislodged by the contemporary sensualist philosophies of men like d'Holbach and Condillac. The attempt to codify a new morality free from orthodox Christian dogma was pursued by a number of men who gradually took on the allure of lay preachers, and of these the greatest and most famous was Jean-Jacques Rousseau. Their collective legacy was singularly ambiguous. It was, variously, both affirmation and doubt. The discredit into which traditional piety had been thrown created the type of nostalgia voiced by Mme du Deffand. The attempts to fill this gap constitute not only the moral history of the eighteenth century but the genesis of the Romantic Movement.

At first sight there may seem little connection between the pronouncements of these *philosophes* who took it upon themselves to set up an alternative morality, and the world

of ardent, heroic, and melancholy activity portrayed by the Romantic celebrants, little connection between the optimism of the *philosophes* and the *mal du siècle* in which the generation of 1830 is steeped. Yet the two situations are linked, over and above the historical circumstances which brought them together. Passion, the consequence of liberated sensation, took some time to emerge in the visual arts and even in literature. When it did it was the consequence of a new consciousness, in which Baudelaire's entirely significant '*moi*' played a major part. Personal anxiety, personal investigation, personal refusal became the filter through which all phenomena were to be evaluated. A place had to be found for Mme du Deffand's vanquished piety, and the instrument was to be that newly discovered doubt, itself encouraged by the undermining of all established norms in the Revolution. Doubt was the condition which all thinking persons were forced to employ, sometimes consciously, sometimes unconsciously, in order to transcribe sensations for which there seemed to be no precedent. When David paints the dead Marat as a religious martyr in a profane context, when Gros portrays Napoleon as a divine healer with death and suffering in his train, they are referring back to that metaphysical vacuum of which Mme du Deffand first complained. Dislocated piety and existential doubt colour the whole of the Romantic endeavour. In his essay on Constantin Guys Baudelaire describes himself as '*un moi avide du non-moi*', a self avid for non-self. This non-self, for Baudelaire, was to be found in the art of imagination, often synonymous for desire or despair. What was not to be recommended was exclusive reliance on Nature. That the eighteenth century could remain open-minded is a tribute

to its stability. That this stability was brought to an end by the Revolution should occasion no surprise. Introspection, the fallen creature's guiding light, was henceforth to be the order of the day.

To evaluate the change from stability to flux, and to appreciate the arrival and indeed the intrusion of the *moi* into public affairs, comparisons are needed. The hand-over of limpid clarity of utterance to tormented self-absorption can be perceived in two portraits of men of letters, that of *Diderot*, painted in 1767 by Louis-Michel Van Loo (Fig. 2), and that of *Chateaubriand*, painted by Girodet in 1807 (Fig. 3). The subjects of both these portraits are of vital importance to the Romantic Movement, Chateaubriand to its mature, Diderot to its formative phase. In Van Loo's portrait little indication is given of Diderot's superhuman restlessness. On the contrary, he is presented as a typical eighteenth-century man of letters, and in many respects this is very close to the truth, for Diderot, art critic, playwright, novelist, philosopher, amateur moral scientist, indefatigable correspondent, fulfilled this role as a matter of course. One fact worth remembering in this connection: Diderot was intended for the priesthood. He lost his faith, or all but a small fragment of it, early in life, and turned his great gifts as a preacher into lay channels. The gigantic enterprise of the *Encyclopédie*, to which he brought his fantastically informed mind, may well represent the final outcome of his original intention. In the course of his duties as an art critic Diderot became the friend of many painters, and a thorn in the flesh of many more, and he was always delighted when he was selected as the subject of a portrait. He professed not to like Van Loo's portrait, claiming that it made him look

too flirtatious. Viewed across the chasm of the Romantic Movement this tiny nuance has become invisible. Diderot appears not so much a professional writer as a man of the world to whom writing is one of the essentials of a full mental life. Van Loo gives him an outward gaze and an apostrophizing finger: society is being addressed, with that air of elegant and essentially unforced enthusiasm which is now associated with any eighteenth-century writer on social topics.

Chateaubriand, on the other hand, is shown in stern and windswept isolation outside the Colosseum in Rome, but a Colosseum so darkly rendered as to approximate as closely as possible to his native Breton heath, to Saint-Malo, where Chateaubriand was in the habit of meditating on a headland and where his tomb now stands. To Girodet, himself an ardent man of letters, the importance of Rome, the ultimate pilgrimage of any classical writer or painter, has dwindled to that of a backcloth. He has even draped the Colosseum in a mantle of ivy, in order to induce melancholy thoughts on the passing of time. For Chateaubriand, despite his classical learning, more modern characteristics claimed both his attention and his power as a writer. His prime subject is himself: his loneliness, his wanderings, his perambulations in Gothic cathedrals, his sudden reconversion to Christianity. His master novel, *René*, is thinly disguised autobiography and is presented as such, René being one of his own names. Coming from a noble family Chateaubriand was involved in the Revolution almost by accident. He was forced to leave France in 1791, and it was as an exile, first in America, then in England, that he found his true vocation. Recalled to his dying mother's bedside he rediscovered the faith that

he had lost: '*J'ai pleuré et j'ai cru*' ('I wept and I believed'). His long rambling book *Le Génie du Christianisme* was published a matter of days before Napoleon's Concordat with the Pope in 1802, and it brilliantly exposed the nostalgia for the old pious ways that had temporarily disappeared with the Revolution. It showed a new reliance on the emotive power of religion, for its main thesis was that as Christian monuments and relics were so beautiful then Christianity must be beautiful in itself. This is persuasive rather than logical. In 1806, still ardent for the faith, he set out on a pilgrimage to Jerusalem. He returned to France by way of Tunis, Carthage, Cádiz and Granada, all of which are described in his *Itinéraire de Paris à Jérusalem*, published in 1811. He was in fact the first to make the Romantic journey to North Africa and to Spain, for which the painters Auguste and Delacroix, and the writers Hugo, Musset, Gautier and Mérimée are usually given the credit. The singular lustre of Chateaubriand's personality and ideas is reflected by Girodet, an astute modernist himself. Not devoid of a satirical disposition, Girodet stakes his own claim to the new fashion.

Mme du Deffand, with her pertinent doubts, might be contrasted with Mme de Staël, who had no doubts at all. Painted by Gérard in 1818 as the heroine of her novel *Corinne*, Mme de Staël was perhaps the only liberated woman of her time who was of interest to both sexes. She is best remembered not for her excellent history of the Revolution but for her long rhapsodic novels: *Delphine* was published in 1802, and *Corinne* in 1807. Just as René was Chateaubriand, Corinne is an idealized version of Mme de Staël. In the novel Corinne is famous for her beauty and intelligence. She is held in high regard in Italy for these

and other gifts. She is given to outbursts of lyric poetry, to which she accompanies herself on the lyre. The action of the novel takes place in Italy, not because Italy is the home of antiquity, as it might have been for a classicist, but because Mme de Staël is drawn to the Italian temperament, superior, she thinks, to that of the French, who lack the fire, the noble impetuosity that she so values. The particular scene from the novel that the painter, Gérard, has chosen to depict shows Corinne, clearly recognizable as a portrait of the author, at her most sublime. In a burst of inspiration Corinne sings one of her odes. The scene takes place near Naples. The performance is witnessed by Greeks from a Levantine ship, local maidens, and Corinne's suitor, Oswald, Lord Nelvil, a Scottish aristocrat with a mysterious aura and a guilty secret. Corinne sings of the glories of the Italian past and of the unhappy fate that has dogged many of the heroes of Italian history. Overcome by emotion she falters, turns pale, and lifts her eyes to Heaven. Oswald, similarly afflicted, advances to her rescue.

The picture was commissioned in 1819 by Augustus of Prussia. He intended it as a present for both his and Mme de Staël's friend Mme Récamier, and he instructed Gérard to paint Corinne as a better-looking version of the author. Not unexpectedly, Oswald bears a strong resemblance to Augustus of Prussia, and the picture is a good example of a Romantic subject treated by a painter who was essentially classical by training. The setting of mountains and ruins is denuded of its mystery, the Romantic concept of inspiration reduced in temperature. But Gérard, who appears to have been unwilling to treat this subject, although unable to refuse the commission, has in fact added a significant gloss.

In the person of Oswald, Lord Nelvil, he has painted one of the earliest Byronic heroes. The first edition of Byron's works, translated into French by Amédée Pichot and illustrated with engravings, appeared in Paris in 1818. Gérard's picture was painted the following year. Girodet's Chateaubriand was a portly unidealized figure. Gérard's Oswald has the windswept hair, the regular features, and the brooding expression of the greatest Romantic hero of them all.

Pictorially this may add up to very little. But the same artist's sketch for a portrait of *Countess Starzenska* (Fig. 4) is more interesting. Moody, her hand on a lyre, in an emphatically Northern landscape, *Mme Starzenska* might have been designed as a riposte to David's *Mme Récamier* (Fig. 5). Mme Starzenska was Polish, which might account for the fir trees in the background, but not for her languishing attitude, which turns her into an early version of Mme Bovary. Gérard has responded sympathetically to the sitter's complex mood: the elongated body, the tiny head, the hint of a mute appeal to the spectator, make of this an unusually subtle exploration of a relatively new idiom.

Le Génie du Christianisme, Chateaubriand's book of 1802, broke the tradition of a hundred years of secularization. Its appeal was not to the intellect but to the emotions. Chateaubriand's Christianity, with its emphasis on the writer's senses, seemed unprecedented. In 1802 personal disillusionment was both new and understandable. The *homme moyen sensuel* of the previous generation had presented entirely different characteristics, had found himself quite happy in society, was more concerned with being enlightened than with being afflicted, and thought the Gothic style barbarous. Although the eighteenth century

accommodated a considerable volume of submerged religious feeling, this was rarely explicit, and nowhere is this scepticism, the prevailing mode of eighteenth-century thought, more apparent than in paintings. When commissioned to paint a religious picture – and commissions were plentiful – artists like Boucher, De Troy, Van Loo and Fragonard not only reduced the whole concept to genre level but even gave it an erotic twist which was generally well received. The subject which held the most genre appeal was *The Education of the Virgin*. This was surpassed in popularity by the two or three salacious subjects: *Susannah and the Elders*, *Lot and His Daughters*, and *Bathsheba at her Toilet*. So seductive and so reassuring was this mode that the new century had yet to encounter a religious masterpiece. This came about in 1822, with Prud'hon's *Crucifixion*. Prud'hon was a Neo-classicist, but with one important difference. He had little respect for classical art as it was taught in the academies. He was not, like all true classicists, enamoured of Raphael. He preferred Leonardo and Correggio, and this in itself was a form of protest against the clarity of his slightly older contemporary, David. Prud'hon preferred the ghostly shadow, the exaggeratedly bloodless flesh tone copied from the sort of Leonardo that has undergone intense deterioration of pigment. The torso of his Christ is Leonardesque, or Correggiesque, rather than Raphaelesque. Conveniently enough Prud'hon, like Chateaubriand, could make the Romantic profession of faith: *'J'ai pleuré et j'ai cru.'* Until the end of his life he was indifferent in matters of religion, but in 1821 he was involved in a particularly lurid personal tragedy. He went into a decline and died shortly after, his mind consumed

with guilt and loss. The *Crucifixion*, his last work, has none of the tranquillity of the true religious exemplar. It is closer in feeling to the painful sensations of personal grief, of intrusion of the *moi* into the most abstract of phenomena.

The implications of religious discourse, most of all of its iconography, re-emerged almost stealthily. Chateaubriand's novel *Atala* provides an excellent demonstration of that dislocation of religious association that was to become commonplace throughout the period. Girodet, the man best qualified to illustrate the story, exhibited a *Mort d'Atala* in the Salon of 1808 (Fig. 6). His picture is not calculated to win one back to the text. Yet Girodet has been a remarkably astute reader, for this coldly voluptuous moonlight lament is close in feeling to one of the less agreeable aspects of Chateaubriand's genius. In 1791, as an exile in America, he was much impressed by the majestic swamp scenery of the banks of the Mississippi, and also by the native Americans, who were for a time considered, in the European world, to be the original noble savages. He embarked on a saga called *Les Natchez*, of which *Atala* was to be one episode. This was published separately in 1801. It takes the form of a story told to the ubiquitous René by an aged Indian brave called Chactas. In his youth Chactas had loved a beautiful girl of mixed race, Atala, whose Christian mother had dedicated her to the Virgin. A Catholic hermit had undertaken the conversion of Chactas, but Atala, who considered herself bound by her mother's vow, poisoned herself in order to avoid yielding to temptation and losing her chastity. She died, clasping to her bosom the crucifix her mother left her.

The lingering burial scene, which is the high point of the narrative, is also the subject of Girodet's picture. His

masterstroke is to pay lip-service to the religiosity of the theme by treating it as a traditional Entombment, but at the same time he underlines the very considerable element of sensuality in the story by his delineation of Atala's superb torso, wrapped, rather more tightly than is the custom, in a shroud or winding sheet. The picture is dark in colour, low in tone, a reaction against the rational clarity of David, who confessed that he thought Girodet insane. How insane may be judged by that same Girodet's *Endymion* (Fig. 7), painted in 1793, when the Terror was at its height. Girodet, his eyes turned resolutely away from contemporary issues, has chosen to concentrate on Endymion's embrace by the moon. His interpretation is far from straightforward and seems to contain a coded message. The ecstatic nude, the very presence of the little winged boy, and the deliberate chiaroscuro can only be understood as a half-serious, half-joking reference to Bernini's *Ecstasy of St Theresa*. A hallowed concept has been discredited by being taken out of its context and given almost burlesque treatment by an artist who prefers the new cult of atmosphere to the old gods of an earlier world.

Portraiture shows the same retreat from lucid exposition. David's *Napoleon Crossing the Alps* (Fig. 8) is conceived as an icon, painted according to Napoleon's brief, which was to be shown calm, on a fiery horse. No matter that Napoleon crossed the St Bernard pass on a mule: this image was destined for posterity and thus for eternity. David's pupil, Gros, turned his back on this image when painting *General Fournier-Sarlovèze*, swearing to be buried beneath the ruins of Vigo rather than surrender to the enemy (Fig. 9). Gorgeously uniformed, blazing with red and gold, portrayed

not as an abstract concept of valour but against the smoke and turmoil of the battle itself, Fournier-Sarlovèze breathes a kind of arrogant informality which matches exactly the nostalgia cultivated by Napoleon's military aristocracy for the great victories of the first ten years of the nineteenth century. This intoxicating decade was soon to be eclipsed in the memory by the disasters that were to follow, and in 1812, the year in which Gros painted Fournier-Sarlovèze, Géricault, ultra-sensitive to historical change, painted his friend Dieudonné as a cavalry officer (Fig. 12), a split-second image of a particular moment, with no allusion to either victory or defeat. Basically Baroque in its tremendous contrapposto, the picture is also mannerist, uncertainty of meaning cancelling out the purely pictorial assurance.

Thus one may say that the themes of mature Romanticism existed long before the greatest Romantic painters and writers turned them into something altogether more memorable. The difference is not one of subject-matter; it is not necessarily one of technique, although the greater the painter's or writer's emotional range the greater his desire to express this. The difference is quite simply the consciousness of a sense of loss, of what Baudelaire called the irreparable. This sense of loss did not lie dormant since it was first formulated by Mme du Deffand. It was forced into the forefront of the minds of an entire generation, the generation that knew first Napoleon and subsequently the defeat of his hopes for France. It is perhaps the aftermath of the Revolution; it is, more specifically, the despair that is the obverse of idealistic endeavour, and it is at its sharpest in artists who are aware of the problems of their own time. This, after all, was why Stendhal defined Romanticism as

modernity. The Salons of the last years 1799 to 1809 were filled with pictures of Napoleon and his exploits; it seemed possible to share his glory. On 11 February 1824 Delacroix wrote in his Journal, '*La vie de Napoléon est l'épopée de notre siècle pour les arts*' ('The life of Napoleon is the epic of our century for the arts'). Napoleon is the presiding genius of mature Romanticism. Even the later phase, represented by Musset and Vigny in literature, by Delacroix in painting, will be steeped in nostalgia for an heroic way of life.

In this historical framework the emotional tide that had been slowly rising throughout the eighteenth century received its apotheosis. Napoleon bequeathed a legacy of aspiration and regret that continued to resonate until two generations managed to outlive the past and to usher in a new era, one free of nostalgia, with eyes turned towards the future. But old psychological habits die hard; regret, even denial, persisted in some cases until the end of the century. And perhaps the traces are still perceptible today, even though the context has been lost. That context, the Romantic Movement, has left its own legacy. Heroes are no longer taken on trust, and the inevitable outcome is a disappointment that is both different and strangely familiar.

2

Gros:
Hero and Victim

The Romantic Movement in France has been described as a revolt against two people, against Voltaire in literature and against David in painting. However much this statement over-simplifies the problem it helps to establish an important fact. It suggests that Romanticism is essentially about dissidence, about rejection, about protest, about breaking the old rules but only incidentally establishing new ones. This breaking of the rules, not always a joyous procedure, led in many cases to a feeling of isolation and rootlessness, and from this point of view the famous Romantic melancholy can be seen to have a serious ideological cause, over and above the loss of certainty experienced in a more general sense.

Gros's disobedience, seen literally as original sin, led him to beg for readmission to the Davidian fold, while at the same time aware that his own originality could not be denied. It could not be denied because it had already been made manifest in pictures which fragmented David's tight control and introduced an element of self-questioning which established new standards in what an image could reveal, not only in the representation of an event but in an attitude more probing than that usually handed down with an official state commission.

David, who loved this brilliant and devoted pupil, could not understand Gros's tormented complexity, and from his exile in Brussels inquired, no doubt sincerely, when Gros was going to produce a picture which conformed to the norm then observed by all who aspired to the title of history painter, the highest category in the academic hierarchy. '*Vite, vite, mon ami, feuilletez votre Plutarque.*' ('Quick, quick, my friend, leaf through your Plutarch!') He saw nothing incongruous in giving this unsolicited advice to a man of fifty. David's lack of comprehension, together with Gros's endemic anxiety, had a fatal outcome. Gros killed himself, an act that led some to interpret his death as in itself a Romantic masterpiece.

For the astonishing fact is that, psychic anguish apart, Gros died for purely professional reasons, because his originality, which was of the highest quality, seemed to him to consti- tute a direct disloyalty to the principles he had learned from his master, David. The story of Gros's life and fame can be read as a struggle between an inherited set of rules, which he quite consciously accepted, and an unformulated protest against those rules which was expressed every time Gros painted a picture in which his imagination led him to discard what David had taught him. Finally his confusion became intolerable and his life unbearable. His death was unnecess- ary but significant. He had given rise to a certain dilemma. He had, almost unknowingly, introduced personal com- ment into accepted versions of the truth. At the same time in his career came a growing conviction that a great adventure had finished. '*Tout n'est-il pas terminé avec Napo- léon?*' questioned Chateaubriand, in his *Mémoires d'Outre- Tombe* of 1848. Gros, who had been Napoleon's painter, no

less than David had been, was witness to that other exile, and was thus indebted to the two great taskmasters who had given his professional life its motivation.

To make matters worse he was entrusted with the task of keeping an eye on David's studio and practice during his master's exile in Brussels. Yet he still considered himself an unworthy pupil. There is evidence that he would not recover from what he considered to be a monstrous disloyalty. In 1824, at the funeral of his friend Girodet, he pronounced an extraordinary eulogy which soon developed into a paroxysm of self-accusation. David's biographer, Delécluze, reports his words.

Je dois m'accuser encore d'avoir été l'un des premiers à donner le mauvais exemple que l'on a suivi, en ne mettant pas dans le choix des sujets que j'ai traités et dans leur exécution cette sévérité que recommandait notre maître, et qu'il n'a jamais cessé de montrer dans ses ouvrages. [I accuse myself of having been one of the first to give a bad example, in not infusing the subjects I painted and their execution with that rigour which our master recommended, and which he never ceased to demonstrate in his own works.]

He then collapsed at the graveside in a dead faint. This loss of control was symbolic as well as very real. He was not to survive it, though he was obliged to experience it for another eleven years.

In June 1835, Gros, or as he was then, Baron Gros, member of the Institut de France, professor at the École des Beaux-Arts, officer of the Legion of Honour, and highly respected member of the artistic establishment, was called for jury duty at the Assizes of the Seine department, sitting at the Palais de Justice. From 16 June on he fulfilled this

obligation, but on the morning of the 25th he left his house in the rue des Saints-Pères and never returned. On the afternoon of the same day he was seen walking through the arcades of the Palais-Royal with an expression of terror on his face. He walked all night, until he reached the forest of Meudon. At midday the following day he was found drowned in a small tributary of the Seine. He was fully clothed except for his hat, which was on the river bank, and it was the mark in this hat which enabled the mayor of Issy to identify him. The stream in which he drowned was two and a half feet deep, and despite the efforts of his wife and his friends the only possible verdict was one of suicide.

This account is taken from the biography of the artist by J. Tripier le Franc, of 1880, one of those reverent and monumental works that are characteristic of nineteenth-century scholarship. Tripier le Franc had access to Gros's letters, which he quotes extensively. Curiously, Gros has attracted few modern scholars, despite the fact that he was the outstanding painter of his generation. This is all the more surprising in view of the spectacular nature of his career and its tragic outcome. Indeed his fault, if fault it was, consisted simply in the fact that he was unable to take the responsibility for having introduced into the painting of contemporary history a full range of imaginative effects at variance with those established by David. Like David, Gros was committed to history as it unfolded, committed also to the spin put on history by professional propagandists. This essential component of the life and activities of Napoleon was entrusted to Gros as one who would follow faithfully the example already set by David. However, unlike David, he operated outside the intellectual framework still thought

necessary to make these events acceptable within the context of history. Gros's response to the legend was that of a man of feeling, untempered by reflection. He accepted the facts, but doubted them. His imagination was both his strength as a painter and a source of dismay to him as an obedient pupil. Delacroix, the first to perceive and to fully sympathize with the nature of his dilemma, wrote of it in a magnificent article in the *Revue des Deux Mondes* in 1848. He describes Gros at work, looking at his watch to see if it were time to *'quitter le travail, et de déposer, avec sa palette, le fardeau de l'inspiration'* ('. . . to stop work, and to lay down, with his palette, the burden of inspiration'). Delacroix also speaks of the intolerable strain which Gros's imagination placed upon a temperament which was fundamentally that of a docile and passive follower. Finally his overburdened professional conscience led him to disclaim all that he had done to modernize the paintings of his time. His finest achievements seemed to him illusory, because David disapproved of them.

If the name of David is constantly cited in connection with Gros it is because he is one of those teachers on whom it seemed impossible to improve, and also because until about 1810 his epic visualization of the events of his own times was unchallenged, and indeed still is. Gros became David's pupil in 1785, at the age of fourteen, but he was in fact only twelve when his father took him to the Salon. There he saw David's *Andromaque*, a singularly unrepresentative work which shows an expansive Andromache mourning over the body of her husband, Hector. The overt emotionalism of the picture determined Gros to paint like David, a misapprehension which was to have lasting

consequences. He entered David's studio on the last day of 1785 and was a student for two years. Although the actual tuition lasted only two years the influence lasted until David's death in 1825, and in a sense lived on until his own death ten years later.

He seems to have had bad nerves even when very young. One day the painter Gérard made a disparaging remark in his presence, and Gros was convinced that it was not safe for him to remain in France. Through the good offices of David he was able to obtain a passport and to leave for Italy. This was in January 1793; he thus escaped the worst of the Terror, with which his peculiar susceptibility was completely at odds. If it is possible to imagine an apolitical hero-worshipper, as he was to become, there are few signs of it in his early behaviour. Owing simply to the fact that he was befriended by a Genoese banker on the journey, he made his headquarters in Genoa, after brief periods in Rome and Florence. Chance served him well, for instead of putting in months of study of Raphael and Michelangelo he was allowed to proceed directly to those Baroque models in which Genoa was so rich, Rubens, Van Dyck, and the sculptor Puget. Gros stands in relation to Rubens much as Prud'hon stands in relation to Leonardo: the similarities are a matter of sympathy rather than of copying. The lesson he absorbed from Rubens was that painting was a compound of energies rather than of static forms. The portraits of Van Dyck reinforced his natural elegance, as they had fashioned that of David before him.

With difficulty Gros was obliged to survive as an exile. The notoriously uncertain years made life dangerous even outside France. But for the second time Genoa was to prove

of strategic importance to Gros. In June 1796 Napoleon made his triumphal entry into Milan. A few days later Josephine left Paris to join him. She broke her journey at Genoa, where Gros was presented to her; she then took him to Milan and introduced him to Napoleon. Gros had found a future hero, who for a time was to supplant David. His timidity was eclipsed under Napoleon's influence. His rapid sketch of Napoleon crossing the bridge at Arcola at the head of his troops was painted on the spot. In this sketch Napoleon is simply a soldier, unburdened by the political ideals of David, who instinctively grafted on to him a public persona. To Gros, Napoleon was a general who led his troops to victory at Arcola, and he painted the incident with no thought of the didactic capital to be made from it. This was Gros's moment of innocence. Formally weak, the sketch is alive with nervous movement, incomplete, immature, but furiously painterly, worlds removed from the classical past and clearly indicating that feeling for the epic quality of contemporary events, which Baudelaire later characterized as the high-water mark of mature Romanticism.

Napoleon rewarded Gros with an official position, the first of many. He was made a member of the commission set up to choose, or rather, commandeer, works of Italian art for France, and in this capacity went to Perugia, Bologna, and Rome. In the following year, 1798, he was given the title of *Inspecteur aux Revues* and automatically became an officer, with a uniform and a horse. He followed the army to Novara, Turin, and back to Genoa. He wrote home to his mother describing that most fashionable state of melancholy, *le mal du siècle*, or, as he puts it, '*le dégoût de soi-même*'.

*Va, vivre seul peut perdre un individu, surtout lorsque, comme moi,
mon âme a besoin d'attachement. Le dégoût de soi-même arrive, et c'est
fini. Combien de fois je vais disant: si ma mère était avec moi, elle
réglerait mon existence, que je suis incapable de faire moi-même. Oui,
je le sens au fond de mon cœur, mon malheur est d'être seul.* [Living
alone can kill a man, all the more so if, like me, he craves
involvement. Self-hatred ensues, and that's an end of it. How
many times have I said: if my mother were with me she would
organize my life, something I am incapable of doing for myself.
Yes, I feel in the depths of my heart that my misfortune is to
be alone.] (Letter of 23 November 1798, quoted by Tripier le
Franc)

He expressed regret, and it is indeed a cause for regret,
that he was not allowed to accompany Napoleon to Egypt.
Finally he was evacuated from the besieged city of Genoa,
and after six months in Marseilles, where he painted several
fine portraits, he returned to Paris in October 1800.

The circumstances of his return were very different from
those of his precipitate departure seven years earlier. He was
now an army officer who still wore his uniform. He was
given a studio in the Couvent des Capucines which became
a kind of permanent salon for visiting fellow officers. At
one end of the corridor Ingres and Bartolini were studying
Greek vases behind closed doors. At the other end Gros was
painting in full view of whoever cared to watch. The
ambience was fervid, optimistic, militaristic. Yet Gros was
still the tenderest of painters, as can be judged from another
official commission, the posthumous portrait of *Christine
Boyer*, the first wife of Lucien Bonaparte, done in 1800
(Fig. 10). This dreamily Romantic evocation, with its fan-

tastic made-up landscape of grottoes and cascades, should be compared with a David of the same date, the tough, delicate, and impersonal portrait of *Mme Récamier* (Fig. 5), in which the painter's sympathy for his virginal subject is never allowed to become overt. In contrast the Gros seems to carry a world of feeling, to foreshadow many an abandoned Romantic heroine. Significantly Gros was also a sensitive painter of children. His alert nervous apparatus responded quickly to vulnerability, to innocence, above all to blamelessness. Yet at the same time his admiration for Napoleon was undimmed. It was only when he began to sympathize with the conqueror's victims, whom, it should be emphasized, he never witnessed at first hand, that doubt began to make inroads into his consciousness.

At the Salon of 1801 Gros exhibited his portrait of Napoleon at Arcola with great success, and in the same year he won an open competition for a commission to paint the Battle of Nazareth, his first essay in this particular genre of contemporary history painting. The Battle of Nazareth took place in 1799; it was won by General Junot, who with 500 horse and foot soldiers defeated 6,000 Turks and Arabs (the numbers are given by Delacroix). The picture was to have been immense, over forty-five feet long, and thus stood fair to immortalize the hero of the event. It was never painted and is now known only by a sketch in Nantes. It has been suggested that Napoleon was jealous of Junot's success and had the commission stopped. It is in fact more likely that Napoleon wished to leave a very different image of the Egyptian campaign, and that image he sought and found in an episode celebrating himself: the scene in the fever hospital at Jaffa. In a letter to his mother Gros laments the fact that

he was not to be allowed to accompany the army to Egypt, where he would have had an opportunity to paint the Alexander of the New World, just as Charles Le Brun had painted the Alexander of the Old. The Alexander of the New World, conditioned to tributes such as this, found Gros's fervour greatly to his liking.

An equally related point throws light on the artistic situation under Napoleon's direct rule. Napoleon's criterion for the fine arts was that everything should be not only realistic but recognizable. As far as painting was concerned he was a judge of effect, but not necessarily of quality: he knew what a picture should contain but had neither the time nor the inclination to communicate his wishes to artists considered capable of executing his commissions. He therefore needed an intermediary to translate his projects into artistic terms. At first he entrusted this office to his brother Lucien, the Minister of the Interior. This proved unsatisfactory. In 1800 Napoleon invited David to be '*peintre du gouvernement*'. David, although a sincere admirer of Napoleon, valued his artistic status and refused to become a virtual civil servant. Napoleon then offered the position to the sculptor Canova. This was manifestly inappropriate and Canova declined. Napoleon was thereby forced back on to his third choice, the existing director of the Musée Napoléon, Vivant Denon, and Vivant Denon, who accepted, did his job so thoroughly that he ended up with enormous power, and was responsible for various Imperial improvements to Paris. He also commissioned battle-pieces and portraits for the Imperial palaces and museums.

In Gros he found the ideal Imperial painter, and between them they created the image of Napoleon as posterity knows

him. Gros never went to the Middle East, nor did he go to the Russian front. It was solely through the agency of Vivant Denon that he was able to produce such highly documented pictures as *Jaffa*, *Aboukir*, and *Eylau*. It was Vivant Denon who informed Gros and anyone else awarded a government commission what their pictures were to contain. Vivant Denon had a team of draughtsmen standing by on every campaign, virtually on every battlefield, noting down details of costume and terrain which would then be dispatched to the painters in their studios. Vivant Denon had the advantage of having been on the Egyptian campaign. His book *Voyage dans la haute et basse Égypte* was published in Paris in 1802. It is precisely this text which marks the difference between the rather generalized Baroque character of the *Nazareth* sketch, and the breadth and detail of Gros's masterpiece, the infinitely superior and indeed unprecedented *Pestiférés de Jaffa* (*The Plague Hospital at Jaffa*) (Figs. 28, 29).

To compensate Gros for the loss of the Nazareth commission he was given one that was to prove more important. The *Jaffa* picture was finished in just under six months. It was painted on half of the enormous canvas set aside for the *Nazareth*, and it was exhibited in the Salon of 1804 where it was crowned with palms and laurels. A banquet was offered to the artist, and David presided over it. It was the most glorious moment of Gros's career, and, to judge from the picture he painted, it was the most glorious moment of Napoleon's, consecrating him as hero, knight, and saviour. This was not in fact the case, and it is precisely the difference between cold fact and brilliant propaganda that makes the picture so memorable, turning it from an icon into a reflection on the ethos of conquest.

The scene is taken from an incident in the Egyptian campaign of 1799, at a moment when an outbreak of the plague was destroying the morale of the French troops. As Napoleon's one-time secretary, Bourrienne, writes in his *Memoirs* (1829–31), Napoleon visited the fever hospital at Jaffa on 11 March 1799 and embraced a dying soldier. This was to spread the message that the illness was less contagious than was feared. The action is well authenticated. What is not recorded on any canvas is Napoleon's second visit, when he made a quick tour of the hospital and gave orders that the very sick were to be poisoned so as not to hamper the French retreat. This order was in fact carried out, but Gros, acting on the instructions of Vivant Denon, has immortalized the high heroism of Napoleon's earlier visit.

The picture constitutes a heresy: it uses Christian symbols in a profane context. Thus Marshal Berthier, the man directly behind Napoleon, holds a handkerchief to his nose against the stench, as if present at the raising of Lazarus. The spectator is thus directed to read the picture as a quasi-religious allegory: Napoleon as thaumaturge, or miraculous healer. Bubonic sores erupt in the groin and the armpits, and Napoleon stretches out his hand to the soldier's infected flesh as if he were in fact able to restore it to its former health, much as the monarchs of both England and France used to touch for the scrofula, or King's Evil. This image of the royal and semi-divine Napoleon was the one to show the French, who received few reports of Napoleon's campaigns, unless they were victorious. So that the picture, which perfectly conveys such inferences, and at the same time unites them in misleadingly straightforward imagery, is an imaginative exercise of the highest order. The pyramidal

structure of the composition enables it to be easily deciphered; there is no apparent intention to mislead. Yet ambiguity is built into its legibility, and one may wonder how much of this was deliberate, or whether Gros was impelled by some inner doubt which his conscious mind was too well schooled to admit. Whatever the motivation behind it, the huge picture still carries weight as an image of the heroic army and its heroic leader, his arm fearlessly outstretched, in strong contrast to puny Marshal Berthier, his handkerchief fastidiously pressed to his nose and mouth.

Some of the credit must go to Vivant Denon who is responsible for the accuracy of the details: the soldier blinded by trachoma, another of the illnesses that plagued the Egyptian campaign; Napoleon's natural repugnance indicated by the right hand clenched on the glove. There is even a touch of Napoleonic sentimentality in the detail of the crazed trooper trying to doff his cap, which is Vivant Denon rather than Gros. But it is Gros who animates the scene through the sheer weight of his painterly sensibility, enlarging the walls of the cloister to give a setting of unusual depth, contrasting the greenish sheen of sweat on the bodies with the powdery golden heat of the far distance. All this is undeniable. But there is, as it were, an additional message. If the sick man in the centre of the picture were to stand up he would be twice the height of Napoleon. This image of victimhood dominates the canvas, as an oblique comment on Napoleon's heroism, which is thereby diminished. This was not foreseen by Vivant Denon and indeed could be read by the orthodox as the painter's failure of proportion, or misuse of scale. But it is in fact a highly personal protest, the intrusion of Gros's own sensibility, his *moi*, into what

has always been regarded as an epic of contemporary life.

In 1805 Gros was commissioned to commemorate Murat's victory at *Aboukir* (Fig. 14). The picture is altogether less impressive, the execution more glacial, and it seems probable that Gros, as if to atone for the excesses of *Jaffa*, has reverted to the method of David, who was engaged at this time on his huge dark canvas of *Leonidas at Thermopylae*. What makes Gros's picture memorable, and as far from David as it was possible to get, is the passage in the far distance, in which blue smoke is set off against pink and gold and grey tents and a silvery view of the harbour, and in which the man surrendering his sword to Murat wears a plum-coloured turban. This passage contains the entire palette of Delacroix's *Scenes from the Massacre at Chios*.

As *Jaffa* followed *Nazareth*, of which Junot was the hero, so the painting of Murat's victory at Aboukir was followed by a picture of an even more resounding victory for Napoleon. In 1806 a competition was held for the honour of celebrating Napoleon's victory at Eylau in eastern Prussia. Twenty-six painters entered, most of them forgotten today, and Gros was the victor. The programme was again laid down by Vivant Denon, and the minute exactitude of his instructions can be deduced from the fact that the two surviving works, that by Gros in the Louvre and that by Meynier at Versailles, are almost identical in arrangement. Apart from Vivant Denon, all Gros had to go on was Napoleon's hat and coat, which he borrowed from Josephine. The picture was exhibited in the Salon of 1808.

Of less obvious beauty than *Jaffa*, *Eylau* is perhaps more impressive. The leaden colouring – green, black, white, grey – had a profound effect on Géricault, on Boissard de

Boisdenier, on Charlet, on Raffet. It excited Delacroix, who noted with enthusiasm the kind of detail that literature could never convey, in this case the frozen drops of blood on the bayonet in the middle foreground (Fig. 11). It is a more deliberate picture, for its moral is more ambiguous. Napoleon was the prime instigator of this carnage, in which the numbers of the dead are respectable even by contemporary standards: 12,000 on the French side, 18,000 for the allies (Delacroix's figures). So that the picture is rightly and overwhelmingly about death: frozen corpses in the foreground, a whole battalion cut down in the background, and ominous fires sending up black smoke on the horizon. Again the dead and dying take over from Napoleon; their disproportionate bodies edge towards the limits of the canvas, obtruding into the spectator's space. Nevertheless an heroic slant is given the incident by the combined efforts of Vivant Denon and Gros. The Lithuanian troops are overwhelmed by Napoleon's mercy. One, whose blood-filled boot is being cut away by a French surgeon, hails Napoleon as his hero, indeed as his saviour. Again Gros has borrowed a gesture from traditional religious imagery to stamp this representation as a cathartic moment. Only the after-image of the foreground figures, which the eye encounters first and last, leaves the spectator with a wholly different impression.

If *Jaffa* was crowned with palm and laurel, *Eylau* had a no less glorious reward. The year 1808 was an important Salon: David, Prud'hon, Gérard and Girodet all exhibited major works. David showed *The Intervention of the Sabine Women* and the very different *Coronation of Josephine*, Girodet the *Atala*, Gérard a large battle-piece, and Prud'hon his

impressive allegory of *Justice and Truth Pursuing Crime*. Napoleon visited the Salon in October. After looking at the pictures he presented David with the rosette of a Commander of the Legion of Honour, and made Prud'hon, Girodet and Carle Vernet *chevaliers* of the Order. He ignored Gros and walked past him to the door. Then, with one of those gestures which could ensure him the devotion of armies, he unpinned his own cross of the Order and offered it to the painter of *Eylau*.

In a sense it would be better to end at this point, on a note of achievement, the achievement being the creation of the image of an heroic generation. But in fact that moment had passed, and even the hero-worship faltered a little. In 1809 Napoleon divorced Josephine and in the following year married Marie-Louise of Austria in order to consolidate the Austrian alliance after the battle of Wagram. This divided Gros's loyalties; Josephine had been his first patron and had remained a friend. The battlepiece of 1810, *The Battle of the Pyramids*, is a cold and rhetorical work, in which all spontaneity seems frozen. Gros was prematurely in decline. Incapable of working without a sense of high exaltation, his sensitivity to historical change ensured that the grand style deserted him when the lustre deserted Napoleon, when the now portly and complacent Emperor was officially encouraging comparisons between himself and illustrious Imperial prototypes. Obediently Gros set to work on the dome of the Panthéon, newly rededicated to St Geneviève, patron saint of Paris. A sketch in the Musée Carnavalet shows four groups of Imperial Christians, Clothilde and Clovis, Charlemagne and Hildegarde, St Louis and Queen Marguérite, and Napoleon and Marie-

Louise. There is a great profusion of orbs and sceptres and also of attributes: Napoleon has brought along the Code Napoléon in order to facilitate his entry into the Kingdom of Heaven. The whole scheme was dogged by disaster, owing to the disappearance and reappearance of Napoleon during the Hundred Days. Thus in 1814 Gros had to change the Napoleon group to one of Louis XVIII and his niece, the Duchess of Angoulême. Then, during the Hundred Days, they had to be rubbed out and Napoleon and Marie-Louise reinstated. Finally, in 1815, Louis XVIII was there for good. Napoleon was not even a ghostly presence. He was not even an historical reminder. Napoleon was no longer in charge of France's destiny.

The year 1815 was a crucial one for Gros. The restoration of the Bourbon monarchy meant not only that Napoleon was exiled but that David, who had signed the document pledging fidelity to Napoleon during the Hundred Days, was exiled as well. Gros therefore found himself in a curious position. He was taken on by the new government, which realized how vital an instrument of propaganda his work had been under the previous regime. He was, however, made to take back his battle-pieces from the Imperial palaces and museums and to hide them in his studio, where they remained for the rest of his days. At the same time he was charged by the departing David to assume the directorship of his studio and to keep alive those principles which David had always taught. Here was an additional dilemma. David's style was out of date. Even the style of Gros's battle-pieces, a style intricately mixed up with specified content, was out of date. Gros, waiting for new instructions, discovered that there was no one to give them, only David, in Brussels,

becoming increasingly acrimonious and dogging him with no doubt well-meant but completely unjustified reproaches. '*Vite, vite, mon ami, feuilletez votre Plutarque* . . .' It is hardly surprising, therefore, that the only successful pictures painted by Gros after 1815 are portraits, in which this kind of conflict can be avoided. Works such as the *Mme Dufresne* in Besançon, or the *Jeune Fille au collier de jais* in Dijon, are the only pictures of this later period which maintain any kind of continuity with the early years.

Apart from isolated pictures such as these the story of Gros's later career is inglorious. He made a half-hearted attempt to apply his Napoleonic style to the new regime by changing sides and showing the tribulations of Louis XVIII and the Duchess of Angoulême during the Hundred Days. As if to emphasize the old-fashioned nature of this work, the Salon of 1822 saw the outstanding début of Delacroix, with *Dante and Virgil Crossing the Styx*. How much more disastrous for Gros was the picture he sent to the same Salon, the extraordinarily *retardataire Saul and David*, now known only from an engraving. Worse still, the exiled David was clearly disturbed that the Ministère des Beaux-Arts had not obtained his indemnification and invited him to return to France. He saw himself dying in Brussels, his former greatness officially overlooked. His one link with the past was Gros, his most spectacular and influential pupil, whom he had charged to continue his teaching. The pedagogic impulse dies hard; by the same token, Gros had been taking orders all his life. In exile David became rancorous, hence the letter of April 1821, '*Vite, vite, mon ami, feuilletez votre Plutarque* . . .' A further letter reproaches Gros for an obsession with uniforms, and charges him with the obligation –

it is almost an order – to paint history as David understood it. Or rather as David had formerly understood it, for Delacroix was now demonstrating that one could plunge into history, or rather histories, as diverse as those exemplified by Dante and Shakespeare.

Discouraged by a failure in the Salon of 1822, Gros, in bitterness, closed the doors of his studio. Delacroix, after persistent application, managed to gain admittance, and the sight of the *Jaffa* and the *Aboukir* inspired him to paint his own contemporary epic, *Scenes from the Massacre at Chios* (Fig. 30). Gros hurried off to Brussels to see David and was heaped with more reproaches. Two years later, in 1824, when Charles X visited the completed Panthéon and conferred on him the title of Baron, Gros begged the king to allow David back to Paris. The king refused. At the end of the same year Gros's friend Girodet died, and Gros made his extraordinary self-inculpating declaration at the funeral. He was by now convinced that his divergence from David's style of painting was a punishable fault, a disloyalty which he could not expunge. When David died the following year, 1825, Gros suffered a final, perhaps a fatal blow. After the failure of his last picture, *Hercules and Diomedes*, he seems to have relapsed into paranoia. '*Gros est-il mort?*' he would ask, when friends tried to intervene. '*Vous venez donc visiter un mort?*' ('Is Gros dead? Have you come to visit a dead man?')

His contempt for his successors was genuine. He was sufficiently a pupil of David to know that a certain technical discipline was essential, and that a certain likelihood or *vraisemblance* should be observed. Thus he criticized Delaroche's *Execution of Lady Jane Grey*, now in the National

Gallery in London, because the frightened girl had red lips, whereas her whole face should be white with fear. There speaks the painter of *Eylau*. '*Grande âme en détresse*', as Delacroix describes him, he received a final accolade from that same Delacroix whose star was in the ascendant. It was Delacroix who underlined his achievement, in his article in the *Revue des Deux Mondes*, and related how Gros had transformed at one stroke, almost in one picture, the type of history painting adumbrated in David's *Oath of the Jeu de Paume* into an epic of contemporary life capable of carrying a whole range of complex emotions. The undertone of pathos, evident in all his works, was to receive full acknowledgement in the tragic harmonies of Delacroix, while the heroism of modern life, soon to be celebrated by Baudelaire, was first demonstrated by Gros. Both hero and victim, his story also illustrates the fact that these two conditions may be interchangeable.

3

Alfred de Musset:
Enfant du Siècle

In his *Salon* of 1846 Baudelaire asked what was for him an imperative question: if the ideal were found and all acknowledged the norm to which they should conform, what would happen to the individual personality? '*Qu'est-ce que chacun ferait désormais de son pauvre moi?*' Since the beginning of the new century, even under a highly authoritarian regime, a new phenomenon could be observed: the imposition, on all sorts of material, of personal tastes and even obsessions, a breaking of the rules of conduct not permitted by the generalizing and idealizing tendencies of a consensus still held to be good as a standard for human behaviour. *Le pauvre moi*, the instinctive individual protest against this consensus, was to have consequences that could not have been foreseen in that initial demand for attention: loss of order, loss of structure, even, bizarrely, loss of opportunity.

Le mal du siècle, or *le mal de l'isolement*, both promised and denied freedom, promised greater application to purely personal desires and the ability to explore them, but also a setting of new limits between one individual and the next. The new ideal is a fantasy of the superlative emotional adventure which can be brought about without any physical activity at all, a dream state fundamentally distinct from

that patrolling of the globe that was commonplace in the Napoleonic era. The artist promotes himself as a work of art, but without profound belief in the process. An awareness of loss – of status, of solidarity, of consolation – is but one manifestation of the disappointment suffered when the Imperial adventure ended. In the case-histories of certain artists and writers it was perceived as the obverse of certainty, a condition that brought in its wake revolt and despair. The artist is sick, to the extent of no longer bringing his work to perfection: Lamartine and Stendhal claimed never to have revised anything they wrote. After decades of good-natured self-scrutiny, deep introspection, almost unwilled, was the new fashion in human behaviour.

Le mal du siècle, in its essence a very serious state of dislocation, is described by Chateaubriand in the chapter entitled 'La Vague des passions' from his *Génie du Christianisme* of 1802.

On est détrompé sans avoir joui; il reste encore des désirs et l'on n'a plus d'illusions. L'imagination est riche, abondante et merveilleuse; l'existence pauvre, sèche, et désenchantée. On habite, avec un cœur plein, un monde vide, et sans avoir usé de rien, on est abusé de tout. [One is disappointed without ever having partaken; one still has desires but no longer any illusions. Imagination is rich, abundant, and marvellous; life poor, sterile, and unfulfilling. With a full heart one encounters an empty world, and one is disheartened even at the outset.]

A profound indictment, yet what is most striking about this passage, quoted in nearly every survey of Romanticism, is its guilt-ridden consciousness of debt to earlier modes of expression. Although the sentiments are completely modern

the utterance – in strophe and antistrophe – is completely classical. An urgency to express new emotions has to confront a comparative strait-jacket of form. This can also be perceived in the painters of the period, Girodet, Gros, Géricault, all of whom convey a certain uneasiness at their own freedom. This uneasiness can be understood in David's bewilderment when he viewed Girodet's borderline iconoclasm, or flouting of the rules of good behaviour, in his picture of the shades of the French generals in an astral encounter of the painter's own devising (Fig. 13).

By 1836, two decades after Waterloo, it was possible to register loss and to point to the reasons for the mood of historical pessimism which was directly responsible for those individual reactions to which it gave birth and for which it provided an alibi. The years 1835 and 1836 saw two significant publications, Vigny's *Servitude et grandeur militaire* and Musset's *La Confession d'un enfant du siècle*. Very different in character and temperament, both men travel towards the same conclusion, that France is bereft, and that the new post-war generation is experiencing bereavement at first hand and in many forms. For Vigny, a man of stoical disposition, the sense of loss could be expressed almost objectively, as a result of being let down not only by history but by destiny as well.

J'appartiens a cette génération née avec le siècle qui, nourrie des bulletins de l'Empereur, avait toujours devant les yeux une épée nue, et vint la prendre au moment où la France la remettait dans le fourreau des Bourbons . . . Les événements que je cherchais ne vinrent pas aussi grands qu'il me les eût fallu. [I belong to that generation, born with the century, nourished on the Emperor's dispatches, which

always beheld a naked sword but went to grasp it at the moment when France put it back into the Bourbon scabbard . . . The events I sought were never as great as I needed them to be.]

For Musset the same disillusionment and the same reasoning produced the finest sustained passage he was ever to write. Although a poet and a playwright, it was in prose that he chose to write his elegy for lost heroism, an elegy that begins, significantly enough, with the words, '*Pendant les guerres de l'Empire* . . .'

During the Imperial wars, while husbands and brothers were in Germany, anxious mothers gave birth to a fervent, pale, and nervous generation. Conceived between two battles, brought up in schools to the roll of drums, thousands of children looked at each other with suspicion and flexed their puny muscles. From time to time their bloodstained fathers would appear, would press them to their gold-embroidered breasts, then put them down again and remount their horses. There was one man alive in Europe in those days; the rest were simply trying to fill their lungs with the air he breathed. Every year France made him a present of three thousand young men; it was the tribute paid to Caesar, and if he did not have this troop behind him he could not try his luck. It was the escort he needed in order to cover the globe and to finish up in the obscure valley of a desert island, under a weeping willow. In this man's time most nights were sleepless; on the ramparts of cities most mothers appeared bereft; never was there such a silence around those who spoke of death, and at the same time, never was there so much joy, so much life, so many warlike fanfares in every heart. Never were there suns as brilliant as those which dried up all that blood. People said that God made them specially for that man and called them the

suns of Austerlitz. But he himself made them with his cannon, and it was only on the days following the battles that clouds appeared. It was the air of this brilliant climate, glittering with glory and the flash of steel, that these children were accustomed to breathe. They knew that they were destined for the holocaust; but they thought Murat unconquerable, and the Emperor had been seen on a bridge in such a cross-fire of mortars that it seemed as if he could not die. And even if one did have to die, what did it matter? Death itself was so splendid in those days, so great, so magnificent with its smoking crimson. It was so like hope, it cut down such green corn, that there was a sort of eternal youth, there was no old age. All the cradles of France were shields, and so were all the coffins; there were no old men, only corpses and demi-gods.

This tremendous passage alone would persuade one of the inspiring compulsion of the Romantic ethos, and of its powers of expression, even in so weak a vessel as Alfred de Musset, mourning not only the loss of glory but the loss of a father. In his novel *La Confession d'un enfant du siècle*, from which this lament is taken, it is the matter of one whole chapter, the second, and it is strictly speaking a digression. It is the striking prelude to a fairly mawkish story of an unhappy love affair, in fact Musset's love affair with George Sand. But although irrelevant to his subject Musset cannot leave Napoleon alone. He describes his fall, and in a long Virgilian metaphor tells how sometimes, on a long journey, one does not feel tired until it is all over, until one is sitting at home quite safely in the bosom of one's family: '. . . *ainsi la France, veuve de César, sentit tout à coup sa blessure. Elle tomba en défaillance, et s'endormit d'un si profond sommeil que les vieux rois, la croyant morte, l'enveloppèrent d'un linceul blanc.*'

. . . France, Caesar's widow, suddenly was conscious of her wounds. She fainted, and fell into such a deep sleep that former kings, thinking her dead, wrapped her in a white shroud . . . A grey-haired army returned, exhausted, and fires were sadly rekindled in the deserted châteaux. Then these men of the Empire, who had travelled so far and killed so many, embraced their shrivelled wives and spoke of their first love; they looked at their reflection in the pools of their native meadows and saw that they were so old, so mutilated, that they thought of the sons who would have to take care of their last days. They asked where they were; the children were coming out of school, and seeing no swords or cuirasses, no infantry or cavalry, asked in turn where their fathers were. They were told that the war was over and that Caesar was dead . . . these children were drops of a blood that had watered the earth; they were born at the heart of war, they were born for war. For fifteen years they had dreamed of the snows of Moscow and the sun of the pyramids. They had never been out of their home towns but they had been told that each high road led to a capital of Europe. In their heads they had an entire world; they looked at the earth, the sky, the streets and the pathways, and everything was empty, and the only sound was the sound of the bell tolling in the parish steeple.

Perhaps it would have been better if Musset had ended his chapter with that beautiful line: '*tout cela était vide, et les cloches de leurs paroisses résonnaient seules dans le lointain.*'

But Musset is not a classical writer; he is, like the hero of his novel, an *enfant du siècle*. He is perhaps the archetypal *enfant du siècle*, and he cannot sustain an adult tone or an adult discipline for too long a time. The analysis continues, but on a more opaque note.

Three elements formed the life that was available to these young people: behind them a past gone for ever ... before them the dawn of an immense horizon, the first streaks of light ... something like the Ocean that separates the old continent from America, something imprecise and moving, a stormy sea full of shipwrecks, with from time to time a white sail or a funnel belching heavy smoke; the present century that separates the past from the future, neither the one nor the other but bearing a passing resemblance to both ...

The hypnotic tone of those visionary first paragraphs has been lost. Musset goes on to weaken his case, but with a certain amount of self-indulgence, by commenting on the afflictions experienced by his hero, Octave, the pseudonymous *enfant du siècle*. These are many and varied and they demonstrate the Romantic shift whereby the individual is the measure of all things, and cases are no longer relative. Each person now puts forward an imperative claim on the attention, together with an array of symptoms which are no longer imposed by outside forces but are in fact the result of their absence. '*Un sentiment de malaise inexprimable*', intolerable uneasiness, gives way to '*un dégoût morne et silencieux*', a wretched and silent repugnance. This in its turn leads to '*désespérance*', hopelessness, and finally to *ennui* (untranslatable). Even *ennui*, or inanition, gives rise to its antidote, excess, and this is one of the more successful compensations for the Romantic malady, an ideal of Napoleonic rapidity, an unremitting compositional effort which offsets the dreaded lethargy from which most Romantic artists profess to suffer. Constant composes *Adolphe*, the perfect novel, in fifteen days, Hugo writes *Hernani* in a month, Stendhal

writes *La Chartreuse de Parme* in fifty-two days. Balzac writes
six novels a year and proclaims, '*Je vis comme sur un champ de
bataille.*' ('I live as though on a battlefield.') Those unwilling
or unable to live as though on a battlefield cultivated a
contempt for facility and a desire to promote the artist
himself as a work of art. Delacroix, his own Napoleon,
remained enthralled to an epic of his own creation. Yet
while breaking all the rules of traditional composition he
insisted that he was a pure classicist. Like Napoleon, who
forswore the ideals of the Revolution to create a new world
order that was to have no progeny, Delacroix, having left
old ways behind in the creation of a new style, had no
followers.

The *enfant du siècle*, therefore, believes in nothing and
has no future. He is in no danger, he is well nourished,
but he is played upon by pernicious influences. Recent
history has conditioned him to hopelessness, while present
circumstances assure his safety. The malady of his
century, as seen from the vantage point of 1836, springs
from two main causes: 1793 and 1814, that is to say the
Terror and the presence in Paris of the Allies. These wounds
were seen to be ineradicable. '*Ne cherchez pas ailleurs le
secret de nos maux.*' ('Look no further for the secret of our
tribulations.')

This great digression, Napoleon's and France's epitaph,
is tangential to Musset's novel, which is the story of a love
affair, but not to its outcome, for Octave, the *enfant du siècle*,
allows his mistress to marry another man, simply because
he lacks the will and the conviction to fight for her himself.
In this sense the *maladie du siècle* is seen as something very
serious indeed, an inert force which guarantees loss or at

the very least lack of happiness. There were no philosophical systems to support these invalids, for what tracts there were centred upon the question of a church which itself occupied a singularly precarious position. The sunny prognostications and philosophies of the Enlightenment had been seen in the light of recent experience to have been hopelessly Utopian, based on the theory that man is a creature of common sense with a natural desire for improvement. The original *enfant du siècle*, as described by Musset, is literally grieving with disenchantment. What is notably missing is any recipe for a programme of recovery. Musset does not distinguish the further despair which occurred after the revolution of 1830, which caused a new timidity to descend. Even Saint-Simonism, a modest proposal for social justice, faltered, as the prudent bourgeoisie sought comfort rather than hero-ism. This marked the inception of a second inglorious period in the history of the *maladie du siècle* and proved a breeding-ground for terminal Romanticism, the bitter but endlessly creative working lives of a Delacroix or a Baudelaire.

One citadel remained, the citadel of art, a system with its own rules and its own adherents. A new genre, that of art criticism, building on the foundations established by Diderot, became increasingly popular. Diderot had pro-moted this as a genre without rules, and this was part of its attraction: Diderot's uninhibited reactions to the pictures and sculptures of his time proclaimed a freedom which his successors were anxious to emulate. No apostasy was involved: the exercise was devoid of guilt. At the same time it absorbed free-floating emotion which had benefited from attachment to an object. In the case of Baudelaire the

attachment was dangerous. Perhaps art cannot stand very much reality. Critics, by the same token, are not always disinterested. In the field of art criticism the dividing line between objectivity and subjectivity was easily crossed. Art criticism became a recognized vehicle for men of letters in which not only to pronounce on the follies and fashions of their time, as Diderot had done, but in which they could explore the vexatious circumstances of life itself, and in time register yet again the disillusionment that any attempt to evade life will inevitably bring.

Unlike Stendhal, who did not expect to be understood until the 1880s, Musset is barely comprehensible to anyone who was not his immediate contemporary. He was born in Paris in 1810; all his biographers, and there are remarkably few of them, make the point that one of his ancestors had been a minstrel in the thirteenth century. He flirted with the idea of studying law, attended one dissection class as a medical student, then drifted off to Victor Hugo's circle, of which he was the youngest member. By the age of twenty-two he had drifted away again, many of the longer-standing members judging him to be impertinent and even trivial. He remained in the bosom of his family all his life, thus earning the liberty to be a full-time *enfant de Bohème*. In Mürger's novel *Scènes de la Vie de Bohème*, we are presented with four young men who profess to be a painter, a musician, and a couple of writers. In fact they rarely follow any of these callings, but they act their parts strenuously: they are performance artists. It is as a performance artist that Musset impresses in his capacity as a member of the Romantic generation, or it would be had he not risen to the challenge of his times in the second chapter of *La*

Confession d'un enfant du siècle. With this grandiose and tragic exception, never to be repeated, Musset is essentially a lightweight, following the profession of man of letters but only occasionally finding the gravitas necessary for this calling.

Fortunately for the historian of ideas Musset also added in lesser ways to the Romantic debate, not as a poet or a dramatist, as he is best remembered, but as a journalist. Most of his prose works were published in the *Revue des Deux Mondes* and were therefore permitted to be ephemeral, although they ran to considerable length. In 1833, on 1 September, he published a short article on modern art, *Un mot sur l'art moderne*. This title might raise expectations, for it would seem to ally Musset with Stendhal and Baudelaire, both of whom were concerned to find a contemporary, or, as they would say, a modern idiom for the art of their day. Musset's article is inconsequential, but it establishes two important points. First, Musset makes a plea for the retention of classical rules. His reason is a fear that unless the classical tradition is kept alive it might vanish altogether. This is a serious Romantic preoccupation. Romanticism is mainly about apostasy; its major activity lies in the flouting of parental authority. Not only did Gros's suicide imply guilt at going beyond his master, David, the fearless Girodet showed an uneasy attachment to the careful finish that he learned in that same David's studio. Interestingly, there is a misty connection between his extraordinary image of the French generals being welcomed into the hereafter (Fig. 13) and the exalted patriarchal group in David's *Oath of the Horatii* (Fig. 15). Musset casts his net even wider. He makes a plea for true contemporaneity. The painter, he says, should

look around him and try to capture the essence of contemporary appearance, rather than pick out the unusual and the picturesque. This theory was to be expanded by Baudelaire into an entire aesthetic. It was the moment when the black frock coat replaced the guardsman's uniform, just as the realism of *Les Fleurs du Mal* was to replace the Muses who periodically visited Musset.

But whereas Baudelaire holds a quasi-mystical view of the artist's duty both to his time and to eternity, Musset is far more practical. Having stated that a work of art must fulfil these two conditions, he concludes that art should appeal to both the crowd and the connoisseur. It is a simple, not to say simplistic attitude. But whereas Baudelaire was to hold a quasi-mystical view of the artist's double duty to time and to eternity, Musset stopped short of expanding his idea and almost cheerfully retreated from what was, or could have been, a major aesthetic theory.

In fact he was limited by a curious form of indifference to art, and also by the lack of an aesthetic system. When he reviewed the Salon of 1836, also in the *Revue des Deux Mondes*, he revealed the limits of his critical capacity. Having no *idée fixe* Musset was enabled to enjoy everything. He spoke respectfully of the death of Gros. He saw nothing untoward in the paintings of Delacroix, about whose works various puzzled views were forming. He maintained that Delacroix was far from being the subversive who was likely to cause trouble, as some maintained. Delacroix was not trying to impose his views on anyone else; he was simply at the mercy of his temperament, his '*organisme*', and he was not seeking to impose that either. Temperament as a touchstone of authenticity was to be erected into a complete

aesthetic by Zola, when he reviewed the Salons of the 1860s. Thus Zola, the amateur, was to benefit from the amateur, Musset. Amateurism in this particular field, even unabashed naïveté, was held to be more representative, more '*moi*', than balanced, scholarly, or objective judgement.

Musset's additional excursion into an examination of the spirit of Romanticism is the collection of lengthy articles entitled *Lettres de Dupuis et Cotonet*, published in the *Revue des Deux Mondes* in September 1836. In that year Musset was twenty-six years old; his adventure with George Sand had taken place in 1834, and his best pieces for the theatre were already written. If he thought he had grounds for melancholia they were certainly justified. But he had the wit to venture into satire, and moreover a satire on Romanticism. The exercise is unfinished and inconclusive. It is also apposite.

In the *Letters* Musset has created two solemn and well-meaning bourgeois from La Ferté-sous-Jouarre and has set them to debating the nature of Romanticism. They are avid newspaper readers, they try to keep up with all the latest trends, and they are always two years out of date. Dupuis begins by writing to the editor of the *Revue des Deux Mondes* with a cautious confession that he and his friend Cotonet have never quite understood what Romanticism was about. Their worries began in 1824, when, on opening the *Journal des Débats*, they were puzzled by words like picturesque and grotesque, and by slogans like the poetry of landscape, dramatized history, pure art, broken rhythms, a fusion of the tragic and the comic, and the resuscitation of the Middle Ages. For two years they struggled on in the belief that, as

far as literature was concerned, Romanticism only took place in the theatre, and that the easy way to distinguish a Romantic from a classical play was by keeping an eye on the unities. If the unities were absent the play was a Romantic one. Stendhal had not written *Racine et Shakespeare* in vain, for he had provided Dupuis and Cotonet with a rule of thumb guide to the Romantic drama.

However, in 1828 the news came through to La Ferté-sous-Jouarre that one could have classical and Romantic poetry, classical and Romantic novels, classical and Romantic epics, and that even one line could contain elements of classicism and Romanticism. Dupuis and Cotonet passed several sleepless nights. It was all very well for Parisians, who, they suspected, had a sort of secret code for deciphering a Romantic work, but things were very different in the provinces. If a provincial said that something was Romantic he meant that it was absurd. But people in Paris were apparently serious. To their relief a famous preface appeared (this was Hugo's *Preface to Cromwell*, though it is not named) which made everything seem quite clear. Romanticism was the fusion of the trivial with the profound, of the grotesque with the terrible, of the comic with the horrible. In short it was a combination of tragedy and comedy. Then Cotonet speaks: Aristophanes had done all that. Nobody had thought it extraordinary.

Dupuis counters bravely that if this is so the two of them must be out of date: Romanticism must be something they have not yet thought of. In moments of pessimism, which are frequent, the two friends wonder whether Romantic is not just a modish way of saying novelettish, just as clever young men are saying that something is rational when they

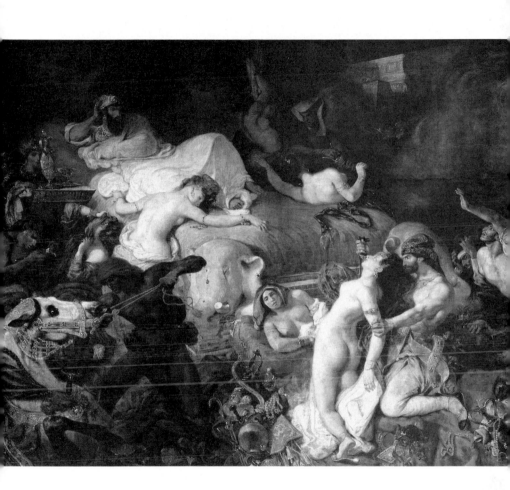

1. Delacroix: *Death of Sardanapalus*

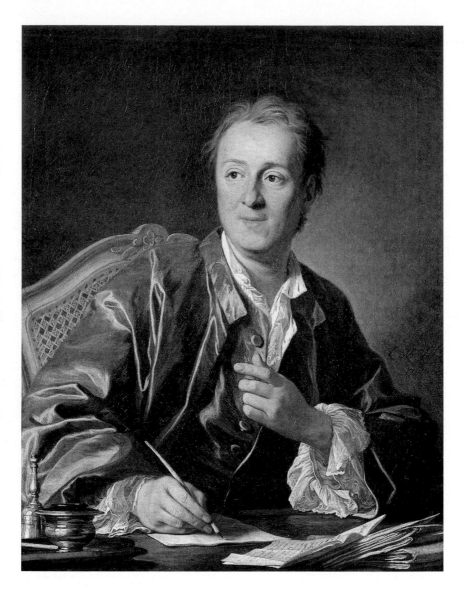

2. L. M. Van Loo: *Portrait of Diderot*

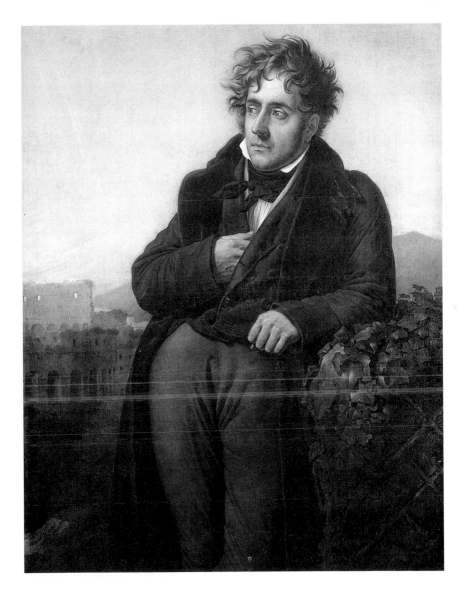

3. Girodet: *Portrait of Chateaubriand*

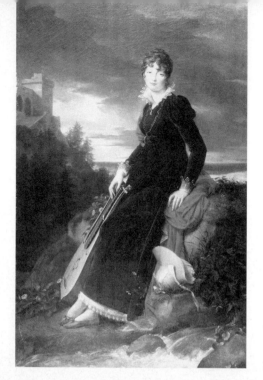

4. (*Left*) Gérard: *Portrait of Countess Starzenska*

5. (*Below*) David: *Portrait of Mme Récamier*

6. (*Opposite, top*) Girodet: *Death of Atala*

7. (*Opposite, bottom*) Girodet: *Endymion*

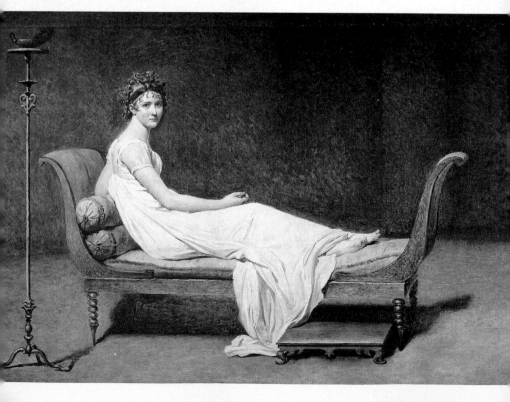

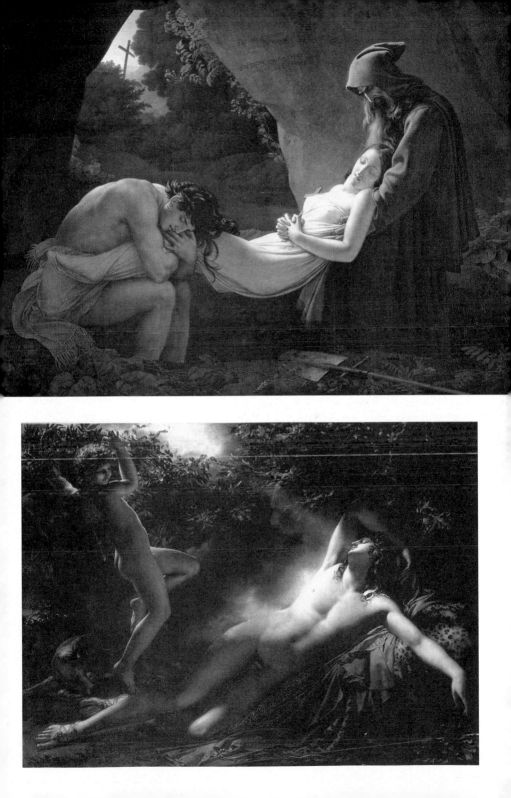

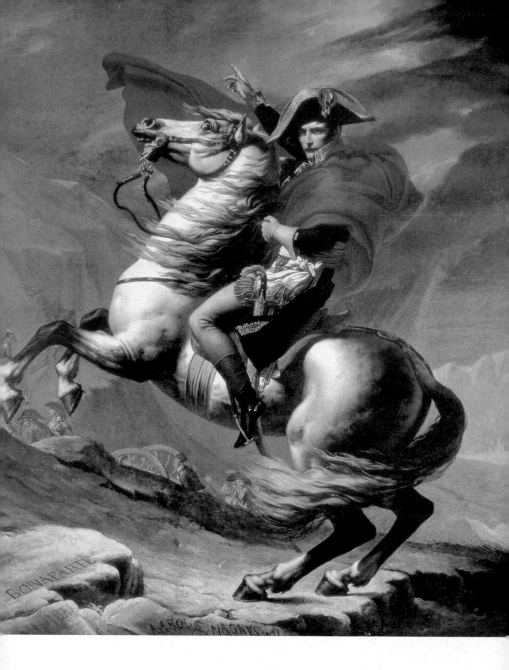

8. (*Above*) David: *Napoleon Crossing the Alps*

9. (*Opposite*) Gros: *Portrait of General Fournier-Sarlovèze*

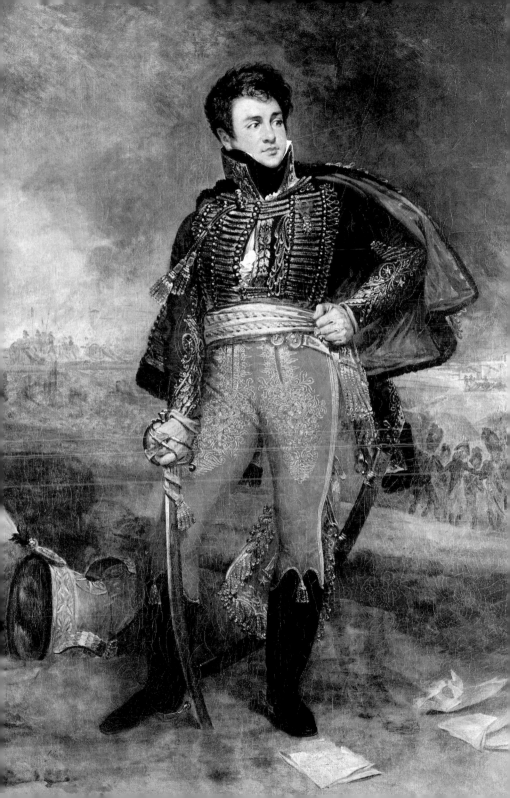

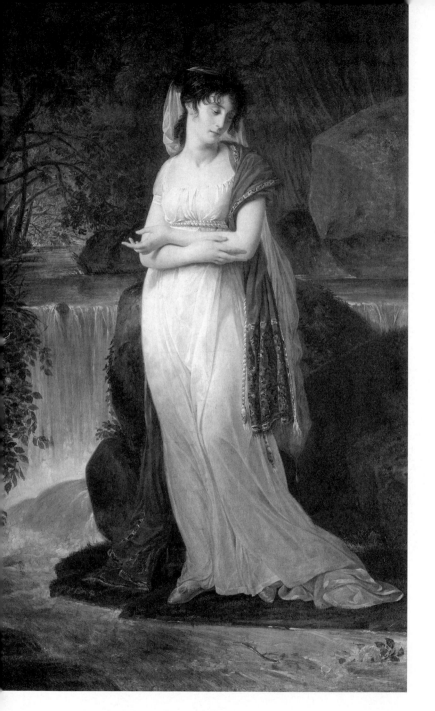

10. Gros: *Portrait of Christine Boyer*

mean it is reasonable. Their troubles are not yet at an end. Until 1830, they state, they thought that Romanticism meant the imitation of the Germans and the English. From 1830 to 1831 they thought it meant the historical vogue. From 1831 to 1832, hearing that history had been discredited, they decided that it was the confessional mode, *le genre intime*. From 1832 to 1833 it occurred to them that Romanticism was a system of philosophy and political economy (in other words, Saint-Simonism). From 1833 to 1834 they thought it meant not shaving and wearing jackets with very broad lapels. In 1835 they thought it meant refusing to do national service. The following year the two friends are driven to interrogate the lawyer's clerk who first launched the term Romanticism into the society of La-Ferté-sous-Jouarre. The lawyer's clerk obliges with a dithyrambic outburst which is in itself a further satire on certain types of Romantic utterance: Romanticism is '. . . *le plein et le rond, le diamétral, l'oriental . . . l'embrasé, le tourbillonnant'*. It is, in fact, or can be, anything and everything.

The time has come to consult an authority, M. Ducoudray, who explains Romanticism as an historical phenomenon. The Restoration, says this excellent man, rewarded men of letters who flattered church and state, and these were likely to be the old guard. At the same time young men, whose physical energies had been formed on the battlefield, took to writing. They had the same interest in the past but they also had a desire to be different. Mme de Staël helped this movement by introducing the principle of hybridization, and by stating that it was legitimate to copy the legends and ballads of the Middle Ages. The result? The most obscure of historical periods was plundered for words

and phrases which were nothing more than the common currency of a people plagued by fear and superstition. On the stage kings, queens, cardinals and pages, either criminal, incestuous, or both, were served up for the entertainment of the French, the healthiest, most courageous, and most high-spirited people in the world. That was Romanticism. By the same token Romantics are the younger generation which has no desire to be confused with an establishment that writes for social rewards and government approval. In this sense to belong to a vaguely dissenting minority might be sufficient to earn the label Romantic. The connecting thread would be a desire for liberty and the right to earn disapproval from one's elders.

Is Romanticism then a state of dispossession? Undoubtedly. That the eighteenth century had contained elements of irrationality, eccentricity, and self-referral is beyond question, but by eighteenth-century standards these elements were considered to be of negative value. There is a fine description of *le mal du siècle* in an eighteenth-century medical treatise, La Mettrie's *De la folie*, where it is defined as a symptom of mental disorder. Yet mental disorder implies dissociation, and the Romantics are furiously committed to their vaguely described cause. History had imprinted them; they were the children of the new century, *du siècle*. The result, perhaps the tragic result, was unlimited free will without the backing of established order or social support. For his moment of insight as a chronicler of this dilemma Musset might have earned the gratitude both of his own generation and of the next.

Musset, though famous in his own lifetime, fails to impress us as serious. This was the criticism directed at him

by Victor Hugo and his friends. Musset does not exhaust his energies through his writings. The hallmark of the mature Romantic is complete self-expression, a state in which there is nothing left to say. Thus Delacroix explains that after a day's work in his studio he has no need for entertainment or distraction; a few words with the porter on the corner of the street will suffice. In the 1830s, after Hugo's manifesto of 1827, and his famous defence of the conflation of comedy and tragedy, it was thought that this fusion was an adequate description of a Romantic work of art. Musset's singular merit is that he managed both modes in a single year, 1836. The noble suffering expressed in the second chapter of *La Confession d'un enfant du siècle* was able to stand side by side with an effective take-off of those who merely subscribed to the latest fashion. This is little more than good journalism and a little less than a sincere pronouncement. He had proved that he was not unaware of the currents of his time, but he was not disabled by them. He is far from living his life through art.

A life in art, which was the path chosen by Delacroix and Baudelaire, imposes severe restrictions on a life lived more simply, through the impulse of the senses. Art, once objectified and identified as a goal, would appear as imperative as the gravest of disciplines, necessitating all forms of self-denial. Delacroix, though courted, was more comfortable as a recluse; Baudelaire was seen as a sick man. Separately and in conjunction the two men pursued their chosen ideal to destruction and thus brought a finality to the first phase of the Romantic Movement. Their successors had to find a different route, but few were satisfied with their conclusions. Art was to play an ever greater part in their

preoccupations, as if art could explain them to themselves. The Napoleonic epic faded into history as an explanation of unease. Attempts were made to replace the past with the future, art standing guard to point out the way. Inevitably there was an attempt to replace one set of values with another. Few managed it completely. The secret *moi* was not to be so easily denied.

Romanticism succeeded in literature for far longer than it did in painting. Literary Romanticism is capable of many mutations because it does not rely on standard imagery. For Baudelaire Romanticism represented the kingship of the imagination, as it did for Delacroix. The final phase of the Baudelairian attitude implies that the cult of images signifies consolation, compensation for the ills of contemporary life, a sublimation of human appetites. This is the Romanticism of the Parnassians, of Gautier and of Flaubert, although their adherence is not in doubt. For the brothers Goncourt art was the antithesis of life. Their fight to sustain a contemporary realist position holds them back from the brink of total withdrawal. It was left to their successor, Huysmans, the last great amateur of the nineteenth century, to complete the last stage of the Romantic journey.

Musset completes the first stage, and he is a not unworthy commentator. He perceived the follies of Romanticism, but he also perceived the reasons for that collapse of certainty which the Romantics strove to replace or for which they tried to compensate. His explanation should be retained, and also his inability, which was widely shared, to establish a definition of what the Romantic endeavour strove to be. For the next generation a definition was no longer possible; Baudelaire's vague description remains inadequate. Once

internalized, and not attributable to an identifiable source, Romanticism would prove to be as burdensome as liberty, and as illusory.

4

Baudelaire:
The Black Frock Coat

'*Nous célébrons tous quelque enterrement.*' ('We are each of us attending some funeral or other.') Baudelaire, distanced from normal thought processes by both heredity and his own morbid disposition, sought his satisfactions in the manner most likely to recommend itself in an unheroic age. For reasons which he failed entirely to explicate he was obliged to displace his energies and his desires into the realm of the imagination, and promoted art, and its major proponent, Delacroix, to a position from which it was possible to regularize his thinking and to lend some sweetness of feeling to his ideas.

His was a life overshadowed by suffering, and by the search for redemption. Obliged to make his living as a journalist and essayist in order to fund his existence as a poet, he devoted his best ideas and his most beautiful sentences to reviews of the Salon exhibitions, which, as he revealed, exerted an obsessional fascination, though he spent little time in objective study, relying on his memory to furnish him with impressions which the pictures themselves could not always be guaranteed to do. It is to this memory that we owe some of the most decisive writing on the art of his time, a time which produced many fine critics, but only one who invested the art of painting with all of Baudelaire's immeasurable beliefs and requirements.

He is a Romantic of a peculiarly intense kind, in almost permanent mourning for a land of lost content which he had never known, or had known only briefly in early childhood. His Romanticism is open to many different interpretations, or rather he is a Romantic on more than one count. He gave a striking if imprecise definition of Romanticism, which seemed to him enshrined in the work of Delacroix. In addition to this he himself lived according to all those characteristics – intimacy, spirituality, aspiration towards the infinite – which he considered indispensable to Romantic art. He is a splendid token Romantic, the familiar figure of the *poète maudit*, a self-styled and self-regarding phenomenon, but an authentic artist of unparalleled gifts. In his lifetime he was known mainly as a prose writer, notably an art critic. His one volume of poems, *Les Fleurs du Mal*, was published in 1857; six poems were condemned for obscenity, and the whole volume was withdrawn from circulation in 1862 when his publisher was declared bankrupt. He began to write poetry as a young man; his poems appear to have been written without very great effort (certainly his corrected proofs are meticulously neat) and little is known about them. Their unique impact remains unexplained, in itself a tribute to the autonomy of genius.

The full intensity of Baudelaire's Romanticism is contained in the two words he used most frequently in his poems: *spleen* and *ennui*. Poems such as 'La Cloche fêlée', 'Le Goût du néant', 'La Mort des pauvres', 'Moesta et Errabunda', 'L'Ennemi', and above all 'Le Voyage' transcribed states of morbid awareness unknown to a previous age, and also an inner life of intense absorbing passion. Romanticism was not always considered such a terminal

complaint. At the beginning of what promised to be the
bravest century that France would ever know, Stendhal
defined Romanticism in literature as that most likely to
please the contemporary public, whereas classicism was
what would most likely appeal to its grandparents. Thus the
past was dismissed: it was quite simply irrelevant. And the
Romantic style of life was – or promised to be – exceedingly
glamorous. Again Stendhal set the rules: one should be
prepared to dance all night and die in battle the following
day. He was referring, obliquely, to the ball given in Brussels
by the Duchess of Richmond on the eve of the Battle of
Waterloo, the battle that was a turning-point not only in
the history of France but in the fortunes of the Romantic
Movement. With defeat came a long period of mourning
and of anger which reached its bitter climax in the lifetime,
indeed in the life of Baudelaire. Napoleon's debonair con-
querors were succeeded by a generation of resentful young
men who felt cheated of their chance of glory. No longer
could an ostler's son rise to become a Marshal of the Empire.
As Musset and Vigny were to state, events and, more impor-
tant, expectations, were never again to rise to the same level
of intensity.

Musset expressed his generation's disappointment in
1836. By 1846 the situation, as Baudelaire saw it, was more
extreme, more final: '*Nous célébrons tous quelque enterrement.*'
To judge by himself, consolation for the miseries of life
could only be supplied by some mystical release from an
oppressive present, in his case from a state of historical and
social disappointment that was more keenly felt by the
young. Baudelaire, born in 1821, saw an older form of
excellence, one to which his generation had no access, in

Delacroix, whose admixture of stoicism and extravagant imagination was to remain canonical for this deprived younger son until his death in 1867.

The real antidote to the nature which Baudelaire so abhorred is art, or, if that is too difficult, artifice. In the narrowest sense, man can transform himself from an act of nature into a work of art by observing certain ceremonies, by paying scrupulous attention to his person, his appearance, his attitude. But there is a higher means of escaping from the state of nature: by creativity, in which man emulates the behaviour of the original Creator. If Nature represents the Fall, then Imagination, '*la reine des facultés*', can point the way to redemption. Paradise can be regained, not by Grace, not even by Will, but by Imagination. The material world is but a poor reflection of God's perfect Creation; this world is full of adumbrations, correspondences of God's ideas, correspondence being the occult term for symbol or analogy. In the realm of artistic creation, which occupies a kind of middle plane between heaven and earth, further correspondences exist between sounds and colours and scents. Therefore the artist who possesses Imagination operates a kind of white magic, revealing the unknowable masked in human terms.

Baudelaire's hero, Delacroix, is reported to have said that when one judges a work of art one should forget the man responsible for it. In the case of Baudelaire this is impossible; the man must constantly be taken into account. What distinguishes Baudelaire from all previous poets and prose writers is his total subjectivity, his constant involvement with a system of values which he develops throughout his working life. For Baudelaire art is a moral undertaking, and

in the widest sense proof that man can raise himself above the level of the animals. His judgements, above all his digressions, are rooted in a life of intense and absorbing passion, his own substitute for the glorious life from which he feels secretly disbarred.

Stendhal, acting as critic of the Salon of 1824, viewed the art of his day with a provisional eye, amused, diverted, but not in any sense overawed. He was a man of action; he had discovered Europe under ideal circumstances, had been on the second Italian campaign, the Austrian campaign, the Prussian campaign; he had stood outside the gates of Moscow and exchanged a few words with Napoleon himself. This produced in him an absolutely valid conviction that the present was more vital than the past, and that the aesthetic standard of the past, represented by an unchanging eclectic norm – Winckelmann's *beau idéal* – was a nonsense. This particular view was a great stimulus to Baudelaire, who, like other sufferers of the period, had no heroic capital on which to draw.

In addition, and more importantly, he was unable to claim parity with the great men of the age. Stendhal had the unique advantage of finding a different family, a different paternity, in the army and its leader; he appears to have sprung fully formed from a happy moment in the history of the collective unconscious. Baudelaire, like Oedipus, like Hamlet, never escaped from the toils of a family which was inglorious and feeble. His father was an elderly civil servant who, at the age of sixty, married a woman of twenty-five and bequeathed his syphilis to his sons by both his marriages, a taint which was to lead to Baudelaire's death, paralysed and aphasic, at forty-six. After his father's death his mother

married again, and chose as her second husband an unsympathetic military man, Aupick, a former ambassador to Constantinople. Baudelaire did not murder his stepfather, nor did he marry his mother, but he was to plague her for the rest of his life with reproaches for his own extravagant faults. None of this produced an equable disposition. Baudelaire was excessive, irascible, unrealistic and desperately demanding, though he was for a little while able to put on a show of worldliness for his friends. His terminal despair, which was inward-looking, casts all earlier sufferers into the shade, although he is recognizably of their number.

Yet as a young man he made determined efforts to outwit his dual heredity, the historical and the familial. He dressed with outlandish distinction: black broadcloth coat, very narrow black trousers, snowy white shirt, claret-coloured bow tie, white silk socks and patent leather shoes. He aspired to the form of distinction, emblem of a highly controlled mental and spiritual life, worn by that curious type of moral pilgrim and sartorial perfectionist whom he calls the dandy. Dandyism is the mark of the aristocrat. At a brief settled period of his life he lived on the top floor of the former Hôtel de Lauzun on the Quai d'Anjou. On the red and black walls of his sitting-room hung a series of copies of works by and after Delacroix, including a set of the *Hamlet* lithographs. He had an extraordinary tolerance of drugs, was able to exceed the normal high dose with apparently little effect. Such an intake, he claimed, stimulated his imagination, intensified the vastness of space and the clarity of light, freed him from the burden of time. He was to seek equivalents for this weightless state in imaginative experience, in the images he particularly favoured and

which he sought to promote, urging the public, through the medium of the press, to share his enthusiasms.

This state of something almost approaching equilibrium was not to last. In 1844 his family judged him incompetent to administer his own financial affairs, and for the rest of his life he was made to subsist on an allowance, for which he had to apply to the family lawyer, Ancelle. He never cleared his debts, and was obliged to make a monthly journey to the lawyer at Neuilly to collect enough to live on. He was also obliged to earn his living. In 1845 he made his début as an art critic.

Despite his desire to impress and on occasion to shock he remained a profoundly religious personality. His religious position was extreme; he regarded the world of the flesh with distaste and even with distress. Delacroix, in one of those conversations which Baudelaire reported, dismissed nature as a dictionary from which the artist chose his materials. Baudelaire could hardly tolerate anything fleshly or vegetable at all. The world of landscape was closed to him because it had no moral sense: the serenity of Corot seemed to him heretical, while the material splendours of an Ingres portrait made him feel physically ill. Naturally his most worshipful admiration was reserved for Delacroix, who could release great imaginative flights without artificial means. Delacroix, whom Baudelaire generously promoted to arch sufferer at the hands of a philistine populace, enjoyed a lucrative career and managed to control his life by the exercise of unremittingly rational thought processes, whereas Baudelaire, who could make rational observations but not live a rational life, was a martyr to Delacroix's cause. The root of Delacroix's dislike of Baudelaire's haggard

enthusiasms was a certain hauteur, which was in a slightly higher category than Baudelaire's assiduous dandyism. Yet the latter was entitled to superior insights. Delacroix might have twenty different ways of saying 'Mon cher Monsieur', but in one sonnet, 'Spleen' ('Je suis comme le roi d'un pays pluvieux'), Baudelaire penetrated to the heart of Sardanapalus and to that of Delacroix himself.

What made Baudelaire's position so precarious – precarious even in comparison with that of Musset – was that he chose to fight his battles in aesthetic terms. Because he disqualified himself for the pursuit of the good, because he abominated the pursuit of the true (which he translated very narrowly as the factual or the realistic), he had to settle for the beautiful. And he projected into this arena a weight of expectation and of longing which could only be intermittently satisfied, and of course never reciprocated.

So great is Baudelaire's desire to emulate Delacroix, particularly in the Salon of 1859 and the obituary of 1863, that it is not quite clear that when he is talking about this ideal dandy, with his twenty ways of saying 'Mon cher Monsieur', he is not also, perhaps primarily, talking about himself. But in sharp contrast to Delacroix, Baudelaire does not find it easy to renounce the present. Certainly it is full of horrors like sulphur matches, gas lamps, and photography, but the present also means the poetry of the city, the crowd, the modern uniform, the modern psyche, images on which his own poems are built. Although he erects a shrine to Delacroix, which serves to mitigate his disgust for his loathed corporeality, he also needs the threatening excitement that he finds in other, more urbane, artists: Ingres, Constantin Guys, Manet. He finds a religious sanction for

this sort of worldliness, talks about the '*ivresse religieuse des grandes villes. Moi, c'est tous, tous, c'est moi.*' This is the aspect of his life and work in which he is freed from his dependence on others, freed from his constraints, and from his sometimes embarrassing apologetics.

... *mon cœur est plein d'une joie sereine, et je choisis à dessein mes plumes les plus neuves, tant je veux être clair et limpide et tant je me sens aise d'aborder mon sujet le plus cher et le plus sympathique* [i.e. Delacroix]. [... my heart is filled with quiet joy, and I deliberately choose my newest pens, so keen am I to do justice to my dearest and most sympathetic subject.]

This childlike prologue does not altogether answer Delacroix's requirements. Paradoxically, the young Manet, with whom Baudelaire used to walk in the Tuileries, and to whom he was dismissive and almost rude, found him much easier to get along with.

Baudelaire always intended to write a full-length book on the arts, and this would presumably have been a compilation of essays, reviews, and miscellanea. The nearest he came to finding an over-riding theme was in his *Salon* of 1846, with its misleadingly entitled chapters on colour, on Romanticism, on the hackneyed and the phoney, on sculpture ('boring'), and on Delacroix, this last section necessitating the new pens and the justification for his '*pauvre moi*'. Criticism, he claims, should be '*partiale, passionnée, politique*' – subjective, impassioned, committed. This tone is entirely representative of Baudelaire at his most euphoric; he applies it to Delacroix, typically going too far in empathetic insights but making the important claim that Delacroix has demolished the still valued standard of *le beau*

idéal. '*Delacroix part donc de ce principe qu'un tableau doit avant tout reproduire la pensée intime de l'artiste, qui domine le modèle comme le créateur domine la création*' – no longer the objective model but the subjective representation of ideas, sensations, phenomena. He then commits an error of taste by interpreting, on his own account, Delacroix's most impassive and beautiful picture, *Les Femmes d'Alger* (Fig. 31), which he turns into an allegory of the degradation of the flesh. '*Ce Baudelaire commence à m'ennuyer,*' observed Delacroix.

Having canalized his ardour and admiration for Delacroix, Baudelaire is led inevitably to criticize Ingres. Ingres was not only the official opponent of Delacroix; his pictures made Baudelaire feel physically ill. There were many reasons for Baudelaire's instinctive dislike of Ingres, the champion, in Baudelaire's eyes, of an unspiritual, materialist, academic canon of beauty. Ingres did not, by this reasoning, contain an inalienable world. He was no dandy. Above all, he was a famous man, whereas Delacroix, in Baudelaire's view, was ignored, despised, and rejected, a Romantic fallacy in which, for once, Delacroix concurred.

For these reasons Baudelaire adopts a very different critical stance towards Ingres. He brings to the task of judging him not the humility and deference lavished on Delacroix but those qualities which make him superior to Ingres as a man of the world: wit, polish, sophistication, even a certain savagery. Yet so great is his integrity as a commentator that he struggles with his dislike of Ingres, and out of this struggle is born an objectivity which establishes his credentials, not merely as an amateur but as the most polished of professionals. He is the first critic to note that Ingres's temperament

and style are made up of various irreconcilable strains, which he, by a gigantic effort of will, manages to blend. Baudelaire's perception of this phenomenon dates from the *Salon* of 1846. In the *Salon* of 1855, which contains his longest essay on Ingres, he names Ingres's sources: Titian, the quattrocento Florentines, Poussin and the Carracci, Raphael, the Nazarenes, and the arts of the Near and Far East. When one reflects that Baudelaire was entirely self-taught, and that he hardly ever left Paris, this is little short of remarkable. He goes on to analyse Ingres's tastes and methods with far greater accuracy than he normally devotes to Delacroix, whom he is content to define in metaphors that feed into his poetry ('*Delacroix, lac de sang hanté de mauvais anges*'). Being identified as a lake of blood haunted by malevolent angels was precisely the sort of comparison to which Delacroix was justified in taking exception. Ingres, however, remains on his pedestal: paradoxically modern, irritatingly classical, and untouched by the heroism of modern life.

De l'héroisme de la vie moderne is the most resounding of the chapter headings in the *Salon* of 1846, and it leads to the reasoning which allies Baudelaire with earlier *enfants du siècle* and at the same time signifies his emancipation from them. In this section, which will expand majestically into the essay entitled *Le Peintre de la Vie Moderne*, written between 1859 and 1861 and published in 1862, Baudelaire notes merely that in those far-off heroic days which Gros painted and Vigny and Musset chronicled, the days of '*attitudes majestueuses et violentes*', uniforms were worn and a kind of paganism triumphed. But, says Baudelaire, there is now another kind of uniform, the black frock coat, worn as a symbol of mourning by a race of undertakers, frail, unhealthy, and

united in their miserable equality. '*Nous célébrons tous quelque enterrement.*'

On the other hand this uniform has its nobility, like many of those who wear it, sad fallen creatures who nevertheless bear witness to the reverse of the Romantic medal, yet in whom the need for heroism obstinately persists. Beauty is a double quality, both eternal and transitory. One cannot avoid being acted upon by one's own time. This is the essence of modernity, and thus the old Romantic equation is justified; the contemporary, unprotected by theory and by traditional arguments, is once again an imperative force. Stendhal had said no less; risk-taking is the order of the day, and Balzac's rascally heroes have replaced the heroes of legend, both ancient and modern.

Between 1846 and 1855, the date of the Exposition Universelle, Baudelaire was more active as a critic of literature than as a critic of painting, with the result that by the latter date he had become rather more entrenched in his own dogma and discipline. In 1855 he is more independent, more wilful, more didactic, more self-absorbed, more theoretical, less descriptive. His method, as he outlines it, is a self-appointed one. '*Je me suis orgueilleusement résigné à la modestie; je me suis contenté de sentir: je suis revenu chercher un asile dans l'impeccable naïveté.*' ('I proudly resigned myself to modesty; I was content to feel; once more I sought sanctuary in impeccable naïveté.') What follows is both intricate and sarcastic. Dead and buried is *le beau idéal* of the academies, for Baudelaire now states that '*Le Beau est toujours bizarre.*' It is bizarre because it is a sort of magic operation which activates the sense of the supernatural, so precious a value in an age of material progress. From this generalization it is

quite natural to concentrate on the cases of Ingres and
Delacroix, the former allied with all that is modern in the
pejorative sense – photography; the latter with all that is
modern in the praiseworthy sense – the evolution of the
modern psyche.

The section on Ingres is extremely valuable in that it
records the primal sensations that Ingres produces on one
who literally shrinks at the spectacle of the flesh triumphant.
'*Cette impression, difficile à caractériser, qui tient, dans des pro-
portions inconnues, du malaise, de l'ennui, de la peur, fait penser
vaguement, involontairement, aux défaillances causées par l'air
raréfié . . .*' ('This impression, difficult to categorize, deriving
in unknown quantities from uneasiness, from ennui, and
from fear, makes one think vaguely and instinctively of the
faintness caused by thin air . . .')

Something vital is missing, and Baudelaire concludes
that it is imagination. The saving grace has gone out of
Baudelaire's life, and only Delacroix remains to make good
the century's deficiencies. Delacroix's pictures now remind
Baudelaire of the effects of opium, as if the seat of the
affections, and of life itself, were no longer the heart or the
liver but the cerebral cortex.

By 1859, the date of his last *Salon*, terminal disillusion-
ment has set in. The year 1857 had seen the scandal following
the publication of *Les Fleurs du Mal*, and Baudelaire sees no
reason why he should have anything to do with such a
philistine public, does not see the necessity even to address
it. Instead he directs his remarks to his editor, Jean Morel.
'*Non cher M.*,' he begins, and his tone is more erudite and
obscure than it has ever been before. He has paid one hasty
visit to the Salon, and he uses this as a pretext for grudges

and obsessions that are now freely expressed. Painters are little more than spoilt children; they have no imagination. Many, like the public they serve, prefer photography. They even claim to copy nature. Baudelaire prefers '*les monstres de ma fantaisie*' to '*la trivialité positive*'. There follows a semi-religious hymn to Imagination, succeeded by yet another hymn to Delacroix. The concept of the artist is now subsumed by Delacroix, and indeed symbolized by Delacroix, who, in 1859, exhibited *Ovid Among the Scythians* (Fig. 32), the final image of the *poète-martyr*. Art, quite simply, is, or should be, a matter for superior souls. The whole *Salon* is a masterpiece of aristocratic condescension, as is the final flourish, '*votre dévoué collaborateur et ami*', 'your devoted collaborator and friend'.

All this is of great historical and intellectual importance. Yet undoubtedly Baudelaire's most memorable utterance on the business of creative imagination is *Le Peintre de la Vie Moderne*, in which painting is hardly mentioned at all. This is nominally a report on the work of Constantin Guys, referred to throughout as 'M. G.', out of deference to Guys's desire for anonymity. The device serves Baudelaire well, for it enables him to take over Guys's work in a way that he was never quite permitted to do with regard to Delacroix. Guys, a minor artist, exerts a powerful impression on Baudelaire as '*l'homme des foules*', a man of the crowds, and also as a cosmopolitan to whom nothing is alien and who spends his life tirelessly noting the passing scene. As a portrait of one kind of artist, the kind that Baudelaire recognized as a fellow spirit whenever he relaxed his grip on the past and his allegiance to Delacroix, this represents freedom, a freedom hitherto elusive, now within reach.

The argument is irrational. One reads through pages of dazzling description without ever feeling the need to refer to an actual image by Guys, for Baudelaire has internalized him. The artist, M. G., and by implication Baudelaire, represents a certain kind of metropolitan excitement; he is portrayed always at a rush ('*Ainsi, il va, il court*'), noting changes in fashion, in carriages, in women, in make-up, all perceived with the heightened enthusiasm that only the artist can command. It is also a picture of the genius at work, a tireless energumen who even resents the need to sleep, and the images that sleep must forgo.

Quand M. G. se réveille, ouvre les yeux, et qu'il voit le soleil tapageur donnant l'assaut aux carreaux des fenêtres, il se dit avec remords, avec regrets, 'Quel ordre impérieux! Quelle fanfare de lumière! Depuis plusieurs heures déjà, de la lumière partout! De la lumière perdue par mon sommeil! Que de choses éclairées j'aurai pu voir et que je n'ai pas vues!' [When M. G. awakes, opens his eyes, and sees the impatient sun assaulting the windows, he says remorsefully, regretfully, 'What splendour! What light! Light already for some hours! Light wasted in sleep! How many radiant things I might have seen and have not seen!']

Light should not be understood here as the quality that will preoccupy the next generation of painters, but as the spirit of the world in which both Baudelaire and Guys, those two selves avid for non-self, those adepts of '*la foule*', the crowd, feel eased of the burden of their corporeality in a world no longer ruled by nostalgia, not even bound to anticipate the future, but at one with their time, with their surroundings, and even able to note their attractions.

This essay is about life by someone who is already sick

and has always regarded himself as disabled. The artist, ostensibly Guys but in reality Baudelaire, compares himself to a child, to a convalescent. These images are dominant. Only the sick man or the artist clings so desperately to the surface of life, values its trivia, tries to catch, as if by contagion, its vitality. Only the child, or the artist, is capable of such surrender to sensations of noise, light, excitement, appetite. These qualities are in fact Baudelaire's credentials as a poet, as a hero of modern life. They demonstrate what he himself, in another context, calls impeccable naïveté.

Apart from its intrinsic beauty this essay occupies a pivotal position in the development of nineteenth-century aesthetics. The brothers Goncourt were to base their method on the study of urban complexity which is the essay's overwhelming legacy. Zola was to reproduce in his novels the sense of being immersed in a flux or tide of humanity, like Baudelaire's aching appetite for '*la foule*', while the images of the child and the convalescent are vital for Proust. Moreover it is possible that the Impressionists of the 1860s, whose work is so intensely Parisian, regarded this text as something of a signpost and strove to become painters of modern life in the sense that Baudelaire intended, and accepted, as he did, the temporal aspect with which he all too often had difficulty, and which had not rewarded him as he may have hoped.

In this sense it is a little disappointing that he does not express a more coherent attitude to Manet. The two met fairly regularly in the 1860s, and Manet's *Musique aux Tuileries* (Fig. 16) is an image of the crowd as Baudelaire used the term in relation to Guys. Baudelaire even figures, as a shadowy profile, in Manet's picture. But the death of

Delacroix, in 1863, proved more decisive, marking not only the death of a great man but of great art. In Baudelaire's eyes the poetic vision of Delacroix could only be followed by anti-climax, by a general decline in ability to measure up to such high and exacting standards. This explains his cruel remark to Manet: '*Vous n'êtes que le premier dans la décrépitude de votre art*,' when Manet expressed his own disappointment at poor reception in the Salon. 'Do you think you are the first man this has ever happened to? Are you a greater genius than Chateaubriand or Wagner? People made fun of them, but they didn't die of it. *Vous n'êtes que le premier dans la décrépitude de votre art*.' He later regretted this harsh judgement, and said so in a letter to a friend, Mme Paul Meurice. He has a temperament, admitted Baudelaire, again prophetically. Temperament was to be the standard it was now appropriate to apply, a revised version, perhaps, of the *moi*, an alternative approach to '*la saveur amère ou capiteuse du vin de la Vie*' ('the bitter or heady taste of the wine of Life').

In 1862 Baudelaire recorded a strange fact in his diary: he had felt the breath of the wing of madness. He retained enough mental strength and courage to write an obituary of Delacroix in *L'Opinion Nationale*, regretting the death of a friendship, or perhaps the illusion of a comradeship that had united the two men in a chapter of intellectual history. It was an essentially Romantic friendship, for both were subject to that regret that is the most marked characteristic of Romanticism. Baudelaire died in 1867, paralysed and aphasic, with command of only two words, and those an oath. Two further images remain. One is taken from *Le Peintre de la Vie Moderne*, borrowed from Edgar Allan Poe but taken over by Baudelaire, and familiar to fellow sufferers

who may not even have read Baudelaire's words. A man has recovered from a long illness. He sits in a café, enthralled, drunk with the prospect of the world going on beyond the glass of the terrace. And the delirium of the crowd, of which he is only a spectator, becomes so intoxicating that he rushes out and tries to lose himself in it. This is one aspect of Baudelaire himself, Parisian, alienated, emotionally drunk, with the painfully acute perceptions of the convalescent, and with a nervous equipment so rare that he can register every degree on the emotional scale from despair to ecstasy.

Hence the second image, a prayer to the God of artist-poets. Baudelaire's God is an aesthete, and although poetic sensibility is not one of God's better-known attributes, Baudelaire is convinced that his sufferings in the life of the body are justified, and that all will be remedied in the world to come. The poem, his most beautiful, is called 'Bénédiction'; it is his own tribute to the *poète-martyr*, and affirmation of his faith that he will see that poet beatified.

As a young man Baudelaire had written in his notebook, significantly entitled '*Mon cœur mis à nu*', My heart laid bare, a curious profession of faith: '*Glorifier le culte des images (ma grande, mon unique, ma primitive passion*' ('To glorify the cult of images, my single, great, original passion'). Despite its oracular quality, or perhaps because of it, this is a significant statement, in which the key word is *culte*. In all his writings on the fine arts, and not only his *Salon* criticism, but, for example, his article on Wagner, Baudelaire is not applying himself directly to the material but glorifying the *cult* of images. The word implies several conditions, above all mystery, inner life, the bending of information towards some abstruse or esoteric end, secret connections, and above

all the use of memory. It may also imply a non-utilitarian approach to the arts, a crypto-Parnassian position, which Gautier will take further. It suggests an intensity of feeling not known to previous writers on the arts, for whom images were not a cult: it is impossible to imagine Stendhal, let alone Diderot, cultivating an inner life so intense that the outer world could only be perceived indirectly.

Baudelaire's personality, his system of belief and substitution for belief, are interposed like a screen between the spectator and the object; the judgements may seem self-centred, as if Baudelaire wished to express the arguments he favours so directly that they overshadow the phenomena he is supposed to be addressing. He is, in fact, a new type of critic, one almost entirely dependent on his own reactions, his *moi*. He believes that his reactions to painting or music or literature are as valid as the things themselves. He is, in every context, an artist in his own right. Criticism, as practised by Baudelaire, is an autonomous discipline, balanced, rather precariously, somewhere between the cult of images and the charting of responses and associations stimulated by those images.

An even cursory reading of *Les Fleurs du Mal* will reveal the despair and horror that dominated his life. Here the images are different, more impalpable: '*le gouffre, l'irréparable, le vieux, le long remords*' ('the abyss, the irrevocable, long time-honoured remorse'), and the atmosphere is one of unmitigated tragedy, determinism, even superstition. Yet this tragic life did not beget unmitigatedly tragic writing, and it is for this reason that one turns to the prose, to *L'Art romantique*, to the *Curiosités esthétiques*. These are substantial. In prose Baudelaire can be brisk, trenchant, even furiously

funny. If he succumbs once too often to the quasi-mystical spell of Delacroix, it is out of sincere and honourable loyalty, out of the belief in immortality which could not quite be vanquished. His life is the enactment of a scene in the drama of Romanticism. Just as no painter ever replaced Delacroix, no poet ever matched up to Baudelaire. With these two men disappear not only a complete repertory of Romantic idealism but a familiarity with the most cataclysmic of human emotions.

5

Delacroix:
Romantic Classicist

Delacroix's *organisme*, so described by Musset, reveals a sensitive use of the word, for Delacroix is essentially an organic painter, one who dissolves the planimetric picture surface of the Neo-classicists, and disdains the logical arrangement of the subject in favour of an exploitation of his chosen pictorial elements. These may range over the whole height and breadth of his canvas, exploding from a barely discernible central viewpoint with a fissile energy which may cause the image to tilt in a precarious diagonal.

The extreme logic of David is subverted in favour of a greater expressionism, yet it is the energy of the painter that is in command. A drawing by Delacroix for even so legible yet intemperate a picture as the *Death of Sardanapalus* (Fig. 1) will be a frenzied explosion of lines that never converge (Fig. 17). This indicates a world outside thought, an over-wrought subjectivity no longer dominated by appearance. That Delacroix was able to control such demonic intensity and to compress it into the sort of eligibility that the nineteenth-century eye was entitled to expect is evidence of both a furious temperament and the stoical discipline needed to bring it under control.

As a Romantic, Delacroix was, as he haughtily claimed, a pure classicist. Creative momentum, the pure expression

of the *moi*, had to be harnessed, made acceptable. But in that process none of the struggle to achieve it need be effaced: the picture would be an event, a manifestation of the artist's engagement with his art. At the same time the artist would seek the protective power of history to justify the tragedies he was intent on illustrating, as if he possessed some otherworldly stance to justify his performance as demiurge.

The duality was noted quite early on in Delacroix's career. A society hostess, with designs on his company, opined how sad it was that such a charming man should paint such terrible pictures. What distressed her may have been evidence, as early as 1824, in his watercolours of tigers attacking horses (Fig. 18), of a violent irrational urge quite at odds with the polite patrician façade presented to the world. The critic Théophile Silvestre memorably described him as ardent and cold-blooded. It is in the energy of the brushwork, an energy directed from the wrist, that one is entitled to discern Romantic despair, a realization and acceptance that logic will never triumph in human affairs, that the spirit craves release, and that the more it is constrained by outside forces the more violently it will require expression.

Delacroix's desire was to transmit through the medium of his paint images suggested by the id but controlled by the superego. In this way texts become altered to suit the painter's requirements. Sardanapalus emerges from Byron's play to decree an orgy of Delacroix's own devising, in which naked women writhe helplessly under the disinterested eye of an inert tyrant. This willed destruction is voluptuous, but the excitement is in the paint rather than in the subject.

Studies for this picture show the violence being dominated and mastered, until the finished work, though excessively disturbing, is at least decipherable. Only the assault on the spectator remains undiminished, and indeed unexplained. All of this functions at the level of the subconscious. In a *Journal* entry of 1822 Delacroix stated that a mysterious bridge connects the soul of a painting with that of the spectator. It is true to say that the spectator remains entirely convinced by the sadism of this particular work. It is an element the spectator will have to deal with on his own terms, not quite sure that Delacroix intended to interpret so remote an event as an orgy.

What has this to do with Romanticism, apart from the fact that the appearance of Delacroix's picture is so blatantly and unequivocally Romantic? Quite simply that Delacroix accomplishes that dissolution of the established order that was still accepted as the norm. After 1827, the date of the *Sardanapalus*, the unities are nowhere in sight. By spreading his composition all over the canvas, from top to bottom and from left to right, Delacroix subverts expectations of how the picture space should be organized. He would do this until the later part of his career, which was absorbed by government commissions imposing a degree of traditional restraint. In 1827 he took a risk which was to be widely deplored, forswearing political correctness in order to paint from his own uninhibited fantasies. Sardanapalus, in Byron's play of 1821, merely gives an order that destruction is to take place, whereas Delacroix chooses to enact it. In 1827, the date of the picture, Victor Hugo published his *Preface to Cromwell*, with its famous defence of the fusion of the sublime and the grotesque. A well-meaning stranger, per-

ceiving not incorrectly that Delacroix had attempted precisely this fusion, congratulated the artist on being the Victor Hugo of painting, whereupon Delacroix replied, with the utmost firmness, '*Vous vous trompez, Monsieur, je suis un pur classique.*' The rest of his career was devoted to justifying this pronouncement.

Delacroix achieves another form of political correctness by disguising his own conflicts behind the conflicts of his chosen subjects, so that the violence he depicts may seem little more than the violence of history. Certain historical episodes serve to explain the shock of the images, their tilting viewpoint, their absence of definition. Shakespeare, Dante, Byron are responsible, as are Rubens, Rembrandt, but also Constable, Lawrence, Bonington. By incorporating influences such as these Delacroix shelters behind the example of others. In the same way he proclaims his independence from classical standards and from the purity of the classical ideal. His resolute modernity is manifested in every picture painted before 1848, when, as he wrote in his *Journal*, he buried his former self, with his hopes and dreams for the future. Immolation as a form of contrition is Delacroix's outstanding characteristic. Yet it was only after 1848 that he achieved epic stature, although his early works are better known. Without the shock reaction to his *Sardanapalus*, which was widely deplored, Delacroix might never have made the transition to maturity that is so evident in his later work.

As a young man he was easily influenced. The *Journals* for 1822 and 1824 describe the excitement he felt when he visited Gros and Géricault. He began his career within recognizable limits: *Dante and Virgil Crossing the Styx* of

1822 is strongly influenced by Géricault's *Raft of the Medusa* of 1819, while *Scenes from the Massacre at Chios* (Fig. 30) is an orthodox composition of interlocking triangles, with a nod to David's Camilla in the *Oath of the Horatii* (Fig. 15) in the slumped body of the girl in the foreground. Stendhal, reviewing the Salon of 1824, reported a certain lack of authenticity, which he explained by the fact that Delacroix had not witnessed the massacre himself but had merely read newspaper reports. Stendhal plainly saw Delacroix as a feeble civilian, or as one who did not have the benefit of a military background. But a military background is not necessary if one is mainly concerned with victims. When the victim takes precedence over the hero it may be a positive advantage to be a thoughtful bystander. All this rigorously built composition lacks is the requisite lesson of stoicism, a stoicism which Delacroix, in time, was to make peculiarly his own.

The genesis of the picture is interesting. There is something slightly unusual about its subject, which is a fictionalized account of an episode in the Greek Wars of Independence. The Greek revolt against the Sultan of Turkey began in 1820, and Delacroix's picture commemorates an incident in 1822 when 20,000 Greeks were massacred on the island of Chios as a reprisal for recent Turkish losses. It is an orthodox and politically correct statement of pity and sympathy, and its good intentions are not in any doubt. But it is more than this: it is a work of discovery which inaugurates many enthusiasms beyond the range of David, or Géricault, or even Gros. Delacroix's picture is on the scale of a Rubens; more specifically it is modelled on certain Rubensian examples. But it is in handling that the picture

is so resolutely modern, for it has a richness of colour and a softness of glazes that Delacroix learned from the English painters Bonington, with whom he briefly shared a studio, and Constable, whose *Hay Wain* he saw in Arrowsmith's gallery and again in the Salon of 1824, after which he is said to have made adjustments to the sky of his own picture. The luminosity of the sky in *Chios*, the horse's mane, the turban of the Turk, and the nude torso of the girl are of a lightness of key that bears witness to the lessons he learned from the English painters, Bonington in particular. He was thus the first to glimpse the potentialities of the *plein air* technique that was to gain momentum until it became a matter of serious study later in the century.

Delacroix's youth was, like many a lesser person's youth, suffused with enthusiasm and anxiety. His mother was a Riesener, a member of the illustrious family of eighteenth-century cabinet-makers; his father, according to a rumour reported by Edmond de Goncourt in his *Journal*, was Talleyrand. A comparison between Prud'hon's portrait of Talleyrand in the Musée Carnavalet and Nadar's photograph of Delacroix in middle age would seem to bear this out; the resemblance is too striking to be ignored. Family prudence would undoubtedly have prevailed in this matter, which was never elucidated. As a young man Delacroix seems to have gone out of his way to establish other credentials. A determined modernist, he was also something of a natural dramatist, drawn to Shakespeare, to Byron, to Walter Scott, all of whom were newly discovered to be superior to the rule-ridden French. Too young to be acted upon by the legacy of Napoleon, Delacroix was open to sympathies of a world order. The forms of distress he chose to chronicle are

in fact universal; they absorb Delacroix's own anxieties without quite managing to defuse them. Thus the artist becomes prime mover in an orgy of feeling, without quite needing to show his hand; he is very clearly on the side of the angels. The distress of Gros, of Géricault, was undisguised. Delacroix rarely departs from a form of universality which is more worldly, but more distant.

This tone is also noticeable in the *Journals*. After the disorders of youth, when he worries whether or not to pursue his models, Delacroix gives evidence of increasing gravitas, so that the entries of the 1850s might have been written by a man in serene old age: Mozart, country walks, and solitude are praised; Berlioz, Courbet and Millet deplored. This is maturity; it may also be compromise. The disastrous reception of the *Sardanapalus*, its even more disastrous self-exposure, were to have a profound effect. Wholehearted sensuality was, in the opinion of the critics, an uneasy accompaniment to pity for the innocent victim. The *Sardanapalus*, they claimed, was a great and terrible bonfire, a poem of destruction. But the picture, as Baude-laire, Delacroix's champion, almost revealed, is not about destruction but about ennui, about the inability to respond no matter how extreme the stimulus. Sardanapalus remains unmoved by the beautiful nude women imploring him for mercy. He is impotent. Delacroix's future career was to be built on a refutation of all possible indictments: impotence, sadism, diabolism . . . '*Vous vous trompez, Monsieur, je suis un pur classique.*'

This later, more mature form of Romanticism reaches its singular climax in *Liberty Leading the People* of 1831 (Fig. 33), Delacroix's only other excursion into the battlefield of

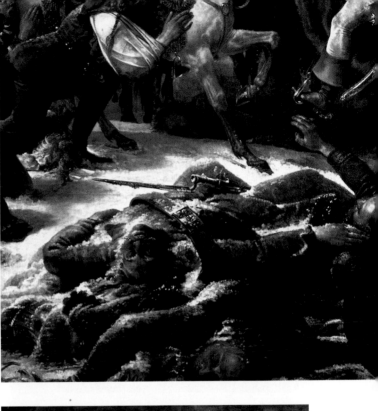

11. Gros: *Battle of Eylau* (detail)

12. Géricault:
*Cavalry Officer
Charging* (study)

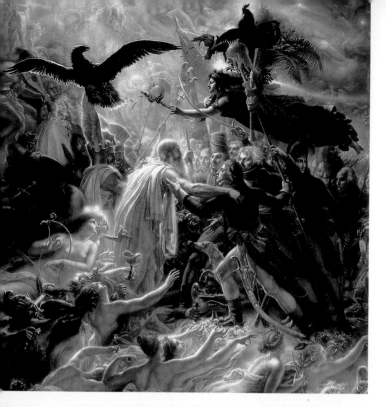

13. (*Left*) Girodet:
*The Shades of the
French Generals
Received by Ossian*

14. (*Below*) Gros:
Battle of Aboukir

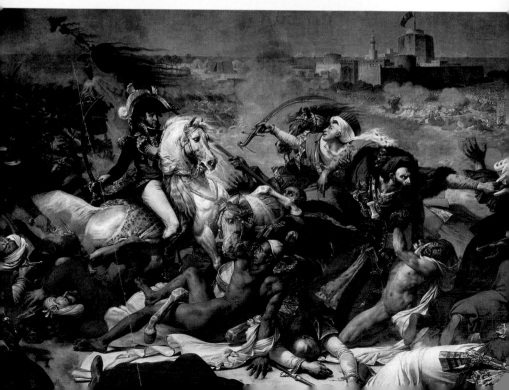

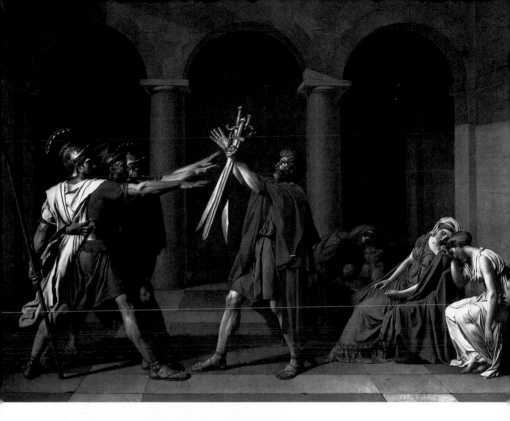

15. (*Above*) David: *Oath of the Horatii*

16. (*Left*) Manet: *Musique aux Tuileries* (detail)

17. Delacroix: Drawing for *Death of Sardanapalus*

18. Delacroix: *Tiger Attacking Horse*

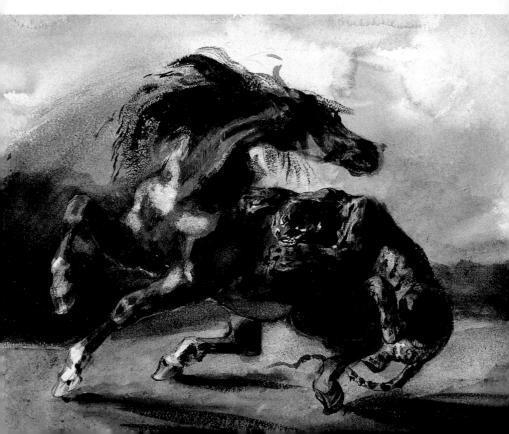

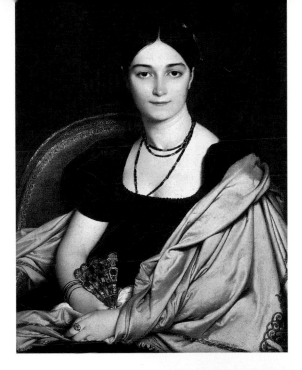

19. Ingres: *Mme Devauçay*

20. Ingres: *M. Rivière*

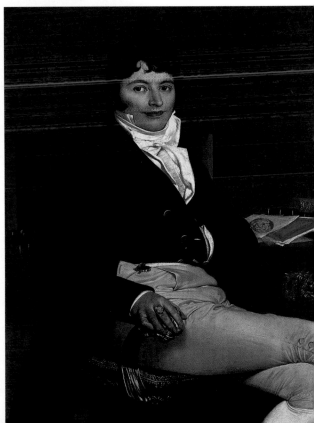

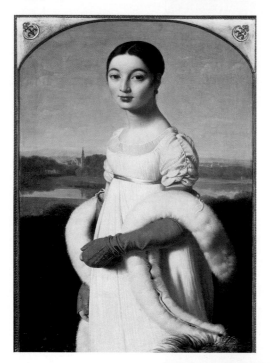

21. Ingres: *Mlle Rivière*

22. Ingres: *Comtesse de Tournon*

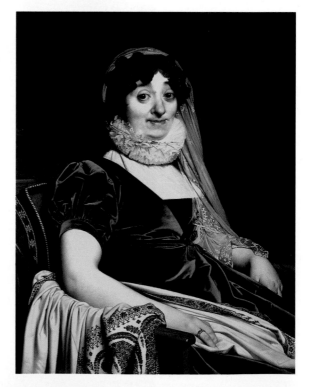

23. Ingres: *Mme Leblanc*

24. Ingres: *M. Leblanc*

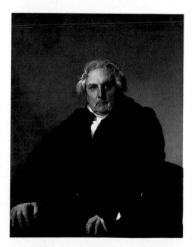

25. Ingres: *M. Bertin*

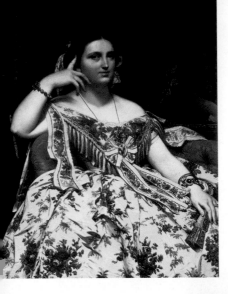

26. Ingres: *Mme Moitessier Seated*

27. Ingres: *Napoleon as Emperor*

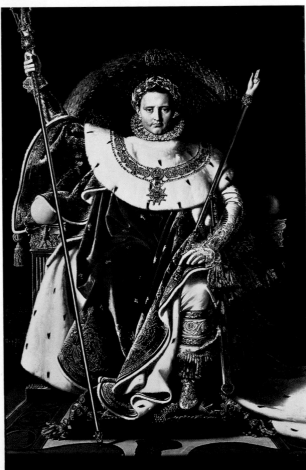

modern life, and his only major work on a contemporary Western theme. It takes the Baroque step of combining real and allegorical figures, much as Rubens did – in itself a bid for two kinds of approval. Yet the picture represents a curious compromise. It is a picture with a message, one which relies far less on beauty of pigment or charm of detail than the *Chios*. Instead of a serene blue sky there is a smoky haze, broken only by the red, white and blue of the tricolour. The foreground figures are very obviously modelled on Géricault's studies of the dead and dying, which Delacroix had been able to see, while the figure of Liberty, with her quasi-Greek profile, is a compendium of Michelangelesque attitudes. The elegant yet nervous figure with the musket is, or may be, Delacroix himself, striking a blow for freedom, or, to use a Romantic word, liberty. His stance, however, is irresolute. Liberty exhorts him directly, but he is remote, wrapped up in some personal conjecture. In fact, while upholding the theory of Liberty, Delacroix is not sure whether he can face the strains of translating this theory into concrete terms, a painful, laborious, and disillusioning process known to all revolutionaries. Even David, for all his Jacobin fervour, knew the same moment of doubt during his imprisonment for having shown a mistaken zeal in his support of Robespierre. Delacroix goes further. In addition to his own moral complexity he appears to wonder whether the struggle is in fact desirable, for the figure in the centre of the picture, and overshadowed, seems to be pleading with Liberty, an action completely out of line with the forward surge of the revolutionary force, which he attempts to delay.

In one sense Delacroix's life is devoid of incident. The

torments and satisfactions of the artist have replaced atten-
tion to outside forces. He never married, and apart from his
housekeeper, Jenny, no woman appears to have featured in
his life. Nor did he undertake the painter's almost obligatory
journey to Italy. He went instead to England, as Géricault
had done before him, to Algeria and Morocco, and to the
Low Countries. Much time elapsed between these excur-
sions, of which the most significant was the journey to
Morocco in 1832, when he joined the delegation of the
Comte de Mornay to pay a six-month diplomatic visit to
the Sultan. This semi-official appointment, to be followed
by others of far greater weight and significance, might
reinforce the rumours about Delacroix's paternity, for he
was, in a way which might otherwise seem mysterious, to
accede to various government commissions which may
have been unexpected in view of the *Sardanapalus* scandal.
The journey to Morocco facilitated both renewal and
greater emancipation from the standards still prevalent in
the studios and in the Salon. The spectacle of the Arab and
Jewish worlds had the effect of freeing him from the last
lingering memories of Davidian classicism. As he said, rather
defiantly, 'Antiquity is at my door; I've had a good laugh at
David's Greeks and Romans.' In Delacroix's vocabulary
antique meant unspoilt, and in his hosts he found something
not only unspoilt but colourful, dignified, melancholy, and
with the kind of impassivity that he himself was beginning
to prize.

These are the characteristics so brilliantly captured in *Les
Femmes d'Alger* (Fig. 31), or women of Algiers in their
quarters, which Delacroix obtained special permission to
visit. Baudelaire found this picture heavy with a weight of

moral sadness, as if the women, admittedly reflective, were expiating the original sin of sex. Baudelaire's interpretation may be justified in one sense, but sex and sin were his bitter preoccupation, as opposed to Delacroix's, which were light and colour. He was to reject Baudelaire's accolade with some hauteur, as he was to reject all attempts to make clear his intentions. These were to remain his alone, and were fiercely guarded.

The most obvious influence of the Moroccan visit was the supply of Moroccan themes which lasted Delacroix until his death. Seven volumes of drawings were compiled, of the Sultan reviewing his troops, of a Jewish wedding, of dervishes, of Arab horses. One picture of the Sultan, Abd-el-Rahman, was painted thirteen years later, in 1845; another dates from 1862, thirty years after the visit and a year before Delacroix's death. The brilliant sunlight of the landscape, and the dim but highly coloured gloom of the interiors, affected his colour scale. On the one hand the outdoor scenes have a silvery-yellow, almost Veronese light, while the interiors have a suffused reddish-gold tonality deepened by blues and greens. Within the scope of this visit, Delacroix developed a full Baroque colour range, and all his figures in his later works have dark features and a pronounced Moroccan physiognomy.

The search for happiness, which Stendhal decided was entirely possible, has been rejected, has been replaced by the consolations of art. In the first and heroic phase of Romanticism it was possible to believe in personal fulfilment, if only in reduced circumstances. In the second and disillusioned phase the world is regarded as a vale of tears; as Baudelaire declared in the crucial *Salon* of 1846, '*Nous*

célébrons tous quelque enterrement.' ('We are each of us attending some funeral or other.') Baudelaire's pessimism was not to Delacroix's taste; when applied to his pictures he saw it as dangerous misrepresentation. His temperament, which was notably aristocratic, deplored plebeian expansiveness. For this reason he fails, or omits, to explain himself in his *Journal*, and, by an irony which he himself did not appreciate, became known through the rapturous excesses of Baudelaire's criticism. On these, apart from one deprecating letter, Delacroix declined to comment.

This refusal to descend to the level of the crowd, this fastidiousness and reticence, were necessary to contain, almost to imprison, the limitlessness of the pictorial imagination. While retreating into a polite version of himself, Delacroix permits his colours to become warmer, harsher, with a typical tonal contrast of reddish-yellow with a deep blue-green. Visitors to his studio found the heat almost tropical, the painter himself unaffected by it. In his middle and later years, Delacroix escapes from the strains and challenges of contemporary life into a past nearer to his own refined taste, nearer in fact to Shakespearian tragedy than the fantasies by which he had earlier been captivated. Scenes of myth and legend come to predominate, and while the technique becomes warmer and more broken, the handling more unconventional, the subject becomes more respectable, taken either from literature or from history. And if these subjects are in a sense more predictable, less personal, there is a far greater and deeper pathos, as if to compensate for the painter's withdrawal behind a screen of reticence, almost of unavailability. The pathos is now in the paint, remote from outside contingencies. The artist has become his own

world, and in a sense his own monument. From this stand-point, interpretation – let alone the excited interpretation of Baudelaire – is indeed an irrelevance.

The *Capture of Constantinople* (Fig. 34), exhibited in the Salon of 1841, depicts a crusading knight dispensing Christian mercy, much as Napoleon was to exhibit in the fever hospital at Jaffa. The picture illustrates the taking of Constantinople by Baudouin, Count of Flanders, in 1204: that is to say in the fourth crusade. Various citizens come forward to beg for the Conqueror's compassion. A Romantic subject, therefore, with the double attraction of an exotic setting and medieval armour and costumes. Yet there is not a trace of Romantic fustian about this picture, for Delacroix has based his style on the example of the great Venetians, notably Titian and Veronese. In addition he had paid a visit to Flanders in 1838, and in the group of women he has included direct quotations from the pictures by Rubens he could have seen in the Brussels gallery. Compared with the *Massacre at Chios* of 1824, a picture on an identical theme of conquest and subjugation, significant changes have taken place. The first, a greater mastery in the handling of a large composition, is fairly obvious. The *Chios* was built on an orthodox classical system of interlocking triangles, whereas the *Constantinople* is as audacious as any Venetian altarpiece. A great Baroque artist has emerged. Delacroix has kept faith with the past, but not the past of David. He looks now to the past which produced the major European masters, a category in which he hopes to be counted.

The second difference is one of colour. Most of Delacroix's easel pictures have either faded or darkened and no longer give a true idea of their original impact. The *Chios*,

for example, now has a kind of Brescian coolness, a coolness which must have increased over the years. But the *Constantinople* shows a deepening of the colour scale which has worn rather better, with saturated blues and greens and deep golden flesh tones. There is another difference, one of morality. The Turkish horseman of *Chios* is represented as a conqueror; in spite of Delacroix's slightly divided sympathies it is clear that one side has won and the other lost. But the conquerors of *Constantinople* are seen *contre-jour,* their faces are in darkness. Compared with the physical presence of their victims they have a ghostly funereal quality. When the features of the leading horseman, the Count of Flanders, can be distinguished, they are seen to be those of Sardanapalus. Sardanapalus destroyed to satisfy his vanity and to confound his ennui. The Count of Flanders's spectral impassivity implies that he anticipates no such release. This represents the Silver Age of Romanticism, an age of disengagement, of a disillusionment no less profound than that experienced by those earlier *enfants du siècle,* but with the compensations of a protective colouring, almost an identity, which confers a different status, the confidence that comes with the authority of a greater, more European, indeed more universal, tradition.

By the 1840s Delacroix's style was out of date. The new direction in art was to be pointed by the realism of Courbet and Millet, a realism with which Delacroix could not come to terms. According to Baudelaire, whose article on Delacroix in the *Salon* of 1846 added immeasurably to the painter's reputation, and who repeated many of his conversations with Delacroix, which he noted like an ardent reporter, a picture should reproduce the artist's world, not

copy that mundane world which is common to us all. Nature is merely a dictionary: the artist's task is to synthesize the elements into a whole not available to those who merely follow the words. The slightly pompous style and tone of these remarks indicates that Delacroix could have been as prestigious a teacher as Ingres, had he so desired. He had neither the taste nor the time for such a calling, for the rest of his career was monopolized by a number of official government commissions for which he was obliged to work in a traditional decorative style. These commissions – surprising for one who had earlier been reprimanded for faults against good taste – began in 1833 and were to occupy thirty years of Delacroix's working life. They were on a vast scale: the Salon du Roi and the Library of the Palais Bourbon, the Library of the Senate, the Galerie d'Apollon in the Louvre, and the Salon de la Paix in the Hôtel de Ville. With the exception of the Hôtel de Ville, which burned down in 1870, all still exist, and are little known. They represent the highest point of Delacroix's career, and demonstrate the ease and brilliance with which he worked in a classical setting, superimposing his free translation of the Baroque style on to the awkward shapes and spaces with which he had to contend.

Having started to paint on such a scale Delacroix realized that such public exercises, should he be successful with them, would be his greatest claim to immortality. The iconography in all cases is classical, and comfortably so, for the former Romantic has become something of a reactionary; raising his voice against the concept of progress, he is at pains to demonstrate that true science is in fact philosophy, and not the race for material advancement, and that

philosophy itself may be a lesser goal than art. In his decoration of the Library of the Senate Délacroix envisages an apotheosis of great men, but his great men are predominantly poets, who rank side by side with Greek and Roman rulers. Homer is there, and so is Hesiod. Suffused with an extraordinary intensity, in common with his other official commissions, Delacroix has created his own Elysium, without the benefit of dogma (always a dubious advantage) and with only the consecrated figures of secular legend in sight.

In comparison with the early works, with the *Chios*, the *Sardanapalus*, the *Liberty*, the artist of the 1850s is more sober and more traditional. Lingering errors of taste have disappeared, the implications of defeat and humiliation have been swept out of sight. Delacroix's decorative work, with its wide classical and philosophical background, seems to have been produced by a man of profound maturity, of great learning, of fastidious taste far removed from the exorbitant and revealing fantasies of *Sardanapalus*. It would be pleasant to picture Delacroix as serenely above the struggles of his youth, struggles which were those of Romanticism itself, and it is true that he had to a considerable extent overcome the excesses of those years. His *Journal* at this time contains long descriptions of solitary country walks, of evenings listening to Mozart, whom he considered superior to Beethoven, of discourses on style which would not disgrace Boileau. He had become a recluse, and in a discreet way a fanatic, using the same literary sources and researching more carefully into the compositional patterns of the earlier masters, Rubens, Veronese, and Titian, even Tintoretto, who are the inspiration behind his last and greatest official commission, the decoration of the Chapelle

des Saints-Anges in Saint-Sulpice, now blackened and barely visible. These pictures of angelic intervention are far too big for their constrained setting; the angels appear as demi-gods, their free and untrammelled movement representing superhuman as well as otherworldly force. Yet there are signs of intimacy. In the scene of Jacob wrestling with the angel, there is a still life in the foreground of Jacob's water-bottle that just avoids pathos. That other detail, of the caravan of animals and servants being sent off to Esau, represents Delacroix's last Moorish fantasy.

Painted between 1857 and 1861, these images strike an almost surreal note in the sophisticated setting of Paris's sixth *arrondissement*. They represent an epic of creativity in a man already weakened by a tubercular infection of the throat, justifying in more ways than one the adoration that Baudelaire had expressed, notably in the *Salons* of 1846 and 1855 and in the obituary, which Baudelaire himself was almost too sick to expand. Terminally exhausted, he quotes himself at length, yet terminal exhaustion is appropriate, for this is an obituary not only of Delacroix but of Romanticism as well. That was how Baudelaire saw it, although his account was partial; in a sense he was writing his own obituary as well.

Delacroix died in 1863, after a long illness during which he prepared his palette every day. He had no followers or pupils to speak of. His art died with him, and of his tremendous *œuvre* only Baudelaire professed to understand the salient characteristics, Baudelaire who underlined Delacroix's aristocracy of intellect and feeling, his universal competence, his self-absorption, his melancholy, and, above all, the peculiar quality of his Romanticism. Baudelaire, like so

many others, makes an honourable attempt to define this elusive entity, and his pronouncement has a certain finality: '*Le Romantisme ne consistera pas dans une exécution parfaite mais dans une conception analogue à la morale du siècle.*' ('Romanticism will not consist in a careful execution, but in a conception analogous to the moral climate of the times.')

But definitions of Romanticism proliferate in Baudelaire's *Salons*. More apposite is his definition of beauty: '. . . *quelque chose d'ardent et de triste, laissant carrière à la conjecture*' ('. . . something ardent and sad, leaving the field free for conjecture'). This is certainly applicable to Delacroix, whose brooding images bequeath a disturbed impression of disharmony and disquiet. Delacroix, again according to Baudelaire, expresses much of modern man's dilemma, notably the melancholy of an exile in an imperfect world. Dispossessed of easy certainties, Delacroix lived a stoical life, which was to impress the slightly younger man as ideal in itself, apparent calm disguising irrepressible impulses, those impulses sublimated into images which retain something of the remoteness of the psychological journey they have been obliged to make.

Delacroix regarded Baudelaire as a man haggard with illness and doubt, certainly a nuisance; this was the opinion of many. He further dismissed his interpretations as dangerous intrusions. He did not return Baudelaire's unstinting compliments. There is no sign of his having read and appreciated *Les Fleurs du Mal*, although a letter of 17 February 1858 acknowledges the copy which Baudelaire sent him. Yet the two men are linked by the exceptional quality of their imagination, and the high value they placed on such an endowment. For that reason Baudelaire was and is

allowed his excesses, and his moral and emotional subtleties. The conjunction is also a tragic one, the sick Baudelaire merely tolerated by a man who had been protected by various important and discreet government agencies almost from the beginning of his career, before he had had time to give a full account of himself. But '. . . *quelque chose d'ardent et de triste* . . .' is certainly the most memorable description of Delacroix's style. Despite their differences in background and outlook it is as two great pessimists of the age of progress that they resemble each other, and in so doing attain an heroic status which their successors will be unable to emulate.

True Romanticism consists in deploying all the resources of the *moi*, and setting them down before a public not always willing to admire or even understand them. In this sense Baudelaire is an obvious Romantic. But Delacroix, in his paradoxical wish to retreat from the public gaze and to let his pictures seek out that gaze with undeniable insistence, is also a Romantic, one who may have seen the dangers of self-exposure but who embraced those dangers with a solipsism entirely in keeping with the exalted self, '*puissant et solitaire*', like Vigny's Moses. This ultimately tragic destiny, of which Delacroix's pictures are a true mirror, exhausts the resources of a period without true heroes. The resultant life is sterile, without progeny. The work of the imagination is more powerful than it would otherwise have been for that very reason. By 1863, the date of Delacroix's death, such beliefs were no longer admissible. The future, in order to become a future, would have to embrace other modes. But Romanticism exerted a hold on the century that was not to be entirely forgotten. Traces remained, survived, persisted.

If disciples were few, followers can be clearly detected. The phenomenon of Romanticism continued both to fascinate and to remain unresolved.

It was perhaps fortunate that Delacroix was not concerned with the future. He had accomplished his task, and even his mission, which was to take his place in the pantheon of great artists who had established the European tradition, giants of universality whose lineage can be easily descried. Baudelaire paid Delacroix the compliment which the painter may have welcomed: Delacroix, he said, was an essential link in this chain, which had to be understood as the painter's birthright. Without him there would be a fatal gap. It was as a spectacle of greatness that Delacroix primarily existed for Baudelaire; how Delacroix viewed himself it is difficult to imagine. It seems that he accepted his gifts as part of his *métier*, and his confidence was not misplaced. There is no evidence of creative exhaustion in his last work; very much the opposite. He accepted too the need for a correct non-committal persona as a necessary component of an oceanic imagination, and acceded instinctively to a way of life that made work his outstanding priority. One of Baudelaire's observations may have pleased him: his classical dependence on a text, to which he gave an essentially pictorial interpretation. From being the boldest, the most instinctive of the Romantics Delacroix had evolved into the most solitary, the most unapproachable, and in a curious way the most hierarchical artist of the nineteenth century. He was at all stages of his career rather too much to take. Even his admirers found it difficult to agree on the terms on which he should be assessed.

The exception was Baudelaire. Baudelaire, like Dela-

croix, was not concerned with the future of art. Both men had a vested interest in prophesying its decline, but they did so from a truly genuine position of native greatness. Both speak contemptuously of younger painters, with their conspicuous lack of literary and philosophical background. To Baudelaire, Delacroix was the civilization that was threatened by the champions of realism. In comparison with those men, Delacroix represented the values of the *ancien régime*. Revolutions, if revolutions there had to be, should take place out of sight, should be expressed through colour, through brush-strokes, through an exalted if mournful understanding of the past.

Baudelaire, in his obituary, does not return to a premiss that had incurred the earlier displeasure of Delacroix: namely that Delacroix was the painter of moral sadness. Possibly this was a dangerous line to pursue, yet looking back on the gallery of disasters that Delacroix chose to paint, looking back to so relatively uncomplicated a date as 1838, when Delacroix, setting out to paint a double portrait of his friends Chopin and George Sand, produced the image of desolation that is the lesser-known half of the canvas, now divided, one may be tempted to share Baudelaire's view, or at least to accept it as valid.

In 1863 such pessimism was no longer attractive, for in that year a new chapter opened in the history of French painting. The Salon des Refusés was inaugurated; Manet became the man to watch. Yet of the two events of that year, the opening of the Salon des Refusés and the death of Delacroix, it was perhaps the death of Delacroix that ensured the most decisive break with tradition and the inevitability of complete and drastic change.

6

Ingres:
Art for Art's Sake

Gautier, heroic survivor, and perhaps Romanticism's most durable representative, wrote his *Histoire du Romantisme* as a sick elderly man with a failing heart. It was published in 1872, the year of his death. More than a lament for Romanticism's ebullient early years, it is a lament for his lost youth, at an epoch when the Romantic generation, the generation of 1830, was seen as a historical phenomenon. Everyone was young, he broods, as in Napoleon's army of Italy. It is interesting to see that this image persisted into the nineteenth century, though that army would have looked askance at the army that attended the first night of *Hernani*, on 25 February 1830. Its general was Gautier, his uniform a rose-pink doublet, light grey trousers with black velvet bands down the seams, a moiré ribbon round his throat, and shoulder-length hair, which he wore long for the rest of his life. He was reputed to have seen the play forty times, and no doubt loyally joined in the roar of approval when the famous enjambment, or irregularly stressed couplet, was heard. The melancholy he felt when discussing these early years, when he had already received warnings of his own death, is readily understood.

Less picturesque, perhaps, was his own working life as a harried journalist, reviewing everything that could be

reviewed, handing each page to the typesetter as soon as it was finished. Indeed one of Gautier's triumphs is to be remembered not simply as a hack but as the '*poète impeccable*', to whom Baudelaire dedicated *Les Fleurs du Mal*. For real connoisseurs of Romantic anguish his poems, even when elegiac, are too optimistic, his novels too exhaustively picturesque. His famous facility with words, those phrases which fall on their feet, was his undoing as a critic; he was never less than enthusiastic, but he must on occasion have been bored.

His approach to art was one of almost automatic reverence, and he spoke with authority. His was the art of the word picture, the *transposition d'art*. He was famously a man for whom the exterior world existed, and it is precisely his eye which causes him the least trouble. An uninterrupted view of the world, a delight in its sensuous pleasures, enabled the artist he genuinely was to join the critic he was destined to be. Art, he was in no doubt, was, or should be, an artist's major preoccupation. He applied the term widely, but with less anxiety than did his contemporaries.

Yet Gautier was not always so generously eclectic. Nor did he ever forsake his belief that Art survives, and will even survive the destruction of civilization: '*Le buste/survit à la cité.*' This is not Art as consolation, so much as confirmation. Art, indeed, is an autonomous entity, as enclosed and as self-justifying as a parallel universe. Above all, it is not necessary to ordinary existence. In the preface to his novel *Mademoiselle de Maupin*, he states that although man is manifestly incapable of self-improvement, Art represents transcendence. This idea persists throughout a ranting attack on everything contemporary, particularly the newspapers to

which he was to spend his life contributing. Critics can only criticize; artists proceed in another fashion, even if the utility of their works is not perceived. '. . . *un drame n'est pas un chemin de fer . . . on ne peut pas se servir d'une antithèse pour parapluie.*' ('. . . a drama is not a railway . . . a couplet cannot be used as an umbrella.') True beauty resides in what is useless, with the proviso that only the superfluous is necessary. Sardanapalus, in his search for pure sensation, is a true artist. He is thereby an elitist, just as the companions of Gautier's youth, the friends who forged the collusive ideal of Romanticism, were elitists. Art, the essential non-essential, was the antithesis of progress. Art, as envisaged by Gautier, lies somewhere between intention and desire.

Despite his generous tributes to Delacroix in his various Salon reviews, the artist who comes nearest to Gautier's conception of Art, the Art that will survive the city, is, paradoxically, Ingres. Ingres represents an absolute, an ideal, as Robert Snell has described it in his fine study of Gautier as a critic, of self-sufficient form. He thus stands outside the Romantic debate; he is not in favour of fusion, of the subversion of accepted canons. Rather it is his respect for these canons, and for authority, which give him a timeless classical stature, to which he adds those appetites which impart a thrill of sensuality to his most ideal forms. The painter was a majestic presence; Gautier, tiring rapidly, perceived this when he visited Ingres in his studio. In hale old age Ingres seemed to him to be in a fair way to outliving the city. In 1857, ten years before Ingres's death, Gautier saw his painting of *La Source*. It satisfied him both as a man and as an artist, a virginal nude with mature proportions, as real as a woman and as chaste as an ideal.

The Goncourt brothers also saw this picture, and in 1862 noted in their *Journal* what they thought of as an absurdity. They found it overworked, slick and stupid, and worse, no longer of its time. 'A woman's body is not immutable. It changes with civilizations, with epochs, with climates. A body of Phidias's time is no longer representative of ours.' There speaks a nervous and unhappy sensibility, repelled, as Baudelaire had been, by the confrontational assurance of Ingres's approach, his world view. Opinions continue to be divided between approval or worship, and the distaste of those whose appetites are less robust. In 1867 Edmond de Goncourt saw what he describes as a *Bain antique*, the harem picture known as *Le Bain turc*, which includes a nude portrait of Ingres's wife, and described it as a group of savages from Tierra del Fuego . . . primitive, like the earliest exercises of art. He also disliked the drawings ('wretched'), but in 1885 confessed that he had no respect for Ingres, adding that he had none for Delacroix either.

Respect was the reaction that Ingres most appreciated, and which he most often received. He felt it justified in the light of his own respect for authority, tradition, and the ideal. Art for Art's sake is as much his platform as it is Gautier's; unlike Gautier he was consistent in its application. Like Delacroix, Ingres believed in the apostolic succession of the great artists of the past. For Delacroix these were Rubens and Titian; for Ingres, Raphael above all, and Poussin. He was therefore able to admire David, whose pupil and assistant he had been, and for a brief moment he can be seen as a Romantic. His portrait of his friend Granet, smiling with delicious certainty against a background of thunder-grey sky, and his portrait of Paul Lemoyne, boldly

dishevelled, hirsute, and unaccommodating (Frontispiece), are his contributions to a putative *petit-cénacle*, that small church of the elect whom Stendhal delineated, the ideal society of which one's young years are composed, before characters are fully formed and native dispositions harden. It is possible to regard Ingres as a Romantic even in his classical disguise. It is even possible to doubt whether that Romanticism was ever fully brought under control. When Gautier saw the portrait of *Mme Devauçay* (Fig. 19) in 1855, he was almost shocked by the portrait's attack. The sphinx-like sitter is as compelling and as challenging as life itself, or rather as *la saveur amère ou capiteuse du vin de la Vie*, the essence, according to Baudelaire, of modern heroism.

Mme Devauçay dates from 1807, when Ingres, born in 1780, was still a young man. She is as like and as unlike David's female portraits as it is possible to be. David's female sitters do not have impeccable complexions; their dress is fashionable but not timeless, as Mme Devauçay's contrives to be. There can be no doubt that a different approach has imposed itself on the naturalism of David. It is clear that the image of Mme Devauçay would survive the city, as it would survive Mme Devauçay herself. This assumption of permanence is enough to justify Delacroix's '*jalousie haineuse*', as noted by the indispensable Edmond de Goncourt. In the first half of the nineteenth century this assumption of permanence represents a fundamental innocence. Ingres in fact continues that strain of almost angelic naïveté – Baudelaire's *impeccable naïveté* – which he inherits from the eighteenth century; he believes, as did the eighteenth-century reformers, in perfection, in perfectibility, and in the infinite potential for improvement of human material. To

grow old in his belief, as Ingres did, to defend purity in the knowledge of your own and the world's impurity, takes a conviction on which time will have only an imperfect hold. Hence the magnificent complexity of the mature and late Ingres. The heads of his sitters become crowded with thought; they are more complicated, as is the artist, but the heroism of meticulous posing and presentation, the assumption of perfection, and the desire to put the spectator at his ease, to assure his equilibrium, remain.

A drawing by Ingres will demonstrate that sublime control which he thought to be the obligation of the true artist. This control might be thought to be Parnassian if there were any evidence that Ingres was aware of the theories abroad in literary circles. He himself said that he read nothing but Homer, and although this can hardly be true it is difficult to imagine him conversing with writers and poets, although he came into contact with them in the salon of the Princesse Mathilde, in the rue de Courcelles. The paintings of Ingres will also be contained within a bounding but unseen line, so that objects are limited, do not merge into one another. Delacroix will work his unease into his paint; backgrounds will be unclear, energies diffused, poses in movement, usually of a despairing kind. The great achievement of Delacroix will be to sublimate his own predicaments into a sort of free-floating anxiety. There are no comparable fail-safe mechanisms in Ingres. Ingres was known to rage and weep until he found the exact place for everything on his canvas, but once that intellectual problem had been solved his anxiety was removed and the picture could be easily finished. What he presents is the ultimate solution, not the tentative or existential doubt, and with

this solution a triumphant balance, so that the spectator is literally becalmed into tranquillity.

If Delacroix represents the liberal conscience, with its absence of conviction, Ingres is a man of the centre who acknowledges authority in every form, whether it is that of the gods of Greece, the senators or philosophers of Rome, Napoleon, Charles X, the Trinity or the Mother of God. His borrowings are not concealed, for he venerates archetypes: thus his *Vow of Louis XIII* is an undisguised tribute to Raphael and Philippe de Champagne. His *Apotheosis of Homer* (Fig. 35) was exhibited in the Salon of 1827, the Salon in which Delacroix showed his ill-judged *Sardanapalus*. The contrast could not have been more striking. The *Homer* is a key work, a manifesto of everything in which Ingres believed. He believed in the superiority of two great artists in the history of mankind: Homer and Raphael. He believed that as these two men had achieved perfection it was not only legitimate but advisable to copy them. The pedigree of art demanded no less. Therefore he was able to invest a subject like the *Apotheosis of Homer* with a sense of serious aspiration which raises it from the dust it might otherwise have gathered.

He sets out a kind of Tree of Jesse, showing Homer, the godhead, with his offspring and descendants, and he casts the subject in a School of Athens pattern. This is his sole adventure into Romantic fusion of the genres. But there is no grotesque here, as there would be in any true Romantic enterprise; on the contrary, all is sublime. Homer sits enthroned, with the two beautiful figures of the Iliad and the Odyssey at his feet. In this group on the left the two most prominent figures are Apelles and Raphael, rep-

resenting true excellence. By the same token Virgil presents Dante. They are surrounded by the most famous of the Greek poets, philosophers, and sculptors. Also at the bottom left Tasso and Shakespeare, Poussin and Corneille; at the bottom right Racine and Molière, Boileau, Longinus, and Gluck. It is a picture loaded with improving images, making no concession to illusionism. Ingres's own particular kind of naïveté seems to have considered anything less than frontality to have been a sort of trick, and therefore disreputable. The fact that the work was commissioned as a ceiling was not sufficient to shake his convictions. He had decided to show his hand. This was to be his unalterable procedure in everything he undertook.

Delacroix's *Femmes d'Alger* was the fruit of a visit to North Africa, and is therefore authentic, and authentically mature. It is interesting to compare it with a similar subject by Ingres (comparisons between the two men were and remain inevitable): the *Odalisque à l'Esclave* of 1839 (Fig. 36). Both are works of great emotional complexity. Ingres, of course, had no opportunity to go to Morocco; one rather imagines he would have ignored such an opportunity had it presented itself, since Rome had precedence over all other pilgrimages. The décor of his picture is therefore pieced together from various fragments and is correspondingly lifeless. The nude, however, is a real odalisque, sensual and unapologetic. The animality and the ennui of this figure triumph over the cardboard accessories which carry no emotional weight.

In the Delacroix this process takes place in reverse. The women are essentially décor, the impression is unified. Whereas the point of the Ingres is one superlative physical form, the point of the Delacroix is conveyed entirely by

colour, and by a feeling of lassitude which was thought accurately to convey the reality of women imprisoned in their traditional quarters. For Ingres the arrangement seemed quite satisfactory; his odalisque is equally bored, but she is also compliant. As far as colour is concerned Ingres has far more in common with the decorators Percier and Fontaine than he has with any obvious tradition of painting. It is significant that he only brings colour to any kind of fullness in his portraits, as if the physical stimulus of the model were too keen to be ignored. In imaginary or transitional compositions, which take place in some kind of ether, colour dwindles in importance, almost vanishes. It is the striking impact of a woman's shawl or a man's collar which inspires him. Nothing could be more palpable than the outer garments of those ardent personalities, *M.* and *Mme Rivière, M. Moltedo, Mme Devauçay*, whose black dress echoes her hypnotic stare, *M. Marcotte, Mme de Tournon*, until some kind of apotheosis is reached in *Mme Moitessier Seated*, who nevertheless dominates her dress with the (borrowed) authority of a figure from Herculaneum.

What makes Ingres particularly interesting is the fact that his devout and rigorous persona is allied with a singularly sanguine temperament, the sort of temperament that makes his female nudes too plump, too passive, the sort of temperament that is beguiled by decoration, by hair, by jewels, by contemporary dress. Hence the paradox that Ingres is in many ways more up to date than Delacroix, who throughout his life dispenses the pessimism of an earlier generation. Delacroix, by exhausting his own idiom, left nothing to be handed on, whereas the tradition of Ingres could be and was passed down to numerous descendants. Ingres, however, painted

with no eye to the future; his conscious attention was drawn wholly to the past. His artistic ancestry is entirely straightforward. A man of the south, like Gautier, he had been brought up in his father's studio to copy statues and engravings. Gautier, who had been an art student, could appreciate the discipline. The world, for Ingres, had no political dimension. Only the demands of Art were permitted.

By the time of his first visit to Rome, in 1806, he had already reached maturity. The portraits of the Rivière family, astonishing formulations of wealth, beauty and connoisseurship, were executed in 1804–5. The engraving of Raphael's *Madonna della Sedia* on M. Rivière's table (Fig. 20) may or may not be the painter's invention, although M. Rivière was known to be something of a collector. Mme Rivière, still in Empire dress, may be made to conform to the oval format of the picture's canvas and frame, but within it she impresses us as being as plump and malleable as the blue velvet cushion on which she rests her arm. Their daughter, Caroline (Fig. 21), who was to die the year after her portrait was painted, is herself not devoid of physical appeal; her thin arms are eclipsed by her acid yellow gloves, while a white fur stole meanders round her virginal body, indication of the fullness to come. This was not to be. But whereas a lesser painter might have suggested the nature of her illness, which was presumably tuberculosis, might have suggested any form of illness, Ingres has preferred to give her an air of radiant serenity. Only the slightly exaggerated volume of the head with regard to the body gives some idea of a maturity that was both promising and deceptive.

The portrait of *Mlle Rivière* did not find favour with the critics, much to Ingres's surprise and disappointment. He

could not understand why it should earn the pejorative comment of 'Gothic', for there was nothing specifically Northern in his conception, apart from the conceit of the river landscape, a play on the name of Rivière. There is even a suggestion of Leonardo in her ineffably comprehensive smile. In fact the whole portrait is the extremely sophisticated reworking of diverse influences in a shockingly original formula. Delacroix was fond of scoffing at Ingres's limited intelligence, by which he meant the narrowness of Ingres's education. But Ingres possessed, over and above the conventional and obedient execution of his large-scale commissions – the *Vow of Louis XIII*, and the *Apotheosis of Homer* – an intelligence of the senses which discerns the plastic possibilities in every form, and their susceptibility to that final improvement that Ingres will devise for them.

His formal portraits are entirely undenominational: men are as beautiful as women, and all have a singularity that attests to Ingres's keen perception of the physical. This held no problems for him, brought no mournful or melancholy associations, no indication of the end to which all flesh must come. This astonishing fervour, the belief in the gifts of the body, is applied to faces which must have been less perfect than they appear in Ingres's portraits. This was not merely a compliment; it was an article of faith. The *Comtesse de Tournon* (Fig. 22), a lively ugly old lady with suspiciously dark hair (probably a wig), hides her double chin behind an elaborate ruff which also disguises the slightly sagging contour of her right cheek. The curve of *Mme Leblanc*'s breast (Fig. 23) is discreetly indicated by her serpentine gold necklace, while *M. Leblanc*'s watch chain outlines his bulk in just such a flattering manner (Fig. 24). When Baudelaire

complained that such portraits made him feel ill he was probably oppressed by their relative lack of aerial perspective. By deliberately positioning his sitters in the front plane of the picture Ingres seems to be insisting on their physical presence, their physical allure. There is no dispersal of vital energies, such as that employed by Delacroix. It is literally impossible to imagine what Delacroix would have made of M. *Bertin* (Fig. 25) had he been given the commission. Ingres was no less a despot than M. Bertin. It was a quality he appreciated, and he brought to it an objective understanding. Bertin might be an Ingres self-portrait. A comparison of the two faces shows surprising similarities.

The Bertin portrait dates from 1832. By 1835 Ingres was in Rome as Director of the Académie de France à Rome, a prestigious appointment which reflects the painter's growing fame and undeniable stature. Though critics might still express reservations, and while those reservations distressed the surprisingly thin-skinned painter, none could deny his unswerving, almost Olympian confidence. He was confident enough to give orders that his works were not to be exhibited at the Salon in his absence. In that way he could give his full attention to his official duties, and to his students. His immense reputation as a teacher did not stand in the way of precious friendships, both intimate and ephemeral, which he commemorated in the form of portrait drawings intended as gifts. It is as a compendium of friendships that these drawings should be appreciated. Direct and convivial, they are additional evidence of Ingres's spontaneous appreciation of character and appearance. But only in paint would they achieve their final majesty, for informality was thought to be unworthy of the public gaze.

The most dramatic simplicity pertains only to the portraits. More confected subjects, many of them taken from classical prototypes, present a rather airless appearance. A picture brought back from Rome to Paris, and exhibited with great success in the Salon of 1840, the *Stratonice* (Fig. 37), disconcerts on many levels. One expects a large austere composition in Davidian colours; the subject was in fact selected as one of David's Rome prize entries. It is a favourite eighteenth-century theme: the young Antiochus laid low by a mysterious malady which the doctor, Erasistratus, diagnoses as a guilty passion for his stepmother, Stratonice. Based on at least two recognizable compositions by Poussin and by Greuze, the image has been reduced to something virginal and withdrawn. The isolation of Stratonice, based on a Greco-Roman figure of Pudicitia in the Vatican Museum, was so attractive to Ingres that he was to use it again in his portrait of *Comtesse d'Haussonville* (Fig. 38), where the pensive head and the bent arm suit the sitter rather better. The colours of the *Stratonice* are, however, bizarre. Stratonice, in lilac, stands in front of a column scarlet to mid-height. There is a scarlet bed cover, blue drapery on a chair; the bed curtain is green, and the doctor wears blue. The key pattern in the foreground is gold and buff; on the right it is red, white, and black. The herm is plum to mid-height, with a gold palm, blue ribbon, and red and blue decorative frieze. The whole picture is conceived in solid blocks of local colour, free of reflections or complementaries, free of light, conspicuously free of air. Ingres's practice was studio-bound. Even the famous drawings were probably transcribed in the studio from sketches made on the spot.

If one can discern an influence in this retrograde exercise it is from contemporary architects, from Baltard and from Hittorf, who based his entire aesthetic position on the fact that the architecture of the ancients was coloured, and who produced numerous occasional buildings to illustrate that fact. One of the most popular, the Cirque des Champs Elysées of 1833, had yellow columns, blue mouldings, and bas reliefs on a red ground. Outside stood a statue by Pradier on a green base. The actual architectural forms of the *Stratonice* are based not directly on antique models but on the more colourful contemporary view of antiquity proposed by Hittorf. The bed almost exactly reproduces the portico of another café in the Champs Elysées, now known only from an engraving. Perhaps the nearest extant comparison is with the portico of the church of Saint Vincent de Paul, near the Gare du Nord, which was taken over by Hittorf in 1831 and finished by him in 1844.

Ingres, the *grand bourgeois*, finally found himself at home with the bourgeois taste of his later years, and this collusion is taken to great heights of achievement in the portraits of the 1840s and 1850s. These magnificent icons, airless, almost unshaded, pushed up against the very front of the picture space, show the sharpness of focus of the painter's eye, his love of the harsh colours of contemporary fashion, his perennial desire for perfection. Nowhere is this more apparent than in his two portraits of *Mme Moitessier*, the 'beautiful and good' (and extremely patient) sitter for his two supreme celebrations of plastic form. *Mme Moitessier Seated* (Fig. 26) in her almost unimaginable dress, was commissioned in 1844, sketched in by 1848, abandoned in 1849, resumed in 1852, abandoned again in 1853, taken up again in 1854,

and finished in 1857. The standing portrait, on the other hand, was completed in six months. The gesture of the upturned hand, in the seated portrait, was taken from a wall painting at Herculaneum, which Ingres knew from an engraving, probably in one of the volumes of antiquities, by Caylus, or by David and Maréchal, which he learned to copy in David's studio. Its hyperreal precision, the apparent inevitability of the pose, and the immaculate execution, bear witness to the strange idealism of the painter's outlook, as keen in his increasing age as it had been when he painted the Rivière portraits in 1804–5. A natural and all too human sensuality has been sublimated into something rarer: Mme Moitessier, both seated and standing, retains a mystery from which all accidents have been removed. She is both human and superhuman, and the spectator immediately accepts the fact that she can impose this dichotomy without strain, almost without ambiguity. This is classicism brought to life by a painter still obedient to his Romantic instincts, so far removed from the morbid stresses of his contemporary, Delacroix, that it is easy to give credence to the latter's '*jalousie haineuse*'. If it is possible to speak of flamboyant perfection then the term is apposite here. Predictably, Gautier approved.

Two late fantasies remained. The first, and arguably the most important, was the ambitious decorative scheme commissioned by the Duc de Luynes for the château of Dampierre, which Ingres worked on from 1843 to 1850 and then abandoned on the death of his wife. Two vast frescoes were to contrast the Golden Age of pagan antiquity with the miseries of the modern machine age: *L'Âge d'Or* and *L'Âge de Fer*. The task of executing two enormous panoramas,

five metres high and six and a half metres long, defeated him; the second was never started. This was a strange commission, unsuitable in view of the fact that Ingres was at his best with the single figure, and was probably a tribute to the painter's great prestige rather than a realistic assessment of his powers.

The Golden Age (Fig. 39) has been called an altarpiece to the cult of antiquity. Ingres imagined a pastoral age very different from the world occupied by his Homer in the earlier ceiling of 1827, a featureless zone in which the inhabitants lead a restrained but purely vegetable existence. As a fantasy it is beguiling, resolutely unscientific. As he said, his pagans toil not, neither do they spin. They live on the fruits of the earth and die painlessly. If this is compared with Delacroix's view of antiquity, in his exactly contemporary decoration of the Luxembourg, in which the ancient world is represented as a place of striving and illumination, the full force of Ingres's lack of abstract imagination can be felt. Yet the Ingres passed into the language of nineteenth-century painting through the medium of Puvis de Chavannes and Gauguin (who had his own vision of a pagan paradise). The Delacroix did not.

Ingres called the denizens of his Golden Age '*un tas de beaux paresseux*': at this stage of his life languor was an appreciable commodity. He was to continue to work hard, apparently impervious to age. His final vision of some other kind of paradise is the *Bain turc* (Fig. 40), which was so disliked by Edmond de Goncourt. One can almost understand the reasons for Goncourt's distaste. This is less a fantasy than a wholehearted tribute to the delights of the flesh, in which his plump naked wife figures prominently. The

picture has impeccable antecedents. It was inspired by an account by Lady Mary Wortley Montagu of women's baths in Adrianople. The second edition of her letters, the edition which Ingres almost certainly knew, was published in French in 1805. Again Ingres has gone back to his sources, to the extent of reproducing one of his own famous figures, the *Valpinçon Bather* of 1808. Only a man at ease with himself is so faithful to his origins. The Adrianople described by Lady Mary Wortley Montagu is completely absent from this almost brutally alive representation. We are in France, even in Paris, a Paris colonized by the painter's own appetites. Again the discomfort of airlessness and lack of shading, but over and above that the discomfort caused by the frankness of the painter's interest in this dense group of unrelated figures giving out an aura of something more complex than erotic availability – erotic wistfulness, perhaps – revealing retro-spectively the power that had exercised him in all his under-takings, a love of the physical world and its treasures, to which his own response would never fail him.

Ingres died in 1867, four years after Delacroix, and in a sense their antagonism died with them; they did not bequeath it to the next generation. In 1867 Baudelaire also died, and perhaps it is fitting to see this great triumvirate as the last representatives of a great formal tradition, allied to the concerns of antiquity and the challenges of the present. The next generation was to open the doors of the jealously guarded studio to let in light and air, or even to abandon the studio altogether. The legacy of the past was resolutely laid aside. After the deaths of Ingres and Delacroix the board was swept clean, ready, as Zola had said in his *Salon* of 1866, for the genius of the future.

Ingres began his career as a young man and continued to paint into relatively old age. The astonishing *Napoleon as Emperor* (Fig. 27) dates from 1806, when Ingres was a comparatively untried twenty-six-year-old; he was seventy when he painted Mme Moitessier. In the years of his maturity he progressed from the simple frontality he had learned as a pupil and assistant of David to an ability to turn the figure in a shallow space, so that whereas his early works still bear the imprint of the primitivism propagated by his fellow students, the *barbus* and the *primitifs*, who exalted line engravings after Greek vases as the highest good, he can endow his later sitters with an almost conversational availability as they lean forward or back, while fixing the spectator with a gaze that cancels space altogether. In major official commissions, like the Dampierre frescoes, he returns to the planimetric construction which he considered classical, and the effect is *retardataire*, perhaps deliberately so.

His spatial effects, or lack of them, were always severely criticized: the *Napoleon* was castigated as Gothic or Oriental, while many later critics took exception to Mme Moitessier's reflection in the mirror behind her sofa. Ingres was to remain extremely sensitive to criticism; he was to protest his good intentions, to vow secretly to do better. He was aware of faults, but not always of faults of taste. The *Turkish Bath* is perhaps a compendium of those faults, underlined by the uncertain recession of the over-explicit figures. Whereas Delacroix provoked responses which were in all cases violent, whether admiring, in the case of Baudelaire, or detracting, Ingres was regarded with some misgivings. Was he the supreme master of line, as Gautier asserted, the inheritor of the classical tradition, or was he some sort of

Romantic, as Gautier also asserted? In which case could he conceivably be both?

If, as Baudelaire averred, Romanticism was '*l'expression la plus récente, la plus actuelle du Beau*' (and '*actuelle*' should be understood as up to date), then there is no difficulty in admitting Ingres to the Romantic camp. It was perhaps harder to arrive at the definition than to classify the painter in any other way. In any case, by the 1860s, the term was purged of its original combativeness. There were to be no more first nights of *Hernani*. And Ingres had, in the course of his career, been responsible for so many wonderful distortions, and such unabashedly erotic fantasies, that he could hardly be included in the opposite camp, although, like Delacroix, he would no doubt have averred that he was '*un pur classique*'. In comparison it is Delacroix who appears to have had the more Romantic temperament, while Ingres impresses as a man of his time, with eyes open enough to concede that life is not always best understood through the medium of literature. The bull-necked youth had become patriarchal, genial. More important, he accepted his pictures as representative of a certain outlook, largely benevolent, wholly appreciative. The eager tone of his letters to Mme Moitessier bears this out. Finally he was not a man for definitions. Art was not only above definitions. Art was above everything.

Public opinion, having conceded that Ingres was a great painter, remained uncertain as to his status. Not so the critic Thoré, who in 1846 stated categorically: '. . . M. Ingres is the most Romantic artist of the nineteenth century, if Romanticism is an exclusive love of form, an absolute indifference to all the mysteries of human life, a scepticism

in philosophy and politics, an egotistical detachment from all common and shared feelings. The doctrine of art for art's sake is, in effect, a sort of materialistic Brahmanism that absorbs its initiates, not into the contemplation of the eternal but into an obsession with palpable form.' Gautier could not have put it better. Few visitors to the exhibition of Ingres's portraits at the National Gallery in London in 1999 would have denied the artist his superior rank in the hierarchy of art. Many were to come away awed and impressed by the full force of his genius. The doctrine of art for art's sake would not have been uppermost in their minds, but most would have agreed that he was a Romantic of an unusual kind, idealistic but confident, and easily contented with his life, his world. The concept of Romanticism as disappointment is almost negated by the career of Ingres. Yet commentators such as Thoré and Gautier claimed him for Romanticism. The only distinction now to be drawn is between Romanticism and the Romantic Movement. The Romantic Movement can now be relegated to the past (though in 1872 Gautier was still keen to celebrate it). Romanticism as a more expansive, even more inventive phenomenon still had many years left to run.

7

The Brothers Goncourt:
The Breakdown of Joy

The work ethic, as personified by Gautier and advocated by Zola ('*Allons travailler*'), did not eliminate '*pauvre moi*', which found a refuge in the novel, in Sainte-Beuve's *Volupté* (1834) and Fromentin's *Dominique* (1863), to take but two examples. And who would deny *Madame Bovary* (1857) her Romantic status, even if Flaubert had devised his own punishment for her, as if to demonstrate what could become of Romanticism in the wrong hands? '*Madame Bovary, c'est moi,*' he famously exclaimed, and he suffered physically when describing her death, as if the symbiosis were altogether too close for comfort, and as if it were a matter of dignity, in keeping with his status as an artist, to distance himself from her expectations.

Then there are the novels of the brothers Goncourt, case histories of ennui and disenchantment, written in a deliberately 'artistic' style which elevates the authors, if not their subjects, above those more naïve or expansive writers whose guilelessness falls below the relentless perfection of the true artist. To the Goncourts should be awarded much of the admiration that has accrued to Flaubert, not for their famous '*écriture artiste*', which in fact wearies the reader, but for their unflinching pessimism which cannot quite conceal a sorrowing outlook: the obverse of Romantic ebullience.

Instead of the friendships which Gautier remembered with such enthusiasm from his early days, the brothers Goncourt had only each other for intimate company, and when Jules, the younger brother, died in 1870, Edmond's gifts as a novelist all but deserted him. He was left with his *Journal*, and those Magny dinners which are but a late manifestation of the reunions, the solidarity, and the genuine fraternity of a generation still eager to impose itself and its values on society in general.

That they too were largely out of date seems somehow fitting. The pictures the Goncourts describe in *Manette Salomon*, their novel about artists, of 1868, lag far behind the Manets, Monets and Pissarros currently on view in Paris. But their very inability to move with the times is also characteristic, as if they were constitutionally incapable of envisaging a future, any kind of future, as if their youth had died too quickly for them to understand that unfulfilled promise is usually illusory, and as often as not quite harmless. For Nature, which they abhorred, they substituted Art; only in the fortress of Art were they in safe-keeping. At the funeral of Jules de Goncourt the congregation watched in horror as Edmond's hair turned white. It seemed a sign of some sort, a manifestation of exhaustion which nothing could repair. As it proved to be.

The brothers Goncourt, who were to all intents and purposes one soul and a single writer, were also a prime example of the ills that can afflict the professional man of letters. Well born and well off, they were in the perhaps difficult position of having no obligations, no need for an official position or salary, yet possessed of inordinate ambition. Their ambition was quite simply for recognition,

or perhaps more than that, for homage; the literary world was to acknowledge their pre-eminence. That they were distinguished and yet minor writers they could never accept. That they were on reasonably close terms with all the giants of the day, notably Turgenev and Zola, bedevilled the position even further. Zola they dismissed furiously as their pupil, although there is a world of difference between the great coarse energies and the social indignation of Zola and their own subdued and clinical pity. Disappointed in their lifetime, and yet unshakeably convinced of their own superiority, they wrote in defiance of the public's appetites, and instead of the capacious novels to which French tastes had been trained by Balzac and Flaubert, they produced miniatures, classic studies of 'cases' which they analysed as if they were doctors, eminent specialists, instead of the seasoned hypochondriacs they never ceased to be.

In one case the hypochondria was not misplaced, since Jules, the younger and more brilliant of the two brothers, died horribly of syphilis. The account which the elder brother, Edmond, kept of his decline is one of the most painful passages in the chronicles of suffering, and it was followed, in 1870, by the Prussian siege of Paris, which added starvation to the grieving survivor's miseries. Small wonder, then, that the novels written by Edmond alone, after his brother's death, lost something of that flair and tact that characterize the six novels which they wrote in conjunction before Jules's decline.

The brothers would be mortified to know that the modern reading public registers the name Goncourt as the title of a literary prize awarded in France in November of every year, and elevates the *Journals* above their more

important contributions to literature. They wished to be remembered as writers, as novelists and playwrights, and the fact that they had only a limited success, and that their efforts were overshadowed by Zola, and even more astutely by Huysmans, irritated them profoundly. In the preface to a late novel, *Chérie*, of 1884, Edmond refers to a conversation that he had with Jules before the latter's death, in which the two brothers discussed their eminence and their posterity.

Now the pursuit of truth in literature, the resurrection of eighteenth-century art, and the triumph of things Japanese – these are the three great literary and artistic movements of the second half of the nineteenth century, and we have initiated them, we two poor obscure writers. Well, when you have done all that, it is difficult to avoid being *somebody* in the future.

All these claims could be refuted, and indeed have been. The eighteenth century and the Japanese fashion were both popular and did not lack celebrants, dealers and amateurs alike. The novels, however, remain, and the Goncourts were correct in perceiving that they were innovative. They claimed that they had invented the working-class novel, yet they did not write with the intention of being read by the working classes: very much the opposite. They saw themselves as applying an altogether superior sensibility to the mute lives on which they trained their considerable intelligence.

They were animated by the great mutual love for one another that sustained them in their isolation from the rest of society, and by the training they had received as painters, which enabled them to train a scrupulous eye on to certain phenomena of the day. They were by nature collectors,

bibliophiles, antiquarians, yet they became connoisseurs of certain pathological disorders, which they observed, notably, in the uneducated classes. They were also ferocious determinists, who believed that a quirk manifested in childhood, a path wrongly chosen, would lead inevitably to madness or disgrace. Their tastes took them to sale rooms and print shops, yet they manfully descended into the abyss of charity hospitals, working-class funerals, cheap eating-houses and dance-halls, the studios of unsuccessful painters, the compositors' rooms of popular newspapers, and all the milieux that would enable them to document themselves on their chosen quarry.

The six novels written in conjunction by the two brothers before 1870 are characterized by great unfamiliarity; but rather more than the effect of novelty what is conveyed to the reader is an immense sadness. Henry James, reviewing one of these novels, decided that they were marked by 'the simple breakdown of joy'. The Goncourts are the most extreme case of lives lived, or perhaps unlived, for art. They learned about the martyrdom of art from their friend Flaubert, with whom they dined regularly, as did Henry James, Daudet, Turgenev and Zola. These Magny dinners are described in the *Journals*, and the striking thing about them is how frequently the conversation turned to ills of the flesh, as if writing led to melancholia of a particularly morbid nature. The Goncourts were, as they proudly claimed, particularly distinguished martyrs, or monsters, in their chosen line of duty.

Their contemporary, Paul Bourget, described this latter quality as lack of moral energy, or '*affaiblissement de la volonté*'. It is in fact a tardy manifestation of *le mal du siècle*,

or to use a more precise Romantic definition, *le mal de vivre*. The Goncourts belong to the school of sick Romanticism, Romanticism as disability, whereas their contemporary, Zola, personifies Romanticism as energy. They suffered for their scepticism, but they also cultivated it, so that in 1863 they were able to state, '. . . no cause is worth dying for, any government can be lived with, nothing but art may be believed in, and literature is the only confession'. In a letter to Flaubert, dating from October 1866, Jules de Goncourt states, 'We three, with Gautier, form the entrenched camp of art for art's sake, of the morality of beauty, of indifference in political matters, and of scepticism with regard to the other nonsense, I mean religion.' More revealing, in a letter to Zola, Edmond writes, 'Our entire work, and this is what constitutes its originality, is built on nervous illness.' In the *Journal* for 23 March 1878 comes Edmond's most striking claim: 'The critics may say what they like about Zola, they cannot prevent us, my brother and I, from being the St John the Baptist of modern neurosis.'

That modern neurosis is scrupulously described in an unsuccessful early novel, *Charles Demailly*, a crude attempt to satirize a contemporary journalistic milieu, in which one of the characters, the Charles Demailly of the title, is a serious writer, with serious sensibilities, who eventually goes mad.

Charles was impressionable to a supreme degree. He had an almost painfully sharp sensitivity to everything in life. Wherever he went he was affected by his reactions to the feeling of the place. He could discern a scene, an argument, in a house where smiles were on every face; he could sense what his mistress was

thinking when she was absolutely silent, he could feel in the atmosphere the hostilities of his friends, he could sense good or bad news in the walk of the man coming towards him. And all these perceptions, which had something of presentiment about them, were so strong that they were almost unconscious. A look, the sound of a voice, a gesture would speak directly to him and reveal what they managed to hide from everyone else, so much so that he envied from the bottom of his heart those fortunate souls who go through life without seeing any more than they are meant to see and who maintain their illusions to the end.

Objects had a great effect on him, were as eloquent to him as people. They seemed to have a physiognomy, a voice, and that mysterious uniqueness that creates sympathy or antipathy. These invisible atoms awakened an echo in Charles. A piece of furniture would reveal itself as friend or foe. An ugly glass would put him off an excellent wine. The colour of a paper, the material covering a chair, would affect him both for the better and the worse, and his mood would change along with his impressions. For this reason pleasure never lasted, because his demands were too great. The spell was quickly broken. A false note in either a sentiment or an opera, an ugly face, even an insolent waiter, would be enough to cure him of a caprice, an admiration, or an appetite.

This nervous sensitivity, this continual battery of impressions, most of them unpleasant and shocking to his delicate sensibility, had made of Charles a melancholic. Not a melancholic such as one finds in books, full of heroic phrases, but melancholic as befits a man of the world, with wit. Irony was his way of consoling himself, an irony so impalpable that sometimes he was ironic for his own sake, for the pleasure of his own secret laughter.

In the last lines of that description can be seen a certain nostalgia for the Romantic hero, the dandy, the superior man disabused by the follies of his world. But the earlier sentences do something to conjure up the painful sensitivity of two men who were without illusions, without that euphoria or that tonic energy that would have enabled them to bear their melancholia with a certain amount of philosophy. The illusionless world of the brothers Goncourt is one of sublime perception without any relief from that perception. They are disturbing company, which may be one reason for their continued decline.

Those who make claims on the future are generally unhappy in the present. The brothers Goncourt laid down their lives not for any ideal, which would have absorbed their sympathies, but for art, and not merely for art, but for their art. They lived like two dignified mandarins, looked after by their housekeeper, Rose Malingre, comfortably accepting their prejudices against foreigners, Jews, politicians, and modern art. When they went out it was to visit antique dealers or auction rooms where they amassed their superlative collection of eighteenth-century French drawings, bronzes, prints, and bibelots; or to shops specializing in goods from the Far East, such as La Porte Chinoise or the Galerie Byng. They preferred to live in the past, in that fantasy eighteenth century which they described in *L'Art du dix-huitième siècle*, or in remote civilizations which were another form of fantasy. And yet they were drawn to the present, for which they undertook another form of pilgrimage. Paradoxically, enthusiasm serves them badly. The style of *L'Art du dix-huitième siècle* is inflated, almost hysterical, whereas a passage from any of the novels reveals a sober

conscientious distaste which serves their reputation infi-
nitely better.

Their development is authentically Romantic. Their
father had been a general in Napoleon's armies; he retired
with a pension after Waterloo and died in 1834. Their
mother lived until 1848, by which time Edmond had reluc-
tantly embarked on a career at the Ministère des Finances.
With the death of their mother came an inheritance which
was to keep them comfortably for the rest of their lives.
Jules, who appears to have been the more sympathetic of
the two, wrote to a friend, Louis Passy, 'My mind is made
up; I shall do absolutely nothing.' Both agreed to devote
their lives to art and letters, although their decision to
be the writers they were eventually to become was not
spontaneous.

Jules had a talent for watercolour; both had received
some instruction, and in 1849 they embarked on a tour of
France as aspirant artists. They got as far as Algeria, no doubt
stimulated by a late Romantic enthusiasm for that country,
or perhaps by the example of Delacroix. From this journey,
and from one made to Italy in 1855, date a number of
attractive watercolours, precise and highly coloured, and
not noticeably amateur, but back in Paris, Jules, who was
trying to complete one of these and not succeeding, jotted
down, with his brush, a description of what he was trying
to paint, and this highly significant transposition marks not
only the inception of the Goncourts' literary career but the
explanation of their literary method. It is a prolongation of
Gautier's *transposition d'art*, an essentially plastic and chro-
matic approach to the use of words, and it leads to the cult
of the word picture at the expense of narrative drive and

even of continuity. The Goncourts were aware of this and took some pride in it. Their incipient career as painters signified to them a right to speak on artistic matters with as much authority as other painters, and infinitely more than most critics.

They defined their particular prose style as '*écriture artiste*', and when Edmond wrote his book describing his collection of works of art in his villa at Auteuil, he entitled it, not, as one might expect, *La Maison d'un collectionneur*, or *La Maison d'un amateur*, even less *La Maison d'un homme de lettres*, but *La Maison d'un artiste*. Curiously enough, contemporaries saw no significance in this, which may explain the note of grievance struck so continuously in the prefaces and the *Journal*.

Their literary career took some time to get under way. They were beguiled by the theatre and spent far too much time writing plays, some of which were produced but none of which were successful. They made their début as art critics with reviews of the Salons of 1852 and 1855. Art criticism was increasingly viewed as a *métier* for the non-professional, almost a vehicle for solipsism, but even as solipsists the Goncourts were hardly up to the task. They were deeply uneasy in the presence of great art, were unable to rise to Delacroix or to Ingres, preferred the small, the intimate, the appealing. Their favourite artist was Gavarni, whom they elevated to heroic status. Modern art, they claimed, would or should be a mixture of Gavarni and Rembrandt. It is surely instructive that the artists who became their friends were men of inferior capabilities, such as Gavarni, Raffaelli, Helleu. In the *Journal* the great painters of their own time, Manet, Monet, Degas, are spoken of

slightingly, or simply referred to as social acquaintances.

Their most important books, with the possible exception of *La Maison d'un artiste*, were all written before the death of Jules in 1870. This somehow leads to the conclusion that Jules was the greater writer of the two, but in fact the mental processes of the brothers were so close, and the experience of Jules's last illness so shattering, that Edmond's life was reduced and maimed by it, and although he continued to write novels these are sparsely worded and lack conviction. Whatever the explanation there can be no doubt that the books written by the two brothers before 1870 are very brilliant indeed. One of their triumphs was the study of certain eighteenth-century painters and engravers, misleadingly entitled *L'Art du dix-huitième siècle*, which was published as a series of monographs between 1859 and 1875, and brought out in book form in 1880. The second and more durable of their triumphs was the series of novels to which the words Realist, Impressionist and Naturalist were later attached.

These novels are six in number: *Charles Demailly*, which deals with the disastrous influence of a stupid woman on a writer of great promise; *Sœur Philomène*, the story of a nun who works at the hospital of La Charité; *Germinie Lacerteux*, the story of a servant – their servant, in fact – and her descent from virtue into vice; *Manette Salomon*, the story of a group of painters and their misfortunes; *Mme Gervaisais*, perhaps the finest; and *Renée Mauperin*, the story of the decline of a bourgeois family.

In their different ways these novels are deeply original. Although they have a strong story line they are not written in straight narrative form. The subject is attacked in a series

of descriptive passages of mounting brilliance, which is a severe test of literary skill, but a literary skill based on a highly developed visual sense. *Manette Salomon*, which has a complex cast of characters, consists of 155 short chapters, some of which deal with people, some with objects, some with landscapes or interiors. It is a style which demands total passivity from the reader and demonstrates in no uncertain manner the Goncourts' desire to impose, to impress, to convince of their artistry. It may at times force the note of sheer brilliance. On reading certain chapters of *Manette Salomon* one may wonder whether the Goncourts were not their own victims, martyrs to fine writing, particularly when one remembers that before sitting down to grind out, first separately, then in collaboration, such effects, they had spent the day in the field, taking notes for their descriptions of charity funerals, working life at its most sordid, operations and diseases of all kinds. An evening walk along the Boulevard de Clignancourt might yield a punch-up between two drunks; in addition it formed a useful counterpoint to their visits to antique dealers, and their skill as collectors contributed to their skill as writers. Their genius is for description, whether of a work of art, or of an aspect of contemporary life. The same method is used for both phenomena, and although they might prefer the one they were drawn to the other, recognizing in a sad but determined fashion their duties as heroes of modern life.

In the preface to *Germinie Lacerteux* the Goncourts claimed that they had brought something new to the novel, that they were the first to write objectively about the working classes. This is in essence true, but they could never accept the fact that there were bound to be imitations and

adaptations of their method. When Zola's masterpiece, *L'Assommoir*, appeared in 1877, they accused him of plagiarism. When Zola wrote *L'Œuvre*, they pointed out that he had copied their *Manette Salomon*. There was a similar disagreement with Huysmans. But although the Goncourts' method was to be a standard one, their style, perhaps fortunately, proved inimitable. The principle behind this *écriture artiste* is the use of uncommon or unfamiliar words, which will automatically lift the meaning out of the popular category and impress upon the reading public that the authors are rare spirits addressing themselves to those who are similarly endowed. Thus the novels are deliberately circumscribed in their appeal, and the authors manage to be more prominent than their characters. The mutation of artist into aesthete is in fact under way.

One could make alternative claims for the brothers Goncourt, less ambitious but no less valid than the ones they made for themselves. They wrote at least two impeccable novels, and it is worth remarking that the novels have none of the combative character of their prefaces. Together they provide a remarkable example of the amateur, researching and writing and collecting for no more sinister reason than an extraordinary sense of duty. Although they professed to believe that Romanticism was dead, there is something eminently Romantic about their own ennui. It is perhaps unusual to find the Romantic search for compensation diverted to such ends, but there is no doubt that work – and they were eminently hard-working – had the ability to change their rancour and loneliness into authentic energy. In *La Maison d'un artiste* Edmond confesses to a '*tendresse presqu'humaine pour les choses*'. But it was their well-disguised

tendresse for those of their fellow creatures whom they were able to observe from something of a distance that distinguishes them not only as writers but as fellow sufferers as well.

Manette Salomon, the novel about artists, is, properly speaking, about the loss of youth. It bears a strong superficial resemblance to Mürger's *Scènes de la Vie de Bohème*, except that the Goncourts have condemned their characters to an unrewarding end, and that love, friendship, human emotion, are dire and dangerous elements that can never compensate for the comfort of a well-run life. The hero, or anti-hero, is Anatole, drop-out, poor painter, entertainer, and the most sympathetic character the Goncourts ever invented. Anatole's endless clowning has something theatrical about it; he is the element of continuity in what is essentially a collection of episodes. The official hero is Coriolis, a languorous and sensitive painter of Creole origin, whose spirit is gradually broken by the exigencies of his mistress, the beautiful Jewish model Manette Salomon. Manette's crime is to demand marriage from her lover and to import a number of her relatives into his house, thereby forcing Coriolis to turn his hand to painting of low degree in order to support them all.

Two of Coriolis's paintings are described in some detail, and they demonstrate how defective the Goncourts' understanding of contemporary painting really was. *Le Conseil de révision* and *Un Mariage à l'église* are sentimental anecdotes writ large. They prove that the Goncourts could only work close to the object, whether that object were a snuffbox or a funeral. They were anatomists, clinicians, whose expert gaze was not devoid of compassion. The despair is discreet

but pervasive. Life is seen as a determinist conspiracy to which all must submit. The scene describing Anatole's search for his former companions is deeply affecting. He is no longer a student; he is a man of thirty-nine who has never grown up. The Goncourts possess a very un-Romantic superiority; they appear never to have been young.

Yet they are reminiscent of those early sufferers, Vigny and Musset, in more ways than one. Whatever seriousness they brought to their endeavours did not eliminate a characteristic sadness which seems to have been born with the century. Just as they remained in so many ways baffled and disappointed by their own times, incapable of turning their affections outwards, incapable of Zola's hearty embrace, so the refinement of their sensibility was to lead in some mysterious way to an empathy that was without parallel. Flaubert empathized with Emma Bovary but he denounced her, and dealt with his own affection for her by treating her cruelly. The Goncourts never commit this particular solecism. A feeling for the dispossessed is seen to co-exist with a love of objects from which all life has fled; both are necessary. The facts, *le vrai*, were beginning to overtake *le beau*. Zola would accelerate the process, thereby replacing the tender refinement of the Goncourts' finest writing with an enthusiasm which swept away minor or even major distinctions of temperament, and all in the name of a life force of which he made himself the mouthpiece. The Goncourts had no such pretensions. Life, as they saw it, held few virtues. Yet ineluctable life drew them to celebrate it in the only manner available to them: in writing.

Their gifts are best demonstrated in their inconspicuously virtuous novel, *Germinie Lacerteux*. (They would balk at the

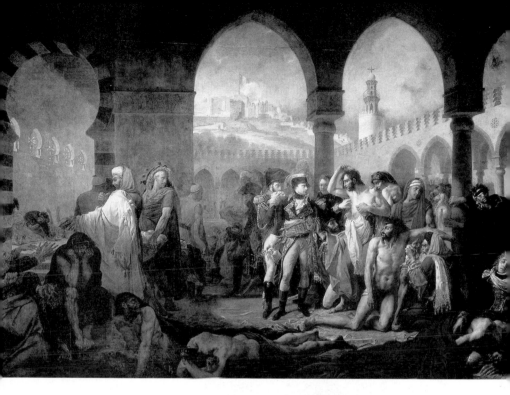

28. Gros: *Napoleon in the
 Plague Hospital at Jaffa*

29. Gros: *Napoleon in the
 Plague Hospital at Jaffa*
 (detail)

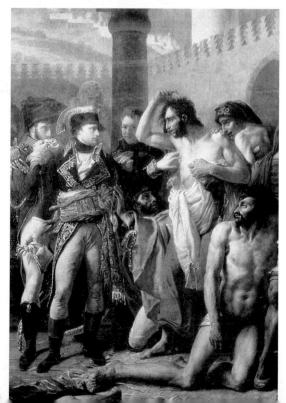

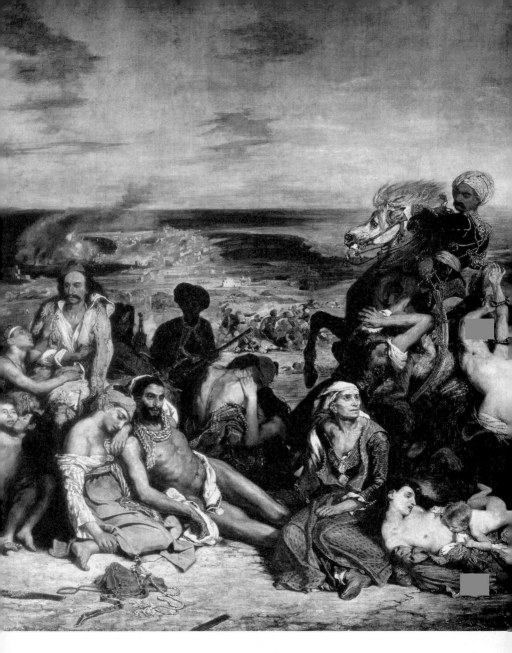

30. (*Above*) Delacroix: *Scenes from the Massacre at Chios*

31. (*Opposite, top*) Delacroix: *Les Femmes d'Alger*

32. (*Opposite, bottom*) Delacroix: *Ovid Among the Scythians*

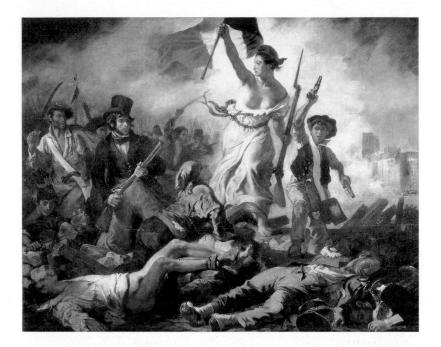

33. Delacroix: *Liberty Leading the People*

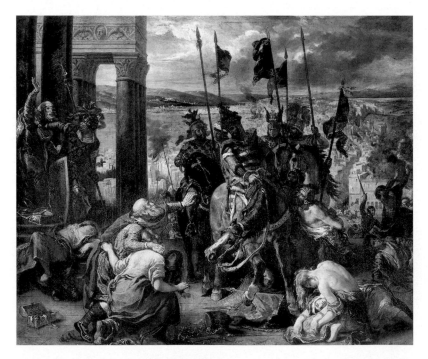

34. Delacroix: *Capture of Constantinople*

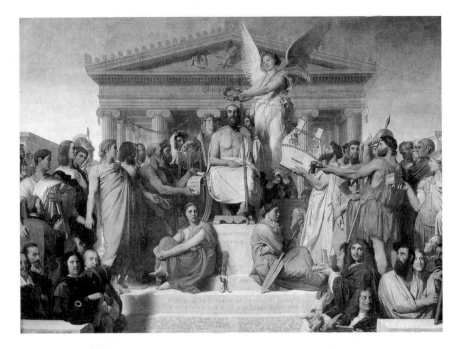

35. Ingres: *Apotheosis of Homer*

36. Ingres: *Odalisque à l'Esclave*

37. Ingres: *Antiochus and Stratonice*

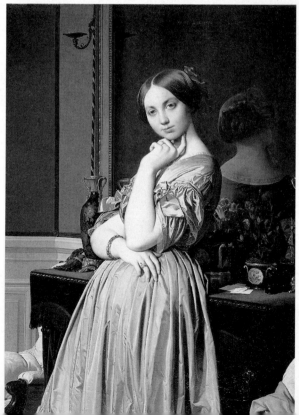

38. Ingres: *Comtesse d'Haussonville*

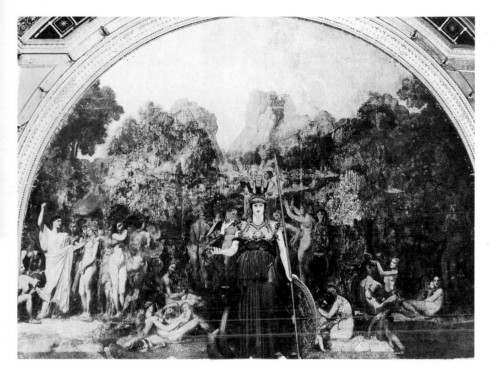

39. Ingres: *The Golden Age*

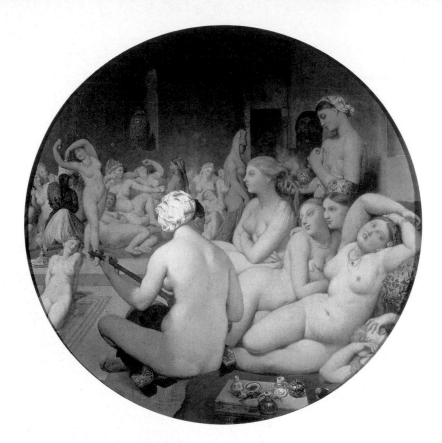

40. Ingres: *The Turkish Bath*

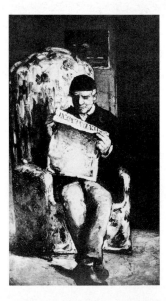

41. Cézanne: *Louis-Auguste
Cézanne reading L'Événement*

concept, and yet it is insistently present.) *Germinie Lacerteux*
is deceptively simple and is marked throughout by a melan-
choly which one recognizes as absolutely genuine. Germi-
nie is a servant girl who has come to Paris after a brutally
deprived childhood and who has found refuge with the
utterly respectable Mlle de Varandeul, to whom she is
devoted. But Germinie is young; she has impulses which
she does not fully understand but which lead her in several
different directions. For a time she is very devout; then she
leaves the church because the priest has spoken coldly to
her. She follows children in the street, and finally she falls
in love, disastrously, with the young son of a local
tradeswoman. The object of her passion, Jupillon, is both
cynical and corrupt. He reckons that Germinie may have a
little money put by, and so she has – but not after knowing
Jupillon. Her savings are used to set him up in business, but
she finds she has to provide for him even after he has rejected
her.

Finally she is indebted to the entire neighbourhood, and
her reputation, once so spotless, undergoes a terrible change.
She manages to conceal everything from her employer,
even the drinking, which comes next, and the sexual
hunger. Drunk, disgraced, and in debt, Germinie falls ill.
Mlle de Varandeul takes her to the hospital, and there she
dies. The old lady returns to her apartment and takes to her
bed, too frail to attend the funeral. It is the porter who goes
in her place. On his return he presents Mlle de Varandeul
with a sheaf of bills. Germinie has left bad debts everywhere.
When Mlle de Varandeul goes to the cemetery she finds
that Germinie has been buried as a pauper. The last scene is
one of Mlle de Varandeul kneeling, at some entirely notional

point in the graveyard, between lots nine and ten, to pay her respects.

The genesis of this novel is surprisingly straightforward. It was the Goncourts' own servant, Rose Malingre, who deceived them in this way, who got into debt, sold their belongings, filched food from their larders to give to her lovers. It was only after her death that stories reached them, yet they managed to change outrage into sympathy, for Germinie in the novel is treated with great delicacy. One evening she follows Jupillon to a cheap dance-hall. She has never been in one before, and she is terribly out of place. She endures taunts and jeers for three hours, waiting for Jupillon to turn up, but when she catches sight of him he is drinking, with two other women.

Certain of their own observations enter seamlessly into the story. There is the evening walk to the suburbs, where the deprived working classes of nineteenth-century Paris timidly enjoy the vacant lots and the catchpenny restaurants as if they were in the real country. There are dangerous sorties into the night streets, and there are those early mornings which find Germinie huddled on her lover's doorstep. There is every kind of shame, and yet there is also wistfulness. For once the famous style is subdued, spare. Germinie's death does not call forth a set piece, as Emma Bovary's had done, but is mentioned almost in passing. It is redolent with that sense of shared loss that is the authentic Romantic legacy.

Oh, Paris, you are the heart of the civilized world, the great city of fraternal charity and humanity. You have a conscience, gentle manners, generous instincts. The poor man is as much at home

in your streets as the rich man. Your churches speak of Jesus Christ; your laws speak of legality; your newspapers speak of progress; and all your governments champion the workers, and this is how you bury those who serve you, who kill themselves to provide you with luxuries, who die of your industries . . . who are the crowds in your streets and the community that constitutes your greatness. All your cemeteries have shameful corners, hidden against a wall, where you bury the dead so hastily that their feet stick out of the earth. It seems as if your charity ends when their life ends, that all you allow is the free bed in the hospital, and once that stage is passed you have no further use for them . . . You bury them one on top of the other, just as a hundred years ago you put paupers in the same hospital bed. No prayers: only a duty priest to scatter a little holy water . . . It is as if the earth were only lent to them. And the earth does not even contain them. In the summer the breeze that plays over this charnel house wafts the miasma back into the land of the living. And in the burning days of August attendants keep visitors away, because there are too many flies, black flies, flies that have fed on the dead, flies that could kill!

The Goncourts have no moral point to make. *Germinie Lacerteux* is art for art's sake, an almost objective examination of a certain case. Their own aims are both literary and profound. They study the circumstances that produce a certain character, without prejudice; their studies occasion a certain frisson which is not entirely comfortable and from which they themselves suffered. In the *Journal* for 2 December 1868 they proclaim themselves '*Les écrivains des nerfs*'. Their researches exhale an immense disillusionment, a high melancholy, as they go about their work of chronicling decline,

madness, death. But it is the lives of their characters that are more interesting and more remarkable than their deaths, and this is a purely literary skill. It is moreover a novelist's skill, and one which feels no need to compete with the characters, as Flaubert boasted of doing with Mme Bovary.

The one mode in which they insisted on retaining the upper hand was in their style, their '. . . effort to render impressions that the plastic artist renders better', as Henry James put it. The Goncourts will the reader to 'see' the text, which has the impact of a visible object. This text is exclamatory, with a plethora of effects, a proliferation of verbs, short clauses, exclamation marks. It creates a longing for abstraction in the reader: James describes this as fighting one's way out of a closed room. And it is their style, of which they were so proud, that has served their reputation so badly. This they could not understand, nor did anyone dare to point this out. Their competition with the object, which they sought only to patronize, has something engulfing about it, and is entirely at odds with the sentiments expressed. These are impeccable.

In another context Henry James coined a useful phrase: the madness of art. Aspirations to immortality are well-known Romantic attributes. Baudelaire even named aspiration towards the infinite as one of the components of Romanticism. The Goncourts saw art as a sacred calling, for which melancholia or illness was the price to be paid: art as martyrdom. The life of the body must be lived in the head: the original life of action must be experienced as inaction. The appropriate emotion is regret, as it was at the beginning of the century, and, as then, no compensation was available.

A challenge was thus flung to posterity, but one faithful contemporary shouldered the burden of answering it.

You say rightly that you pioneered the working-class novel, introduced the eighteenth century and Japan into contemporary society. Yes, but what about the language? . . . It seems to me that you had a fine feather in your cap with the three others, for it is an undeniable fact – which nobody would attempt to deny – that you have been outstanding craftsmen of the language whose influence on all of us is enormous. [Huysmans to Edmond de Goncourt, on 21 March 1884]

The influence of their triturated style was certainly enormous on Huysmans, but on hardly any other writers of note. Today their fame rests on the ardour of their aesthetic response, their constant awareness of things seen, whether famous or infamous. It is entirely fitting that they should have admired the paintings of Vermeer ('Van der Meer') some five years before this totally unknown artist was discovered by Thoré-Bürger.

And beyond this, beyond the excessive pride taken in their own taste, lies the dedication which they brought to the heroism of modern life, even though they saw this as decadence. It is their position, half-way between dandyism and decadence, together with an altogether enlightened awareness of the '*saveur amère ou capiteuse du vin de la Vie*', that makes the brothers Goncourt outstanding exponents of Romantic decline. Their desire to create a false life in the agitation of their phrases, and, more important, their recognition of the impossibility of doing so completely, consecrates them as the tragic heroes of an epoch and an ethos of which they were the true legatees.

8

Zola:
Art for Life's Sake

In 1832 Balzac wrote a novella entitled *Le Chef d'Œuvre inconnu*, in which an aged painter, Frenhofer, invites his friends, Poussin and Porbus, to view his latest masterpiece, a portrait of an imaginary woman. To their consternation they see nothing but a jumble of incoherent lines: '*Je ne vois là que des couleurs confusément amassées et contenues par une multitude de lignes bizarres qui forment une muraille de peinture.*' ('I see nothing but colours piled on top of one another and enclosed by a mass of crazy lines forming a wall of paint.') All that emerges from this confusion is a perfectly formed foot. Frenhofer, in the face of his friends' evident surprise, affirms that he has lived with this magnificent creation for ten years, and when the disbelieving Poussin brutally tells him that what is on his canvas does not amount to a picture, Frenhofer concedes that perhaps they are right; then, rallying, accuses them both of lack of faith. He bids them goodbye, and dies that night, after burning all his canvases.

In 1882 Zola wrote to a friend, Giacomo Giacosa, '*Je trempe dans le romantisme jusqu'à la ceinture.*' ('I am steeped in Romanticism up to the hilt.') By this he meant not only that he had read Balzac and Hugo as a boy, although he had certainly read and admired both, but that he had a perhaps idealistic view of all that Romanticism could still achieve.

Zola's Romanticism was based on friendship, on the idea of '*la petite bande*', Stendhal's '*petite église d'élus*': a group of friends with the same aims and the same convictions could face the world heroically and impose their own values on an increasingly cynical society.

This is the motive power behind his historically important championship of Manet and the painters who were to be known by the collective name of Impressionists in the reviews he wrote of the Salons in the 1860s. In May 1866 Zola dedicated his first brilliant critical campaign to Cézanne, his childhood friend, with the words:

Il y a dix ans que nous parlons art et littérature. Nous avons habité ensemble – te souviens-tu? – et souvent le jour nous a surpris discutant encore, fouillant le passé, interrogeant le présent, tâchant de trouver la vérité et de nous créer une réligion infaillible et complète. [For ten years we have been talking art and literature. We lived together – do you remember? – and often daybreak came when we were still talking, ransacking the past, questioning the present, seeking the truth, and trying to create for ourselves a complete and infallible religion.]

Although it is difficult to imagine the uncommunicative Cézanne participating in these exciting discussions, there is no doubt that Zola brought to the friendship an ardour that was perceived as heroic – Romantic, in fact. That Zola's ideal of friendship was a form of socialism, as he later confessed, only underlines the solidarity that was his true ideal. Disparities of fortune would be eliminated by equal representation, so that Cézanne, Manet, and their friends would gain the right to exhibit in the Salon, along with all the approved sentimental painters whom Zola secretly

admired. The situation in 1866 was the situation that Balzac had described in his story. What the public saw was an incomprehensible break with familiar tradition. Zola would compensate for its lack of faith with a ringing affirmation of what a painting was, or should be: '. . . *un coin de la création vu à travers un tempérament*' ('. . . a corner of creation seen through a temperament').

Such simplicity is misleading. Although, after Zola's manifesto, anyone could understand a Manet, few could understand Zola, and to his chagrin his painter friends drifted away when he was no longer of use to them. In spite of those long discussions with Cézanne, their aims were not his aims, nor their tastes his tastes. They saw that he possessed a certain gigantism, a brutal robustness which led him to value the heroic workmanship, and workmanlike heroism, of Courbet, which he defined as true creativity. The friendship with Cézanne foundered for equally complex reasons, the most obvious being the fact that Cézanne identified himself as the model for another mad painter, Lantier, in Zola's novel *L'Œuvre*. The book is itself a reworking of Balzac's novella, and there are grounds for believing that it was Zola who saw himself as Lantier, relying on that earlier symbiosis to explain his intention to his friend. Cézanne, however, saw the situation differently, applied the stricture to himself, and broke off the friendship, which had been that of two naïve and hopeful young men, in which no blame attached to either.

The tragedy of *L'Œuvre* and its aftermath, revealing in its implications for both participants, merely added to Zola's history of disturbing experiences. Chief among these was a superstitious view of fate, or perhaps fatality, that underlies

all his novels, that dark undertow in which the life force battles for superiority and is usually overcome. Known to the public as the critic who championed Manet and therefore as an unusually combative journalist, Zola had no intention of remaining in a subordinate position. He had his own masterpiece, or masterpieces, to create. In eight months, between 1868 and 1869, he outlined the twenty novels he was going to write on the theme of heredity: two families, the Rougons and the Macquarts, tainted with alcoholism and syphilis, were to inter-marry, to proliferate, and to pass on their inherited weaknesses to a third, fourth, and fifth generation. In outlining this plan Zola was influenced by various scientific, or rather sociological theories current at the time. In an article on Taine, in *L'Événement*, for 25 July 1866, he presented himself as a humble follower of the man who had elucidated the theory of '*race, milieu, moment*', as explanation for man's physical and mental attributes, much as Balzac had attempted to follow the theories of Cuvier. In 1862 a complete translation of Darwin's *Origin of Species* had appeared in French; this was followed in 1868 by Claude Bernard's *Introduction à la Médicine Expérimentale*. Zola was delighted with a world view that eliminated supernatural or transcendental rationalizations, but preferred not to, or was in any case unwilling to, adhere to a purely mechanistic outlook. He praised Taine for having introduced 'the exactitude of science, with all the liberty of the personal and living artist, into a classification of intellectual life, so as to make it as faithful as possible a replica of what happens in the physical sphere'.

But it was not to be so simple. Zola, devoted son, faithful husband, loyal friend, was in fact deeply irrational, liable to

devise strange retributions for the characters in his novels which are not explained by their inherited disorders. The dead erupt, like the imaginary body lying in the bed between Thérèse Raquin and her lover, in a manner that is less than scientific. No one is immune from this kind of visitation, or from a similar disaster. His characters may be homely bourgeois or outrageous millionaires, but they will be brought down not merely by heredity but by an unseen flaw which Zola will have devised for them. This anxiety, which is often translated into a literal blackness, gives the novels a dimension which is almost supernatural. Fate, or destiny, cannot be outwitted, and the only prophylactic is work, more work. '*Allons travailler*' are the last words of *L'Œuvre*, as friends leave the funeral of one who was considered the most talented of their number. On 14 December 1868, the Goncourts noted in their *Journal*:

Our admirer and pupil Zola came to lunch today. It was the first time we had ever seen him. Our immediate impression was of a worn-out *normalien*, at once sturdy and puny, with Sarcey's neck and shoulders and a waxy anaemic complexion . . . The dominant side of him, the sickly, suffering, hypersensitive side, occasionally gives you the impression of being in the company of a gentle victim of some heart disease. In a word, an incomprehensible, deep, complex character; unhappy, worried, evasive, and disquieting.

This is deeply perceptive. Although written before Zola's fortunes were really consolidated by the vast success of *L'Assommoir*, it already departs in every respect from the popular notion of the bluff fearless warrior who had made Manet famous and had lost his own livelihood in the process.

This standard view of Zola tended to harden as the years went by, until he was accepted, in the 1880s, as the archetypal middlebrow, popular with the average reader, and basically a member of the public for whom he wrote.

Yet his Romantic roots allied him with Balzac, with Hugo, and with Musset. Both Balzac and Hugo were concerned with the production of an epic; both had the staying power needed for the task. There is a close comparison to be drawn between Zola and Hugo, for both had the Messianic faculty well developed, both are composed of a sustained feeling for greatness, and the sort of banality which can descend into heartiness, or worse, emptiness. Only the Goncourts had the nervous equipment capable of discerning Zola's psychic anguish. 'Good luck,' he wrote to Huysmans on the publication of *À Rebours*. 'I am simply trying to work as calmly as possible, but I no longer know what I am doing, for the longer I go on, the more I am convinced that our undertakings are absolutely not a matter of will.' Our destiny also escapes the operations of our will, as Zola, flushed with determinism, would agree. But at the heart of the matter determinism is not enough. It cannot explain the melancholy of Zola; it cannot explain his fear of death, which made his love of life so poignant. Nor can it explain his peculiar relationship with what was later to be known as the collective unconscious. In his most personal works the brisk explanations of Claude Bernard are translated into a darker and more ancient concept of doom. This is the message of *L'Assommoir*, of *Nana*, of *Germinal*, of *La Joie de vivre*. It is easy to be swayed by the fiery gaiety of the journalism into forgetting this unhappy tendency. When Huysmans read *Germinal*, he pronounced, '. . . *ça dégage*

une sacrée, une sacrée tristesse'. This sadness is Zola's other
dominant characteristic, one which he was able to overcome
but which he could never quite contain. It is present in his
letter to Huysmans in which he acknowledges the unwilled
element in his work. Yet it is precisely that unwilled element
that made of him a great, almost mythic writer.

Zola was born in Paris in 1840, the son of a French
woman and a father of Greek and Venetian extraction. The
father was a civil engineer, and in 1842 the family moved
to Aix-en-Provence, where François Zola was given the
important job of canalizing the city's water supply. He died
in 1847, before he was able to complete the project, and a
stigma of failure hung over the whole enterprise, particularly
as the authorities refused to pay any compensation to the
widow. Much litigation took place, which may explain
Zola's later interest, to the point of obsession, in the power
and money nexus of Second Empire society, particularly in
a small town, the town he calls Plassans in the novels. The
mother was forced to work to keep her son at school, but
Zola was enjoying a moment of freedom, perhaps the only
genuine moment he was to know, with his friends and
fellow Aixois Baille and Cézanne. The friends had pre-
dictably Romantic tastes, wrote poetry, and envisaged a
career in the arts. At this stage Zola was very much the
leader, Cézanne the follower. The two men were linked by
lurid old-fashioned tastes and precocious erotic yearnings.
If one is to compare them at all – and the comparison is
perhaps inevitable – it must be on the basis of their early
experiments, Cézanne's murder and rape scenes with Zola's
hectic early novels, *La Confession de Claude* and *Thérèse
Raquin*.

In 1858 this existence ended for Zola. He and his mother moved back to Paris, where they lived in extreme poverty. By 1860 Zola was working in a warehouse and supporting his mother, which he continued to do until her death in 1880. He suffered from hunger, from cold, and eventually from a severe illness, which may have been typhoid. He suffered above all from loneliness, and he wrote to his friends, urging them to join him in Paris, as they had originally planned. By 1862 he was working in the packing department at Hachette. By determined efforts he got himself transferred to the publicity department, and there his career (as a publicist, one might say) got under way. He began to make friends with editors, publishers, men of letters, by sending out free samples of books published by Hachette. By 1865 he was writing a gossip column entitled *Les Confidences d'une curieuse* for the downmarket newspaper *Le Petit Journal*. In the following year, 1866, he was taken on as a book reviewer by the more important *L'Événement*. In the same month Cézanne arrived in Paris, his third or fourth visit, resolved to submit a picture to the Salon.

Zola now had four of his boyhood friends in Paris: Cézanne, Baille, Numa Coste, and Philippe Solari. They met on Thursdays at Zola's apartment; Cézanne brought his friend Pissarro. They talked of their personal ambitions and of the forthcoming Salon. In May came the news that the Salon jury had rejected Cézanne's pictures. Cézanne wrote to the Comte de Nieuwerkerke, the Minister for the Arts, demanding the re-establishment of the Salon des Refusés. His letter was not answered. Cézanne appealed to Zola to print something to this effect in his newspaper. The result was the series of articles in *L'Événement*, most of which

were axed by the editor, but all of which were published separately by Zola as a short book entitled *Mon Salon*. This appeared in May 1866 and was dedicated to Cézanne.

These articles were undertaken largely as an act of friendship. Zola believed, as he said, in the present and the future, but beyond this fact he was better acquainted with painters than with painting. Certain qualities in painting appealed to him: '*la franchise*', was one, the use of black perhaps another. At any time after 1863 and before 1870 there was one foolproof way of writing a review of the Salon. One attacked the jury, which was a symbol of censorship, and one demanded the re-establishment of the alternative Salon, the Salon des Refusés, open to those painters who had not found official favour. Zola's attack on the members of the jury was so actionable that his editor was forced to suspend him, but the method, which Zola found congenial, served him as well in 1866 as it was to do thirty years later, when he attacked, in exactly the same manner, those members of the military and government commissions which had convicted Captain Dreyfus.

Secondly, Zola not only demanded the re-establishment of the Salon des Refusés, he devoted the rest of his article to the arch-refusé himself, Edouard Manet. He did this out of sympathy, but also because to do so symbolized a fight against reaction. Most of the phrases in the *Salon* of 1866 have a political ring to them. Zola nevertheless made an honest attempt to rationalize his enjoyment of Manet's pictures, which was quite genuine, and in doing so he performed an immense service not only to the painter but to the general public, which, if it cared to, could read an article on contemporary painting which dispensed with the

jargon of criticism. The results surpassed all expectations: a scandalous success for Zola, nationwide publicity for his friends, and above all something relatively new in the history of nineteenth-century aesthetics: the integration of the critic into a new artistic movement. The painters did not fail to acknowledge their champion. Cézanne portrayed his father reading *L'Événement* (Fig. 41), the same newspaper figures largely in Renoir's riverside restaurant, *Le Cabaret de la Mère Antony*, while a young, solemn and virtuous Zola peers out of the gloom of Fantin-Latour's portrait, *Le Groupe des Batignolles*.

This ideal situation persisted throughout 1867 and 1868. In 1867 Zola again made his sympathies clear by reviewing the Exposition Universelle, the official exhibition, in one paper, *La Situation*, and a Manet exhibition in another, *La Revue du dix-neuvième Siècle*. The Salon fares badly, but the article on Manet, entitled *Une nouvelle manière de peindre*, is, by contrast, elegant, carefully written, and almost certainly based on Baudelaire's articles on Guys, that pioneering introduction to modernity. There is undoubtedly a shortness of response to the pictures themselves, but Zola wisely makes up for this by trying to explain the artist to the public in such a way that those with no aesthetic training at all will understand and be included.

The year 1868 saw the triumph of Zola's first campaign. Manet, Monet, Renoir, Bazille, and Pissarro were accepted by the Salon jury, and in reviewing the exhibition of that year Zola concentrated on them almost to the exclusion of other painters. There was no mention of Cézanne, but Cézanne was still, on his own admission, a virtual beginner. Zola the fighter was almost disappointed by the ease with

which victory had been achieved. He saw the moment as propitious for handing over the struggle to the painters themselves. His final rallying cry contained a warning that was easily overlooked in the general euphoria. '*J'interroge l'avenir,*' he says, '*et je me demande quelle est la personnalité qui va surgir assez large, assez humaine, pour comprendre notre civilisation et la rendre artistique en l'interprétant avec l'ampleur magistrale du génie.*' ('I look to the future and wonder who will be comprehensive and humane enough to understand our civilization and turn it into a work of art by interpreting it with the broad majesty of genius.')

Certainly not Cézanne, who always avoided the sort of confrontation at which Zola excelled. Perhaps not even Manet, who was too much of a dandy ever to aspire to the broad majesty of genius. Zola still saw himself as both outrider of a new artistic movement and victorious journalistic campaigner. This conviction was not shared quite equally with his painter friends. When Manet painted Zola's portrait in the winter of 1867 he included in it many of his own fetishes, the print after Velázquez and the Japanese screen, as if Zola were another attribute of the painter. Zola was naïvely delighted with the portrait and in 1868 dedicated his novel *Madeleine Férat* to Manet.

This rejuvenating solidarity, this re-enactment of youth and expectation, was brought to a natural conclusion by the war of 1870, which caused the protagonists to leave Paris and to pursue their individual interests. Zola, exempted from the call-up because he was the only son of a widowed mother, went to Marseilles and tried to start a new periodical. When this failed, and his return to Paris was blocked, he went to Bordeaux, where he acted as secretary to a minor

minister in the Gambetta administration. His interest in painting, which had always been an affair of warm personal sympathies rather than a genuine passion, faded quite naturally from his mind. His own career as a writer was once again seriously menaced because at this juncture his publisher went bankrupt and serialization of his new novel, *La Fortune des Rougon*, was suspended. This event was a defining moment. *La Fortune des Rougon* was to be the first of those twenty novels which represent Zola's major literary undertaking, the novels that were to rival Balzac's *Comédie humaine*, and to provide a complete survey – sociological, physiological, phenomenological – of Second Empire France.

For Balzac, money and ambition were the mainsprings of human conduct. For Zola human conduct was determined by heredity and environment, the thesis of Taine adapted to a literary purpose. In his twenty novels Zola constructs an elaborate dynasty, the issue of two families, the Rougons and the Macquarts, injects into this dynasty two inherited weaknesses, and works out the ravages that these inherited tendencies inflict on his characters and on the society in which they live. The fate which he has decreed for them, and which is in fact reductive, is thrown into relief by great orgiastic set-pieces, animated organisms which illustrate the oceanic nature of Zola's genius. The apartment house, the store, the laundry, the mine, and finally the astonishing garden of *La Faute de l'Abbé Mouret*, all testify to Zola's Promethean appetites which have themselves something tragic about them, as if the physically puny character whom the Goncourts described could not hope to contain all the grandiosity and despair which perpetually sought to be recognized.

Although Zola had a completely genuine belief in determinism as a precipitating factor in human behaviour, the task of creating a family, a task which he was denied in real life until very late in life, developed a faculty which had so far lain dormant. The Rougon-Macquart novels are works of sublimated fertility. The weakest are those in which the formula is predictably worked out, and in this category one must place the novel which was to have such disastrous consequences for Zola's personal life, *L'Œuvre*. The strongest are those in which it is possible to forget the original formula altogether, or to attach it to some other cause, as in *La Joie de vivre*, *L'Assommoir*, and *Germinal*.

These novels were to carry Zola to heights of literary fame and fortune, but they are not the works of a dandy. Zola's method of documentation now began to embarrass his friends. His idea of creativity was very close to a concept of paternity; he was, as he called Courbet, '*un faiseur de chair*'. For the actual details he was dependent on a number of helpers, both voluntary and involuntary. The figure of Zola walking round the streets of Paris with his notebook, interrogating porters, market workers, laundrymen, and salesgirls is a familiar one in literary history. For the brothel scenes in *Nana* he was obliged to write to a friend for information, adding, by way of excuse, '*Moi, je suis un chaste.*' More impressive in human terms is the sight of Zola taking his notebook down a mine to write *Germinal*, or travelling in the cab of a train to write *La Bête humaine*. And although these activities may reveal him as a writer who had served his apprenticeship as a journalist they were to have surprising results, because when Zola came up from the mine, or away from the goods-yard, he was so engrossed

in conditions of labour, in matters of social justice, that the man of letters began to give way to the practical philanthropist. A letter to his Dutch translator, Van Santen Kolff, of 1886, contains the key sentence, '*Toutes les fois que j'entreprends une étude maintenant je me heurte au socialisme*' – I come up against socialism. It was a form of socialism which had led him to demand equal representation for the Impressionists in the Salon of 1866, and a form of paternalism which made him believe that, given the right circumstances, creative spirits could contribute to the life of their times in terms of strength and clearsightedness. Conversely – and this was a growing conviction – artists had obligations to their community, obligations which they seemed reluctant to acknowledge.

This failure, which he perceived, led him to the conclusion that his painter friends lacked greatness. It was a human reaction to a group with which he could no longer identify, or could no longer identify in moral terms. Though still active on their behalf, a carping note began to enter his reviews. He implied that it was easy enough to be a precursor but that a more sustained effort was necessary for total victory. What was lacking was '*quelque chose de solide et de durable comme l'art des musées*'. (Ironically, Cézanne would have agreed with this.) Zola, bearing in mind the crushing fatigue that went into the composition of his novels, and indeed suffering from that fatigue, began to resent the relative rapidity with which the Impressionists painted their pictures. Yet in the 1870s, when French papers were reluctant to employ him, Zola continued to plead for his friends. Writing for a Russian paper, *Le Messager de l'Europe*, he insisted on bringing the names of Manet and

the Impressionists to the notice of the public, even if it meant dragging in an allusion to the Impressionist exhibition in the rue Le Peletier in 1876 which had already closed a month earlier than the official Salon he had been engaged to review. In 1875, with a note of genuine emotion, he had restated his original position, but that restatement contained a note of regret. '*Hélas, avec quelle joie ardente je me livrerais à l'enthousiasme pour quelque maître . . . Mais . . . nous attendons toujours les génies de l'avenir.*' ('Alas, with what joy I would celebrate a master . . . but we are still waiting for the geniuses of the future.') The warning was issued: '*La place est balayée pour le génie de l'avenir.*'

So that when Cézanne, in 1880, once again enlisted Zola's help on behalf of Renoir and Manet, it was a rude shock to read in *Le Voltaire*, to which Zola had been reinstated, what looked like an attack but what was in fact a revision of Zola's recent argument, with the addition of one very significant word: *impuissance*. It was no longer a question of what the Impressionists would not do: Zola concluded that they were incapable, *impuissant*. In the article of 1880 is adumbrated the theme of *L'Œuvre*, a novel about artistic impotence. This was the factor that so wounded Cézanne and brought the long friendship between the two men to an end.

Zola's own compulsive industry can be judged by the output of his novels. In 1882 he published *Pot-Bouille* and *Une Campagne*; in 1883 *Au Bonheur des dames*; in 1884 *La Joie de vivre*; in 1885 *Germinal*; in 1886 *L'Œuvre*; and in 1887 *La Terre*. There was a reason for this phenomenal output. In 1880 Zola's mother died, and Zola, for whom the idea of death was a nightmare, went through a prolonged nervous

crisis, with hallucinations of the kind suffered by Baudelaire before his stroke. Victory, for Zola, always envisaged, was always postponed. His productivity began to strike a harsh note. *La Joie de vivre* is an ominous book about frustration, while the title of *Germinal*, with its black symbolism, is taken from the month in the Revolutionary calendar which indicates new growth underground. The idea that had fertilized his early writings, the idea of the value of individual temperament, had been replaced by a preoccupation with collective undertakings, particularly on a democratic level. This is why *Germinal*, which deals with the struggle of the workers against a corrupt mine-owner, is a work of passion and genius, and why *L'Œuvre*, a Romantic, even sentimental story of a painter working in isolation, is a failure.

One might accuse Zola of naïveté, that deadly virtue that rebounds on those who possess it. *L'Œuvre*, published in 1886, tells the story of Claude Lantier, a painter who hangs himself when he cannot complete the masterpiece that will vindicate his entire career by being shown in the Salon. In fact he hangs himself because his heredity is so disastrous that failure is a foregone conclusion. Claude Lantier is first and foremost a demonstration of Zola's theories of determinism: he is the son of the unfortunate Gervaise of *L'Assommoir*. However, Lantier also bears a sinister resemblance to Cézanne, and in the notes for the novel is described as '*un Manet, un Cézanne dramatisé, plus près de Cézanne*'. It is easy to see that the hirsute and unsociable character of Lantier is based physically on Cézanne, particularly as he purports to come from the Provençal town which Zola calls Plassans. On one level, *L'Œuvre* is thinly disguised autobiography. Zola himself figures in the novel as the

writer, Sandoz, while the other characters can be traced to men in real life with whom Zola was associated. It was on this level that the novel gave such offence. Pissarro remarked, correctly, that it was merely a bad novel. He showed himself to be perceptive, for *L'Œuvre* is essentially a literary creation which owes almost everything to Balzac's *Chef d'œuvre inconnu*, which Cézanne knew and admired. But Balzac's painter, Frenhofer, although mad, is given the benefit of his genius throughout. Claude Lantier suffers from a form of spiritual impotence, and Cézanne was quick to seize the inference. Zola sent him the novel. Cézanne acknowledged the gift. They never spoke to one another again.

No overt mention of disloyalty was made, but an atmosphere of accusation and counter-accusation prevailed. It is in this context that one should look back, as Zola does in his last *Salon*, published in *Le Figaro* in May 1896, to younger days. Zola's experience of early poverty in Paris was absorbed by the optimism of youth. He saw no discrepancy in urging a life of art and high endeavour on wealthier friends, but at some point in middle life, when his own gigantic labours had finally brought him security, some memory of that early inequality took possession of him and could not easily be discarded. His attitude to Cézanne came to be coloured by the fact that Cézanne represented failure, or perhaps permission to fail, in worldly terms, and Zola felt threatened by this particular dilemma which he himself had so narrowly overcome. If there is any animosity in *L'Œuvre* – and what there is is largely unconscious – it must stem from this factor.

The *Salon* of 1896 is only marginally about painting. It is

dismissed or ridiculed as final evidence of Zola's philistinism because it refers to Cézanne as '*un grand peintre avorté*', a great still-born painter, and because it now seems to Zola that he has been waging a paper war for an inferior army. '*Mon Dieu, est-ce pour ça que je me suis battu?*' For these dashes, this decomposition of light? My God, was I mad? '*Mais c'est affreux, je le déteste!*'

Something very interesting has taken place. Not only does Zola dislike the painting of the day; he actively resents it, and for an extraordinary reason. In May 1893 Zola had made this moving statement.

I have had only one faith, one strength, and that was work. What has sustained me has been the vast labour which I have imposed upon myself . . . Let each of you accept his task, a task which should fill his life . . . It will make you live in health and happiness, it will free you from the torment of infinity.

This was almost true. But there is another factor which must be taken into account. In the late 1880s Zola had fallen in love with one of his wife's servants, and had fathered a child. His biographers claim that from this moment of fulfilment, this freedom from the torment of infinity, Zola ceases to be able to write, or rather that what he writes lacks both interest and value. This is not quite the case, and the articles written during the Dreyfus case are proof, if proof were needed, that Zola is a writer to the end. His interest now is confined to living causes. Still-born masterpieces have ceased to be relevant.

The *Salon* of 1896 contains the noblest words that Zola was ever to write. They are the words of a great Romantic, surveying the battles he fought and won in younger and

more candid days, and it is impossible to read them without experiencing some kind of revelation about the true nature of Romanticism and the Romantic temperament. '. . . *J'ai combattu le bon combat . . .*'

I fought the good fight. I was twenty-six and I was with the young and the brave. What I defended I would defend again, because it was the cause of the time, the flag that had to be planted on enemy territory. We were right because we had enthusiasm and faith. Whatever truth we possessed is now assured. And if the way ahead seems easy it is because we have made it so . . . And then the masters remain. Others will come along from new directions, but those who determine progress survive when their schools are in ruins. And decidedly the only ones who triumph are the creators, the makers of men, the genius who gives birth and gives life and truth.

It is the battle of *Hernani* all over again. It is the emancipation of '*moi*', no longer '*pauvre*', but fearless and vindicated.

Late photographs of Zola show a tender careworn man who regards the camera without a hint of self-aggrandizement. He places a protective arm around Jeanne Rozerot, his much younger companion; she holds their son, Jacques, on her knee. He has detached himself from his old life, or perhaps been detached from it. His face holds experience but no regret. It is the face of a man with a clear conscience, which was also, as Anatole France said, '*un moment de la conscience humaine*'.

It has been suggested, by Henry James among others, that Zola spent his life gravitating towards the defence of Dreyfus, the Jewish army officer wrongly convicted of passing documents to German army headquarters. Certainly

the *Salon* of 1866 can be read as a blueprint for his journalistic campaign, *J'Accuse*, of 1898. Zola's five articles demanding a retrial of Dreyfus, who was already serving his sentence, are the crowning achievement of a lifetime. They turned the author into a folk hero, whose lustre has remained undimmed. The writing is of a peculiarly inspired kind, as if Zola had at last found a cause worthy of his energy. He took no payment for these articles, and was rewarded with a heavy fine and a year's exile. He arrived at the Grosvenor Hotel, Victoria Station, in July 1899, with no luggage, very little money, and a hesitant command of English. For these reasons he was asked to pay a deposit of one pound.

He died in 1902, in extremely unusual circumstances. Returning to their Paris apartment one September night, Zola and his wife, whom he had never left, had a fire laid in their bedroom. They woke in the night of 26 September unable to breathe. Mme Zola stumbled to the bathroom and managed to clear her lungs, but Zola was dead by the morning. The cause was found to be a blocked chimney. It had never been blocked before, and it was noted that there had been men working on the roof of the adjacent building. Foul play was immediately suspected and has never been disproved. Indeed it has been confirmed, though the evidence is mysterious, being partly covered by the secret of the confessional. Every night before the funeral an impassive Captain Dreyfus kept watch over the body. On hearing the news, Cézanne shut himself in his room and wept. The funeral cortège was immense; Zola's position as moral leader was universally acknowledged. In 1908 he was awarded the honours of the Panthéon.

On 23 March 1860 Zola had written a touching letter to

Cézanne. 'I had a dream the other day. I had written a fine book, a sublime book, which you had illustrated with fine, with sublime engravings. Our two names, in gold letters, shone on the title page, and in this brotherhood of genius will pass inseparably to posterity.' This is one kind of Romantic confession. Another and more durable kind is contained in Zola's own words. 'I believe in the day that is passing, and I believe in tomorrow . . . having put my passion in the forces of life.'

Zola's novels are perceived as epic exercises, superstitious attempts to extirpate faults for which the characters are not responsible. They are about succumbing to a fate against which willpower cannot compete. '*J'assiste à la ruine de ma volonté*,' observes a character in *Pot-Bouille*. It is likely that Zola recognized this helplessness as his most ancient conviction, but used all the force of his character to disarm it. Henry James described Zola's activity during the Dreyfus case as the 'act of a man with arrears of personal history to be made up, the act of a spirit for which life . . . had been too much postponed, treating itself at last to a luxury of experience'. Zola would no doubt have agreed with this. His method, however, was very much simpler. It had already been encapsulated in the final words of *L'Œuvre*, at a moment of downheartedness, of grief, and of disenchantment: '*Allons travailler*,' 'Let's go to work.'

9

Huysmans:
The Madness of Art

The most brilliant of the critics, the most ardent of the disciples, the most outrageous of the solipsists, and the most sado-masochistic of the Romantics was J. K. Huysmans, whose desire to be not only Baudelaire but Edmond de Goncourt and Zola combined overtook him at an early age but was discarded when his *moi* pointed out to him a more excruciating form of self-denial.

Huysmans, whose literary roots are shallow, is an outstanding exponent of ennui, that characteristic inherited from Chateaubriand's René; his morose self-questioning forms the bridge between René and Sartre's Roquentin. His is an honorary name in the annals of ennui; his life was bedevilled by physical and mental discomfort, yet he was the doyen of sharp-eyed and avant-garde critics, the first to champion Gauguin and Degas, the first to cast doubts on Zola's Naturalism, although he was to apply the Naturalist method to his own mystical quest, anatomizing the singing at Saint-Sulpice, the congregation at Saint-Germain-des-Prés. His reconversion to Roman Catholicism can be seen as a reversion to Romantic values, and this journey could not be accomplished without patrons, advisers, companions. Stendhal's '*petite église d'élus*' takes on a new meaning when applied to Huysmans's later years. His appalling last illness

can be seen as a triumph of God's Naturalist tendencies. He ended in a state of grace, like Baudelaire's *poète-martyr*: '*Soyez béni, mon Dieu, qui donnez la souffrance / Comme un divin rémède à nos impuretés.*' He is remembered by Catholic apologists as a true martyr, only a few steps removed from sanctity. He represents the final stage of the Romantic journey: the Romantic search for the infinite. What Baudelaire described as one of the characteristics of Romanticism – '*l'aspiration vers l'infini*' – he took as inspiration for his search. He also applied it literally, in true Naturalist fashion.

The career he pursued had been pointed out to him by Baudelaire, by Edmond de Goncourt, and by Zola. His progress was almost too easy. From the *Croquis Parisiens* of 1880, which attempted to be a reprise of Baudelaire's prose poems, to the Naturalist novels of the same era, notably *Les Sœurs Vatard*, whose seedy brilliance outdoes Zola and even the Goncourts of *Germinie Lacerteux* in its fidelity to Naturalist values, Huysmans followed a well-trodden path, but with several interesting diversions. A prolific writer, he nevertheless gives an impression of anorexia, of reluctance, together with the exasperated nervous equipment of one in the Goncourt mould, but without the Goncourts' assurance of their own pre-eminence. What he has in abundance is '*tempérament*', the sort of temperament that led him to seek out unattractive suburbs, to take his Parisian walks in areas unpatronized by the bourgeoisie. His best novel, *Les Sœurs Vatard* of 1879, was dedicated to Zola, from his '*fervent admirateur et dévoué ami*', yet Zola was the first to reproach him for his sensational fantasy *À Rebours*, accusing him of forsaking Naturalism, and, more important, of devising a

style which could have no future because it was hermetically sealed in its own form. For Zola, both strictures were relevant. The future was all-important; the task of art was to engender further art. Yet Huysmans claimed, whether ingenuously or disingenuously, that the novel had suggested itself, had indeed almost written itself. In the preface he wrote nineteen years after the book appeared, he stated, '*Ma vie et ma littérature ont une part de passivité, d'insu, de direction hors de moi très certaine.*' ('My life and my books contain an element of passivity, of the unconscious, of a definite other-directedness.')

There is no reason to doubt this, although it would seem to contradict the highly wrought character of *À Rebours*. But there is, equally, no reason to doubt the final words of this outrageously secular, almost blasphemous story, which turns into a prayer for faith. Huysmans, or Des Esseintes, is not yet a convert: he describes himself as a '*forçat de la Vie qui s'embarque seul dans la nuit, sous un firmament que n'éclairent plus les consolants fanaux du vieil espoir*' ('one of life's convicts, embarking alone at night, under a sky no longer lit by the consoling shafts of former hope').

This was truly prophetic. Huysmans gives the impression of being one of life's convicts from promising youth to relatively early death. His senses were a torment to him, whether they involved a visit to the barber, as described in *Croquis Parisiens*, or acknowledging the less agreeable aspects of modern life, which to him was not heroic: on the contrary. Manners, he complained, had become American, yet the world he describes is recognizably French, with perhaps an admixture of strangeness due to his partly foreign ancestry. A man of the utmost rectitude, he nevertheless conveys

an impression of slyness, of perversity. His inheritance was robust, yet it is as a dilettante that he is at his most persuasive. His eternal dissatisfactions may stem from a path too easily chosen. To overcome this he undertook a search for the ultimate, which he described, without a trace of irony, in Naturalist terms. Whatever the objects of his search his journeyings were parallel: from the age of pessimism (Schopenhauer was a major influence) to the age of faith: from observer of modern life to an oblate's retreat; from disciple of Zola to the biographer of the Blessed Lydwine of Schiedam. Zola's prediction was in fact correct. *À Rebours* contained no future. It was a work that exhausted its own idiom, just as Huysmans closed the magnificent parenthesis that had opened when Baudelaire discerned the heroism of modern life.

He is arguably the most intriguing and the least transparent of the great Romantics. Nervous, thin-blooded, given to diverse ailments, he seems from his earliest days to have suffered from various forms of malnutrition, which, given his inability to find a digestible meal, seem to have been all too concrete. His judgements on his contemporaries were not unlike the humours of an invalid, his view of the world as subjective as that of a patient in a hospital bed. Georges-Marie-Charles Huysmans was born in Paris in 1848, although he was later to emphasize his northern descent and even to change the forms of his Christian names to Joris-Karl. His father was Dutch, and purported to come from a long line of artists and craftsmen. Huysmans made considerable capital out of this fact, which had undeniable importance for him, to such an extent that he embraced and identified with all things northern, even Gothic, and

there is a certain paranoia in his hatred of southern exuberance, which gradually extends to the whole of Italian Renaissance art. His suspicious scrutiny of certain Renaissance altarpieces, such as Bianchi di Ferrari's *Virgin and Child with Saints* in the Louvre, is a true indication of his supreme distaste for what is mildly conventional and recognizably sweet-tempered. A genuine *fin-de-siècle* temperament supplied him with morbid tastes long before those tastes found an outlet in enthusiasm for both the most tortured and the most indifferent examples of artistic extremism.

His mother was French, and after his father's death in 1856 she married again, as had Mme Baudelaire, with a similar effect of alienation on her son. The stepfather had a bookbinding shop in the rue de Sèvres, and Huysmans continued to be responsible for the business, and for his two half-sisters, for the rest of his life. He was sent to a boarding school only a few minutes away from his home, and the brutal discomforts of his early years were translated into a novel, *En Ménage*, of 1881. In some mysterious way these discomforts seemed to have been prolonged throughout his life, so that he never found an adequately heated room, or indeed an appropriate lodging, even when he was dying. He became a law student, but simultaneously began work at the Ministry of the Interior in 1868. He remained there for thirty years, retiring in 1898 with the Légion d'Honneur for meritorious service. His working day was short, from midday to five-thirty, and his duties were not onerous. Most of his letters appear to have been written at his desk.

His literary career began in 1874 with a short volume of prose poems entitled *Le Drageoir aux épices*, written without

a trace of Baudelairian ardour but easy of access. From the first, Huysmans follows ostentatiously in the footsteps of those he admires, yet, also from the first, his writing has a rebarbative quality, making up in complexity what it lacks in natural grace. In 1876, the publication of his first novel, *Marthe, histoire d'une fille*, brought him into contact with Edmond de Goncourt and Zola. Contact with Goncourt was in fact uncomfortably close, for the latter was about to publish his own story of a prostitute, *La Fille Elisa*, and Huysmans, by dint of taking his book to Brussels, managed not only to avoid censorship but to establish an early reputation. Edmond de Goncourt wrote a slightly repressive letter of congratulation. Zola, on the other hand, welcomed him warmly into the Naturalist fold, heroically overlooking the fact that Huysmans's Marthe owes more than a little to his own Gervaise in *L'Assommoir*. This sense of his own characters engendering others was best calculated to please him. Plagiarism was, after all, a form of homage, as Huysmans undoubtedly meant it to be.

At this stage of his career Huysmans remained close to both his mentors, to whom he paid public homage in *À Rebours*. To a certain extent he was that sick man with high ideals whom the Goncourts claimed collectively to be, inheriting not only the bleakness of their vision of the Parisian scene, dominated by the pathos of the working-class suburb, but the gamey quality (*faisandage*) needed to arouse the Goncourts' interest, and his own. In addition Huysmans was to study, to digest, and occasionally to reproduce the pattern of Edmond's greatest non-fiction work, *La Maison d'un artiste* of 1881, that marvellous perambulation of a collector's home, which provides the justification for those

endless descriptions of Des Esseintes's house, and eventually his cataloguing approach – one might say his collector's approach – to the cathedral of Chartres.

His connections with Zola are nobler and more straight-forward, and are expressed very directly in four articles on Zola and *L'Assommoir*, published in the Belgian review *L'Actualité* for March and April 1877, and in the dedication of *Les Sœurs Vatard* of 1879. It is possible that he saw Zola as a surrogate father, yet he also admired him as a writer, singling out for his particular approval *La Faute de l'Abbé Mouret*, which tells of a young priest seduced by a half-wild girl, Albine, who has grown up in the ruins of a magnificent domain called Le Paradou. Their love affair is a very simple paraphrase of the Fall and Expulsion from the Garden of Eden, but the many descriptions of Albine's fabulous garden are transformed by Zola's passion and energy into what Huysmans calls a Hindu poem. Secondly, *La Faute de l'Abbé Mouret* is a genuinely devout book, although the cult cele-brated is that of nature, in which the created world conspires to bring two human beings to full knowledge of themselves. There is no doubt that Huysmans was impressed by the conviction of Zola, which he saw, quite rightly, as com-pletely alien. Zola, for his part, considered Huysmans a disciple, used him as occasional researcher for his novel *Pot-Bouille*, reproved him for his taste for abstruse words, and finally, after the publication of *À Rebours*, reproached him for disloyalty. Zola's more lasting gift to Huysmans, however, was an object lesson in how to be an art critic.

Les Sœurs Vatard brought Huysmans to the notice of the public and revealed him as a man who could paint word pictures which out-distanced those of earlier practitioners,

Gautier and Edmond de Goncourt. Although Cézanne and Pissarro preferred the earlier, more humorous *En Ménage*, it was in *Les Sœurs Vatard* that Huysmans revealed a striking affinity with contemporary painters. The novel is a story of two working-class sisters, but the main protagonist is Paris, suburban Paris, the Paris of railway stations, cafés, and cheap restaurants. Action is subordinated to description, and the passages that dwell on the music-halls and crowds of the Avenue du Maine and the Boulevard Saint-Michel, or the railway yard seen from the back window of the sisters' house, have a visual immediacy and a kind of personal enthusiasm which are unusual in Huysmans's work. Although he was to continue writing novels before devoting himself to art criticism, it is in *Les Sœurs Vatard* that one can detect a strong line of continuity with the theme of the painter of modern life which Huysmans celebrated in the various reviews published in book form under the title of *L'Art Moderne* in 1883.

These reviews, devoted both to the official Salon and to the independent Impressionist exhibitions, were published in *Le Voltaire*, *La Réforme*, and *La Revue Littéraire et Artistique*. In a sense they are the most pleasing of Huysmans's writings and the most traditional. Baudelaire had established a poetic subjective approach to painting, claiming that the creative writer was in a sense especially well qualified to translate the painter's intentions. Zola had drawn the vital distinction between the official Salon and the breakaways, those who opposed the hegemony of the established rules in painting, and had celebrated the first artist whom he considered the equivalent of the new Naturalism in literature: Manet. Both had understood that the amateur is the one best qualified to

speak on a specialist subject, contributing to the matter the resources of the *moi* which professional critics were too correct to bring into play. The Goncourts, though quite fallible in their attitude to contemporary art, had added enormously to the documentation of Parisian life and had therefore furnished circumstantial material for the subject-matter of modern art. They had extended and refined the repertory of urban subjects which Baudelaire had enumerated in *Le Peintre de la Vie Moderne*.

Huysmans inherits the essential literary formation of Zola and the Goncourts, and it is in his closeness to all three that he first impresses as an art critic. His reviews delighted his contemporaries: Mallarmé praised him, and, more important, Monet praised him, saying that nobody had ever written so nobly of modern artists. This is a substantial claim. Certainly the reviews in *L'Art Moderne* are a remarkable achievement, not only because Huysmans manages a consistent fidelity to the painted image, but because this collection of essays marks the culmination of the century's campaigns in search of a new art form for a new situation. They have as their central theme the triumphant discovery of the painter of modern life, thus bringing to closure that profound investigation that began with Stendhal's desire for an art that would satisfy the intellectual and emotional demands of the *enfant du siècle*.

The *Salon* of 1879 is in the main a recapitulation of earlier attitudes. Like his mentors, Huysmans begins with an attack on the institution and manages the right note of robust simplicity in his exclamation, '*De l'art qui palpite et qui bouge, pour Dieu! Et au panier toutes les déesses en carton et les bondieuseries du temps passé.*' ('Let's have living breathing art,

for God's sake. And into the dustbin all those cardboard goddesses and that devotional rubbish.') Like Zola, he manages to insert into his review a long parenthesis on the Impressionists, electing as his ideal painter and protagonist in the fight against the traditional ateliers Degas, the Manet of the new situation. He can only tolerate landscapes if they are sad ('*Au fond, la beauté d'un paysage est faite de mélancolie,*' he says in *Croquis Parisiens*), and he makes explicit the Baudelairian implication that whatever is sad will inevitably be from the north. In 1879 he can find specifically northern characteristics in the suburban dreariness of Raffaelli, his eye having been sharpened by the memory of certain descriptive passages in the Goncourts' *Germinie Lacerteux*. This emotional attachment to the grey and the bleak makes his appreciation of such radiant pictures as Manet's *La Serre* and *En Bateau* all the more attractive.

In his review of the Independents' exhibition of 1880, Huysmans writes as a pupil of Zola. It was surely of some significance that Huysmans was introduced to Zola at an exhibition of modern art in 1876. It was entirely logical in this particular context that Huysmans should isolate Degas as the ideal painter of modern life, for Degas is an avatar of Baudelaire's Guys and Zola's Manet. As if conscious at this point of his inheritance, Huysmans writes a fine, measured and uplifting passage on Degas's pictures, and ends the review with the Baudelairian exclamation, '*Toute la vie moderne est à étudier encore,*' adding that the world of modern machinery and modern industry, only touched on by Monet in his pictures of the Gare Saint-Lazare, remains to be celebrated.

Huysmans has no hesitation in naming the painters who

please him most. First and foremost there is Degas, in his capacity of consummate intelligence and understanding of modern life. He is followed by Forain, whose dilapidated Parisians, seedily lecherous, patiently disenchanted, are particularly close to the protagonists of *En Ménage*, and are observed with the same ironic gleam by both writer and painter. Huysmans and Forain were to become close friends, and Forain was to follow Huysmans back to the church. Also singled out for honourable mention are Raffaelli, Caillebotte, Mary Cassatt, Berthe Morisot, and Renoir. Both Pissarro and Monet are praised, but with important reservations: their technique is found to be too experimental, too inadequate. Manet's *Chez le Père Lathuille* is hailed as a triumph of modernity – the term continues to be crucial – although there is more than a hint of dissatisfaction with the ephemeral nature of his subject-matter. The masterpiece of the future will need to be more heroically conceived.

Huysmans is at his best when following the guidelines laid down by Zola. Even his appreciation of Gustave Moreau picks up on a curiosity which had already caught Zola's eye. Similarly his digression on the use of iron in modern architecture, in the *Salon* of 1881, has the stamp of Zola's approval. Yet he departs from Zola and establishes his own originality in one important particular. Whereas Zola could never accept the fact that the Impressionists were performing as audacious and original a task in painting as the Naturalists in literature, Huysmans was perfectly convinced of the parity between the two arts, making the specific claim that the Impressionists had reformed painting as Flaubert, the Goncourts and Zola had reformed literature, referring to Degas as the pictorial equivalent of the

Goncourts, describing Moreau as being overwhelmingly indebted to Flaubert. By 1881 Huysmans was the serenest modern of them all, indifferent to that putative genius of the future who was Zola's abiding obsession and his secret desire. It is impossible to close *L'Art Moderne* without feeling that Huysmans is writing within the best French tradition. His style was to deteriorate, to become spectacular but fallible and overwrought, but here he writes elegant nervous prose, the correct style in which to discuss works of art, with a generous but discreet admixture of personal opinion to flesh out his verdicts. Subjectivity and objectivity are ideally balanced: Huysmans contrives to be both amateur and enlightened guide, and an acme of good taste.

This moment of equilibrium was not to be sustained. In 1884 Huysmans published a novel which he dedicated to a new friend, Léon Bloy, 'in hatred of the present century'. This novel, in which Huysmans took a giant step towards overt autobiography, was *À Rebours*, on which his notoriety rests. In 1903, in a preface to a later edition, Huysmans was to describe *À Rebours* as a forerunner of his Catholic novels. It is also a summary of his early Naturalist enthusiasms, but in this instance summary may also signify rejection, for in this story of Duke Jean Floressas des Esseintes, who retires to an elaborately furnished house at Fontenay-aux-Roses in an attempt to shut out the horrors of the modern world, the methods of Baudelaire, Zola, and Edmond de Goncourt are turned to ridicule.

Des Esseintes is best known by his attributes; as languid as a latter-day René, vitiated by the philosophy of Schopenhauer, he nevertheless retains a certain power to corrupt and deprave. The formation of Des Esseintes's elaborate

library provides Huysmans with an excellent opportunity to review the works of his favourite writers, some of whom are shaken in the process. For example, though no one can doubt the sincerity of his admiration for Baudelaire, the episode of the mouth organ, an arrangement of liqueurs which the ultra-sensitive Des Esseintes can combine at will while enjoying the sensations and images which the resulting tastes evoke for him, is a pointed and not ineffective comment on Baudelaire's never very securely argued theory of correspondences, an extrapolation of his own synaesthesia. Only Zola appears to emerge unscathed, for the novel contains an impressive passage in praise of *La Faute de l'Abbé Mouret*, which appears to have been Huysmans's favourite novel, yet Zola quite rightly assumed that Huysmans's book was a criticism of his own method, and one, moreover, which was meticulously planned.

À Rebours is also famous for its appreciation of artists outside the Naturalist canon, notably Gustave Moreau, Redon, Jan Luyken, and Bresdin. Yet the highly coloured prose masks a dwindling aesthetic response. For Huysmans, or Des Esseintes, is now more interested in the subject-matter of these artists, rather than in the fusion of style and image, and his interest is coloured by a growing fear and hatred of the modern world. He states his position by refuting Taine, explaining that the theories of heredity and environment can frequently be observed to work in reverse, by reaction, *À Rebours*. Thus, those baffled by the world depicted by Gustave Moreau will find an explanation and a justification of it the moment they step outside into the street, where the sheer horror of life will be revealed to them. Evidence is to be found in

. . . that epitome of modern taste, the street; those boulevards with their sclerotic trees, orthopaedically corseted in metal bands . . . those streets shattered by enormous omnibuses and wretched advertising vans; those pavements teeming with hideous people avid for money, women worn out by childbirth and stupefied by horrible exchanges, men reading vile newspapers and thinking of fraud and fornication as they pass by the shops and are spied on by the licensed sharks of business and commerce, waiting to fleece their prey. All this would give one a better understanding of the world of Gustave Moreau, timeless, escaping into the beyond, hovering in the realm of dreams, remote from the fetid ideas secreted by an entire people.

In other words, Des Esseintes is a fine illustration of that other disorder isolated by Baudelaire: spleen. *Le Spleen de Paris*, one of the latter's titles, might be a diagnosis of Des Esseintes's or Huysmans's complaint.

Yet at the end of *À Rebours*, Des Esseintes is forced to leave his onanistic retreat and return to the nightmare city which Huysmans only briefly deserted. Although an emotional northerner, his intellectual formation was entirely Parisian. Des Esseintes packs his bags with a prayer on his lips and the desire for another retreat germinating in his mind. There is little doubt that the prayer which closes the novel is entirely spontaneous; there is no less doubt that Huysmans had great difficulty in leaving the world behind, and that he continued to value Paris and Parisian life as an abrasive agent which stimulated him to his brilliant intellectual best.

Nowhere is this more vehemently demonstrated than in *Certains*, a volume of essays on artists and works of art

published in 1889. Huysmans's bifurcated career as both novelist and critic, a combination which he said was impossible, showed signs, in this volume, of being subjected to hitherto unknown pressures. Whereas his earlier writings on art bore the stamp of real enlightenment, *Certains* is animated by a convulsion of disgust. His judgements are both extreme and partial. He refers to 'that animal Courbet' with his working-class mind. On the other hand, the indifferently talented Belgian pornographer Félicien Rops is placed on the same level as Memlinc because he has '*une âme de primitif à rebours*'. Blemishes such as these, although obtrusive, pale into insignificance beside the occasional flashes of judgement which manage to capture something of that childlike vision so esteemed by Baudelaire. The most singular essay in the collection, and the one best known to readers of Mario Praz's *Romantic Agony*, is on Bianchi di Ferrari's mild *Virgin and Child with Saints* in the Louvre, which Huysmans sees as an anagram of sexual deviations. In the faces of the Virgin, St Benedict, and above all St Quentin, can be read various forms of fatigue. If chaste, the explanation of their apparent listlessness is easily come by. But are they chaste? Signs of depravity are not difficult to find. St Quentin, '*un éphèbe au sexe indécis*', has long hair, wears delicate linen and a blue ribbon; he is still waiting to experience a state of grace. The saints are clearly mired in an atmosphere of mortal sin, and the family resemblance between them is no accident, for St Benedict is the father of the Virgin and St Quentin, and they in their turn have given birth to the angel playing the viola d'amore. This conceit, says Huysmans, is typical of the perfidious Renaissance which so regrettably replaced the '*rigide blancheur du*

moyen age'. This, he was to spend the rest of his life celebrating.

Paranoia is undisguised here; the tentative good humour of the early years has vanished. When Huysmans paid a visit to Frankfurt in 1905 he found to his horror that not only did the museum contain certain Italian paintings but the town itself was full of Jews. The rigid whiteness of the Middle Ages was nowhere in sight. Reverting to a polemical brilliance which marks a dynamic contrast with the flaccid writing of the later novels, *La Cathédrale* and *L'Oblat*, Huysmans sees a sinister connection between these two phenomena. The picture known as *La Florentine*, which is in fact now attributed to a Venetian painter, could only have been executed by 'an Italian living at the court of Rome and in a state of considerable personal degeneracy'. And it is entirely fitting, he concludes, that this symbol of the shame of the Papacy should end up in Frankfurt, the town in which the rout of the church is being accomplished '*entre les mains des juifs*'.

The Romantic agony of Huysmans becomes explicit in *Là-Bas*, acute in *En Route*, and becalmed in *La Cathédrale*. Of these three late novels, *Là-Bas*, which deals with satanism, is the most Romantic, for the first page contains a condemnation of Naturalism, the story includes characters – notably Carhaix, the saintly bell-ringer of Saint-Sulpice – who might have escaped from a discarded chapter of Victor Hugo's *Notre Dame de Paris*, while the whole tenor of the story, with its simple confrontations of black and white and its grave acceptance of phenomena like incubi and succubi, demands a credulity which the author evidently possessed in greater quantity than most of his readers. *En Route*, the

impressive account of Huysmans – he is Durtal in the novel – in his trial period at the Trappist house of Igny (called Notre Dame de l'Âtre, for the purposes of the story), drops all this literary paraphernalia, and although Huysmans professed to have written the book '*surtout pour le monde intellectuel de Paris*', it is the clearest and most candid of all his works, as honest in its portrayal of the descent of grace as is Durtal's relief when he gets back into the train for Paris. But in *La Cathédrale* the Gothic syndrome is present again in full force. Ostensibly a study of Chartres, the book was composed from a number of manuals of architectural history, medieval treatises on the symbolism of colours and numbers, and other arcane documents, and whatever Huysmans's quarrel with Naturalism it is evident that he is on shaky ground when he abandons the method of direct observation.

In the final analysis Huysmans is simply not a dandy. He is not even a dandy of the perverse. His awestruck contemplation of the death of the body even has something orgasmic about it. His original connoisseurship, now applied to religious orders or the quality of plainchant to be heard in various monasteries and convents, has been routed without a trace of regret. He looks at many religious pictures, but does not hesitate to dismiss whole schools of painting for lack of unction. Only one masterpiece detains him; he hesitates, then gives Grünewald's famous *Crucifixion*, in Colmar, the benefit of an involvement that has now parted company with the tastes of his times and of his century.

Dislocated, almost dragged from their sockets, the arms of the Christ seem pinioned from shoulder to wrist by the cords of

the twisted muscles. The collapsed armpit was cracking under the strain. The hands were wide open, the fingers contorted in a wild gesture of supplication and reproach, yet also of blessing. The chest quivered, greasy with sweat. The torso was barred and furrowed by the cage of sunken ribs. The flesh was swollen, stained and blackened, spotted with flea bites, spotted as with pin pricks by splinters that had broken from the rods at the scourging and still showed here and there under the skin.

Decomposition had set in. A thick stream poured from the open wound in his side, flooding the hip with blood that matched mulberry juice in colour. Discharges of pinkish serum, of milky lymph, watery fluid the colour of grey Moselle wine, trickled from the chest and soaked the belly and the dripping loincloth below. The knees had been forced together so that the kneecaps touched, and the relaxed legs hung helplessly to the feet, curved apart, and meeting again only where the distended feet were pressed on top of one another, stretched out in full putrefaction and turning green beneath the rivers of blood. These feet, spongy and clotted, were humble, the swollen flesh rising above the head of the nail, the clenched toes contradicting the imploring gesture of the hands, seemed cursing as they clawed with their blue nails the ochreous earth, impregnated with iron, like the red soil of Thuringia . . .

The translation is by John Brandreth, in his monograph on Huysmans of 1963. The imagery, reflected faithfully by the translator, is of death and disintegration, rather than death and transfiguration, as might be expected. Connoisseurship is an old reflex, here put to questionable ends. Decadence is perhaps an appropriate term; certainly it has been used by his biographers. Gothic is perhaps more fitting,

in the pejorative sense habitually employed by Diderot as appertaining to the superstitious and obscurantist Middle Ages. Forward thinking has entirely disappeared; even the regret and disenchantment of the earlier *enfants du siècle* has been replaced by a life of archaic observance. Yet Huysmans did not entirely abandon the Parisian literary scene. Edmond de Goncourt's will had nominated him as founding president of the Académie Goncourt, which meant that he had to read quantities of novels in order to award the annual prize. He thus ended as member of a jury, he who was the scourge of juries, as Zola had been before him. If he noted the irony he did not remark on it.

After his retirement from the Ministry of the Interior in 1898, Huysmans spent two years as a Benedictine oblate at Ligugé in Poitou. In 1901, however, the Waldeck-Rousseau law on religious associations dissolved the community and sent him back to Paris, where he suffered in a succession of chilly, noisy rooms and finally succumbed to cancer of the mouth and jaw. In these last years he wrote his most committed works, *L'Oblat* and the biography of the Blessed Lydwine of Schiedam. Something of the old irascibility reappears in *Les Foules de Lourdes* of 1906, in which the horror of the architecture occasions a brief struggle between faith and criticism. His secretary, Lucien Descaves, put together various marginalia, which appeared in *Pages choisies* in 1918, the year that buried Huysmans's sufferings in the greater sufferings of the First World War.

In 1847, Sainte-Beuve had written in his notebooks, '*La morale n'est pas le goût; l'art n'est pas la foi; Phidias et Raphael, les plus grands des artistes, faisaient des dieux et n'y croyaient pas.*' ('Morality is not taste; art is not faith; Phidias and Raphael,

the greatest of artists, made gods in whom they did not believe.') Whether or not morality is a form of taste – and it is, or can be – Huysmans managed to combine the two to his avowed satisfaction. In so doing he turned his back on the truth that earlier Romantics took as their starting point: that there is no consolation. But perhaps there is a more subtle message, that art for art's sake might serve for a time as a useful aesthetic creed, but art as a refuge from reality will not satisfy human needs. It is significant that Des Esseintes's doctors advise him to go back to Paris and to re-enter the world from which he was so anxious to escape. It is also significant that the final words of *À Rebours* are intent on finding a way out of the world of the senses, of voluptuous concocted sensations.

Seigneur, prenez pitié du chrétien qui doute, de l'incrédule qui voudrait croire, du forçat de la vie qui s'embarque seul dans la nuit sous un firmament que n'éclairent plus les consolants fanaux du vieil espoir! [Lord, take pity on the fallible Christian, on the unbeliever who longs to believe, on the convict of life who takes lonely steps, in the night, under a sky no longer illuminated by the consoling shafts of former hope!]

Huysmans thought that he had found the one way to transcendence that remained to the unbeliever. Yet his investigations, though wholehearted, do not free him from the artist's alter ego, artifice. The description of the Grüne-wald *Crucifixion*, although sympathetic, is also horrifying, a literal imitation of Christ. It would seem that Des Esseintes's doctors were correct in advising him to resume the burden of a life without heroism. It is at this point that one can observe the disappearance of a helpful Romantic illusion.

From the ruins of an heroic past, Baudelaire, Zola, even Gautier, envisaged a hypothetical heroic future. Baudelaire went further, stating that the present must suffice, and that if one is sufficiently attentive the present will yield satisfactions for which only observation is required.

But the old nostalgia for vindication persisted, and was transferred to a situation which might or might not be revealed in time. *Le génie de l'avenir*, the genius of the future, would bring about some sort of quietus, and would justify all the hard work done in preparation for the arrival of such a genius. Huysmans was undoubtedly correct in transferring his hopes for such vindication from an earthly to a transcendental sphere. It is interesting that in the preface to *À Rebours* of 1903 he claimed that the novel was a partly unconscious creation. Such urgings, such promptings as are experienced in the closing lines of the novel have an effect of easy spontaneity. He who had been so much in and of the world purported to be content to write about magic and saints, and there is still a certain amount of vigour in the writing of *La Magie en Poitou* or in the life of the Blessed Lydwine of Schiedam. An enormous amount has been lost, and with it the world of every day – the birthright, one might say, of every apologist, of every artist, of every pilgrim. But then loss is a constant factor in the composition of the Romantic temperament, whether of the past or of the future. Huysmans proposed no general solutions. His retreat into yet another closed world marks the end of the Romantic endeavour. The way is clear not for the genius of the future, but for the ever more alienated heroes of Sartre and Camus.

Conclusion

It is a paradox that the solution to a problem is rarely the same as the problem itself. Solutions involve a species of lateral thinking. By almost common consent the Romantics in France transferred their idealism to the domain of art, either as practitioners or as critics. Art was common ground, almost as religion had once been; art, moreover, was an elite calling, a vocation, '*un apostolat*' according to Ingres. And few were inclined to doubt that there was something sacerdotal in operating even on the fringes, in celebrating the new that might in its turn be revelatory.

In dedicating themselves to the cause of art, amateurs discovered a new validity, both in art and in themselves. Only the constitutionally depressed Sainte-Beuve realized that this would not provide a universal panacea. In that sense it is possible to appreciate the neophytes, the men, like Baudelaire, like Zola, who preserved the naïveté of the true believer, and alternatively, those men of huge beliefs, Delacroix, Ingres, who exemplified the eternal demands of their own creativity.

Directly and indirectly approaches were made to a new belief system, in which outward observance and inward compulsion could be equally accommodated. This balance, always precarious, was maintained throughout the century.

The Romantic generations in France achieved victory on their own terms, sustained by a memory of victories which had passed into history.

Doubts persisted, and were, again naïvely, expressed. It was the perception that the work remained to be done that links Gros with Delacroix, Musset with Baudelaire and Zola. The eventual outcome could only be adumbrated, but in charting the transformation of disenchantment into prophecy, albeit of a fragmentary and tentative kind, the artists and writers in this study made the heroism of modern life their creed, and thus brought about a recognition of possibilities that had previously lain dormant. Their own heroism should not be in any doubt.

Index

(References to plate numbers are in *italics*)